To all the young people who have taken part in joinedupdesignforschools.

The aim of the Sorrell Foundation is to inspire creativity in young people and to improve the quality of life through good design. It creates and prototypes new initiatives to explore their potential before development, and seeks new ways to join up public sectors such as education and health with the UK's world-class design community. The fast-track nature of the Foundation's work aims to deliver immediate benefits whilst creating models with long-term value.

Joinedupdesignforschools explores how good design can improve the quality of life in schools by listening to the voices of the consumers. It inspires pupils by putting them in the driving seat, giving them control and responsibility as clients. Through this experience, they discover creative and life skills such as problem-solving, reasoning, teamworking, communication, negotiation and citizenship, all of which lead to self-belief. The initiative acts as a catalyst for potential improvements by identifying common issues and providing concepts for the built environment, storage, signing, internal and external communication, websites, interactivity, uniforms and identity. And joinedupdesignforschools also demonstrates ways in which the UK design industry can be joined up with the education sector so that schools can benefit from its experience and skills. Other areas of work include:
Joinedupdesignforhealth: a research programme working with client teams of front-line medical staff to explore ways of improving the patient experience.
Personalised Learning: a research programme with thirty Special Advisory Teams of primary- and secondary-school pupils across the UK to explore the potential for personalising the learning experience.
V&A Learning Centre: an exploratory programme with Special Advisory Teams to support the development of a new V&A resource.
Understanding Us: photographs and stories from people with a learning disability, published by Mencap and supported by the Sorrell Foundation.

joinedupdesignforschools

John and Frances Sorrell

MERRELL
LONDON · NEW YORK

Contents

6 Introduction 9 The Process 33 Common Issues

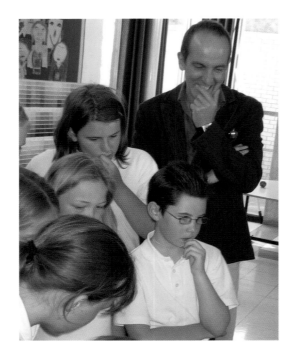

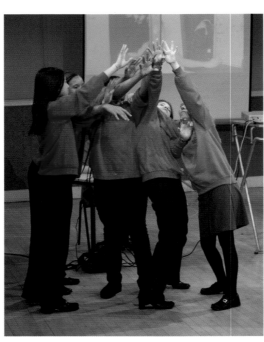

161 Life Skills

169 Education & Design

173 The Gallery

When we first had the idea for joinedupdesignforschools, our aim was to inspire creativity in young people. But we have ended up being inspired by them: by their knowledge, enthusiasm and realism. They have shown us that if you really listen to them, they know better than anyone what the key issues are in their school environment. This is hardly surprising, because they are the consumers of education and, like consumers everywhere, they have strong views about the environments, products and services that impact on their lives.

We have worked together for thirty years, and ran an international design business with clients across the world. One of the areas in which we worked was education and, when we set up our Foundation in 1999, we hoped to use our professional experience to help join up the worlds of education and design.

We wanted to create a different kind of project for young people in schools that would build their self-confidence, give them self-esteem and unlock their creativity. To do this we devised a new approach that included an element of role reversal. Instead of being told what they had to do and being evaluated on their work, pupils would do the instructing. They would compose a *brief*, telling a designer exactly what they wanted in order to improve the quality of life in their school. They would be the *clients*, representing their school in a client/consultant relationship that would take place over two school terms. The pupils would not be marked or assessed so, in that sense, they could not fail. They would be part of a team, working hard to achieve a common purpose whilst developing their own creativity and life skills.

We had three main aims: first, to identify what pupils most wanted to change in their schools (the Common Issues) and then show how design solutions to these could lead to practical improvements in their schools and provide models for use elsewhere. Secondly, to help the pupils discover *life skills* and attributes that would be useful to them all through their lives, such as Problem-solving, Communication, Teamwork, Negotiation, Reasoning and Citizenship. Thirdly, we wanted to highlight the value of joining up *education and design*, so that schools could benefit from the experience and expertise of the UK design industry, which has some of the best creative talent in the world.

We ran a pilot of joinedupdesignforschools in 2000–01 with seven schools in different locations around the country, which we matched with seven top designers. The results were encouraging and exciting. Client team-members told us they had discovered new skills, head teachers told us how much their pupils had developed, and designers described how impressed they were with their young clients. Most of the schools said that the concepts resulting from the projects were of such high quality they wanted to find a way to make them happen.

Demos, the independent think-tank, published a study of the pilot entitled *Design for Learning*, which recommended a national initiative. The report was launched at a seminar at Number 11 Downing Street, hosted by the Smith Institute, which focused on joinedupdesignforschools in the context of inclusivity and featured presentations from members of the client teams. Channel 4Learning made four television programmes about joinedupdesignforschools as part of its Design and Technology series.

In 2002, the Department for Education and Skills agreed to provide funding support to help extend the initiative over a three-year programme. This meant we could test and refine the process with more schools, bring more designers into the programme and research further into the issues concerning pupils about their learning environment. The knowledge gained could be made widely available, provide guidelines for adopting the process, and feed into initiatives such as the Government's Building Schools for the Future programme.

Joinedupdesignforschools projects have now been carried out with over sixty schools; seven hundred pupils have been directly involved in the client teams, and thousands more have been part of the wider initiative. Pupils have identified the things that concern them most about their school environment: use of Colour, Communication, Dinner Halls and Canteens, Learning Spaces, Reception Areas, Reputation and Identity, Sixth-Form Spaces, Social Spaces (indoor and outdoor), Storage, Toilets and Uniform. There has also been a special project about the design of an entire school called Whole School Plan.

Over 100 heads and 175 teaching staff supported the pupils in the client teams, and more than fifty design practices have been appointed to work for their young clients, involving over 150 individual designers. For many, it was their first experience of working with schools, and for most it was a unique experience to have pupils as clients.

The results of the collaborations are described in this book, and presented in an exhibition about joinedupdesignforschools at the Victoria and Albert Museum in 2005. A workshop programme, involving a further fifty schools and a thousand pupils, created fifty new briefs specially for the exhibition.

Several of the concepts created by the designers for their client teams have already been implemented (see p. 28) and the Department for Education and Skills is partially supporting the delivery of a further, representative range of concepts on a match-funding basis.

Many people have been involved in joinedupdesignforschools since its conception. We would like to thank all of them, and we would like to say a very special thank you to all the young people who have taken part. This book is dedicated to them.

John and Frances Sorrell

The Process

"What! You mean the kids are the clients?"
Head teacher

The *process* for joinedupdesignforschools is based on our professional experience of working with clients. In this case, because pupils were going to be the clients and design consultants would be working for them, we developed a specially tailored approach which we refined through prototyping and testing.

We devised a programme that divided into clearly defined stages to match the rhythm of the school year, starting in September and ending before the summer holidays. We took steps to ensure that the development of the client/consultant relationship was at the heart of the project, which in our experience is the key to successful projects.

As far as the young client teams were concerned, there were four stages to joinedupdesignforschools. The first we called the *challenge*, when pupils decided which problem they would ask their designer to solve to improve the quality of life in their school. The second was the *brief*, in which the client teams prepared and presented a detailed study to their designers of what they wanted changed. The major part of the project was the third stage, which we called the *conversation*. This was the key period of interaction between the young clients and their designers. The fourth stage was the *concept*, when the designers presented their final design ideas to the client team. Once the team accepted them, which sometimes involved further reworking, they would then, together with their designers, present the concept to the head teacher and governors.

Before all this was the important *planning and preparation* stage, during which we identified the schools and matched them to the designers. The final stage was the *follow up*, when discussions took place to explore the possibility of implementing the design concepts.

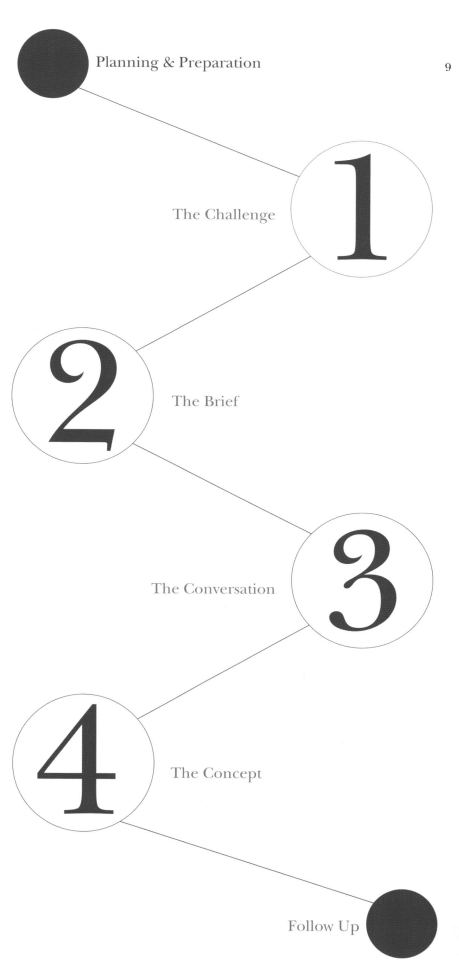

Planning & Preparation

1 The Challenge

2 The Brief

3 The Conversation

4 The Concept

Follow Up

Planning & Preparation

"I didn't know precisely what to expect at the beginning. I thought it was going to be good but it's exceeded my expectations."
Head teacher

10 *Planning and preparation* began during each summer break, when we drew up a list of possible schools based on the guiding principle of diversity. We were aware that the research element of the joinedupdesignforschools programme would mean little if it did not address a wide range of educational circumstances. To ensure that we worked with as many different types of schools as possible, the Foundation team researched across the UK for primary and secondary schools in both urban and rural areas. We wanted to work with schools that were in challenging circumstances (such as special measures), as well as schools that were regarded as exemplary. We were also looking for cultural variety. The Internet, local government and Local Education Authorities were key sources of information. We read DfES publications and checked DfES and BBC websites. As a list of potential schools developed, we could see advantages in time and cost for grouping them into clusters. We looked at published academic results and we studied OFSTED reports. Where we could, we also checked individual school websites. Later in the programme, as the educational grapevine spread news of our work, and as our interim publications were circulated, schools approached us direct.

It takes a head teacher with vision to see the benefits of a project like joinedupdesignforschools. Without the head teacher's support, initiatives like this cannot succeed. The Foundation's first contact with each school was direct to head teachers by telephone. We explained the initiative and then invited them to a regional event, where we presented the programme in more detail. This was usually followed by a dinner enabling us to discuss the programme further. This approach had the added advantage of sometimes introducing head teachers who had not previously met. It also saved time and was cost-effective.

We asked the heads to do two things: select up to twenty pupils to form a client team and choose a 'lead' teacher to support them. We said they could choose the client team on any basis they felt was right; for example, they could select year groups or make up a team of pupils drawn from different years, like a school council. Or they might want to choose 'gifted and talented' or 'diffident and disaffected' pupils. They knew their pupils; we were happy to work with any team they gave us; variety supported our research.

Schools did things in different ways. One client team was selected because they'd worked well together on an earlier school project. One primary school chose the entire pupil and staff population for the client team so that they could create the challenge and the brief together. A lead teacher in London discovered so many pupils wanted to be a part of joinedupdesignforschools she decided to issue a job application form. This included a key section on what qualities the applicant would bring to the team.

The head's selection of the lead teacher was equally important. The teacher had to be energetic and committed, yet willing to take a back seat and let the client team take control. Like the client team, he or she also had to give up many hours of free time. It was a demanding role, but many teachers said they got a lot out of it. In particular, many reported their relationship with their pupils improved as they worked with them on a common cause. "They see me as a human now," one commented.

Simultaneous to the liaison with schools, the Foundation team developed a list of potential designers from the four design disciplines in which we expected pupils to make challenges: the built environment, clothing, communication and product design. We talked to leading designers to gauge their interest and availability. This work evolved into a database of designers who were willing and able to work on the programme.

"Teamwork needs lots of co-operation and even if they are not our friends to try to get along." Client team applicant, 11

"I believe that everyone in the school should be heard and give ideas." Client team applicant, 11

"I think it would be useful for later life if I had a go at this. It's a once in a lifetime chance and I'd love to do it." Client team applicant, 14

Above: Extracts from job applications for a place on the client team.
Opposite: The schools that participated in the joinedupdesignforschools project.

SCOTLAND

Quarry Brae Primary School, Glasgow

NORTH EAST

Bishopsgarth School, Stockton-on-Tees
Hookergate Comprehensive School,
Rowlands Gill, Tyne & Wear
Kingsmeadow Community Comprehensive,
Dunston, Gateshead
Monkseaton Community High School,
Whitley Bay, Tyne & Wear
St Cuthbert's Catholic High School, Newcastle

YORKSHIRE

Abbeydale Grange School, Sheffield
The City School, Sheffield
Hinde House School, Sheffield
Mount St Mary's Catholic High School, Leeds
Porter Croft Church of England Primary School, Sheffield

GREATER MANCHESTER

Barlow Roman Catholic High School, Manchester
Ivy Bank Business & Enterprise College, Burnley
Kaskenmoor School, Oldham
North Manchester High School for Boys, Manchester
Wentworth High School, Eccles

MIDLANDS

Aldercar Community School, Langley Mill, Nottinghamshire
Finham Park School, Coventry
Heart of England School, Coventry
Holte School, Birmingham
Leasowes Community College, Dudley
Lode Heath School, Solihull
Summerhill School, near Dudley

LONDON & SOUTH EAST

A2 Arts College (Thomas Tallis & Kidbrooke Schools), Blackheath
Acland Burghley School, Camden
Brecknock Primary School, Camden
Camden School for Girls, Camden
Clapton Girls' Technology College, Clapton
Deptford Park Primary School, Deptford
Dunraven School, Streatham
Fortismere School, Muswell Hill
Grafton Primary School, Holloway
Hampden Gurney Primary School, Westminster
Hugh Myddelton Primary School, Islington
Islington Green School, Islington
Langdon School, East Ham
Park View Academy, Haringey
Plumstead Manor School, Greenwich
Ranelagh Primary School, Stratford
St George's Catholic School, Westminster
Swanlea School, Whitechapel
William Patten School, Stoke Newington
Beechwood Secondary School, Slough, Berkshire
Castleview Primary School, Slough, Berkshire
Hockerill Anglo-European College, Bishop's Stortford, Hertfordshire
Robert Clack School of Science, Dagenham, Essex

KENT

Hythe Community School, Hythe
The Ramsgate School, Ramsgate
Sussex Road Primary School, Tonbridge

BRISTOL

Fairfield High School, Montpelier
Hartcliffe Engineering Community College, Hartcliffe
Speedwell Technology College, Speedwell
Whitefield Fishponds Community School, Fishponds
Withywood Community College, Withywood

CORNWALL

Beacon Community Junior School, Falmouth
Cape Cornwall Comprehensive, Penzance
Falmouth School, Falmouth
Mounts Bay School, Penzance
Newquay Tretherras School, Newquay
Treviglas Community College, Newquay

① The Challenge

*"This is the first time we've been asked
what we think about our school."*
Client, 14

12 The *challenge* was the point at which each client team
engaged with the joinedupdesignforschools programme.
The Foundation team organized regional workshops
at inspiring venues, to which we invited client teams
and lead teachers. In some cases six schools and over a
hundred pupils attended.

From the start it was essential for us to establish that
the pupils were going to be clients, and were going to be
taken seriously. We introduced ourselves to every student.
Then we asked each lead teacher to introduce their
school, and each pupil to say who they were and what
year group they were in. This was an ice-breaker designed
to help everyone in the room to find their voice.

We then made the pupils a promise: we told them
this was a different kind of project, that they would never
be marked, tested, evaluated or individually judged.
Should they decide they didn't want to be on the client
team, they could resign, but if they did stay on the team
they would develop important new skills, and have new
experiences. We were trying to establish this as a different
kind of project, where they would be taking responsibility
for the programme and be in control of its outcomes.
Instead of the usual situation of being told what to do,
they would be instructing adults, their design consultants,
on what they wanted them to do.

We gave a presentation that explored the question,
"What is design?", introducing the many different
design disciplines and how they impact on daily life. We
explained joinedupdesignforschools, looking at each
of the four core stages (challenge, brief, conversation,
concept). Then we went through the basics of how to be
a good client.

After a break, we divided into client team groups to
brainstorm what the challenge to each team's designer
should be. Someone, usually the lead teacher, was
asked to record the session on a flip chart. We started
by asking, "What is good about your school?" We asked
what they felt about its reputation, about its environment
inside and outside, its uniform, and issues like lockers
and toilets. These questions triggered debate, and soon
the teams were discussing what was good, or not so good,
in their schools. It was from these discussions that our list
of Common Issues began to emerge (see p. 33).
Each team produced a shortlist of three challenges
that they then presented to everyone at the workshop.

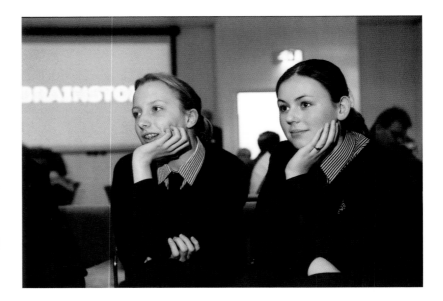

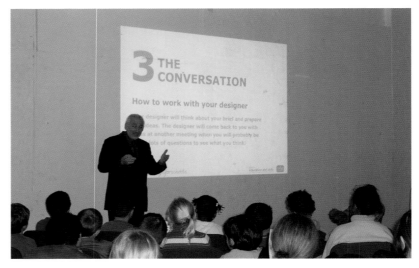

*"Children are the experts about the problem; they're the ones who
know what needs to be improved because they are living with the
problem every day."* Teacher

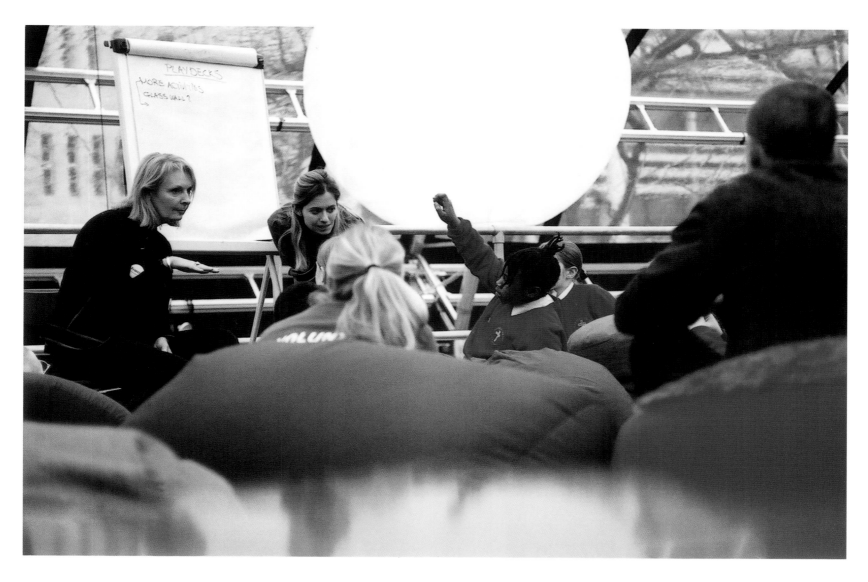

HOW TO BE A GOOD CLIENT

Be clear about what you want and what difference it will make

Be thorough in preparing and presenting your brief to your designer

Be supportive throughout the project to your team and the designer

Be on time for your meetings

Be reliable: do what you promise when you promise it

Be fun to work with

Opposite from top: Client teams brainstorm at a workshop; John Sorrell explaining the process; the National Maritime Museum Cornwall in Falmouth and the At-Bristol exhibition space provided workshop venues; the guide given to all client teams. *Above*: Frances Sorrell with the client team from Hampden Gurney Primary, London at the Bloomberg temporary art centre.

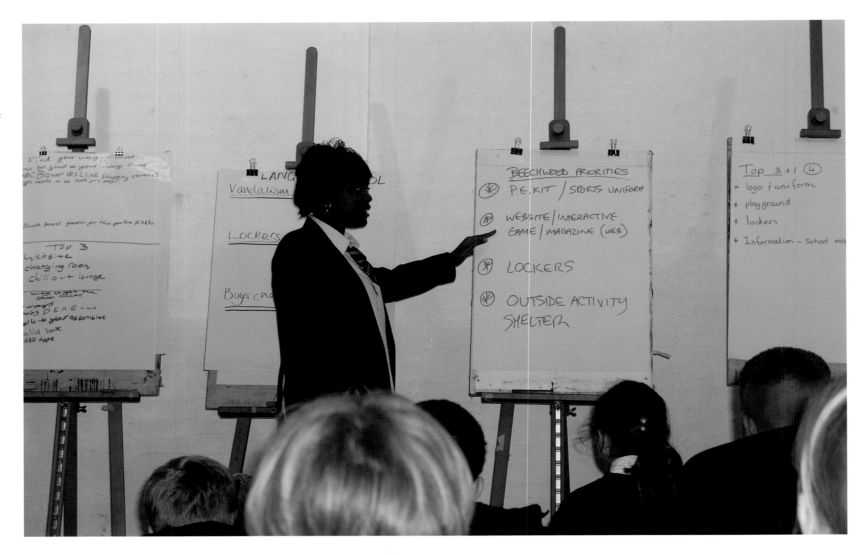

Their presentations were met with a round of applause, acknowledging the work they had done. Finally, we asked the client teams to meet with their head teacher for a discussion about their challenge shortlist. In some cases the teams surveyed the whole school's opinion before negotiating with the head teacher about what their final challenge would be. Some heads organized assemblies to help the process. When the teams had made their final choices, they sent them to the Foundation.

As the challenges came in, we matched them to designers on our database, and organized evening briefing events for the designers, at which we explained the programme and suggested guidelines to working successfully with the young client teams. Our aim was to have all the schools and all the challenges matched to designers by mid-December, so that when the client teams returned from their Christmas holidays, they would be ready to start detailed work on producing their briefs.

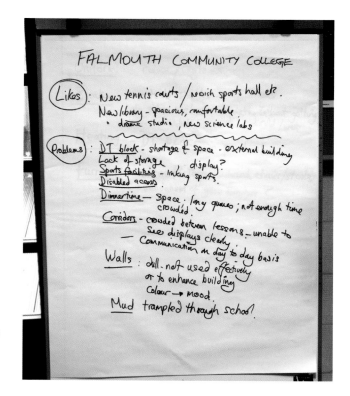

"The pupils' challenge went to the heart of what we needed to do." Head teacher

WORKING WITH PUPILS AS CLIENTS

Treat your young clients as you would any adult client.

You are talking to clients with knowledge: have respect for them. They are the consumers of education.

Listen to them – they know what the problems are.

Be prepared to change your language – avoid jargon.

You are not teachers, but the children will learn from you.

This is not just another job. This is something that can change lives.

Opposite: The client teams presented their issues back to the entire challenge workshop. And then they took a well-earned break.

This page: A list of issues from Falmouth School, Cornwall; *left – right from top*: Joinedupdesignforschools' designers – Paul Smith; John MgBadiefe & Paulo Ribeiro; Sebastian Conran; Amanda Levete; Will Alsop; Andy Stephens & Dave McKendirick; Thomas Heatherwick; Ally Capellino; Sally Mackereth; Natasha Wright; Dave Simpson, Phil Skegg, Sue Strange & James Quail; Mike Davies; Ben Kelly; Dinah Casson & Roger Mann; Ferhan Azman; Keith Priest; Phin Manasseh; Simon Waterfall; Paul Priestman; Sam Jacob & Sean Griffiths; Kevin Gill; Julia Barfield; Marksteen Adamson; Nick Eldridge & Piers Smerin.

② The Brief

"Their brief was incredible; it had such vigour, life and enthusiasm. It was really stimulating. It was the key that unlocked the process."
Designer

16

The *brief* was the stage during which each client team carried out research and developed a presentation to tell the designer what they wanted. We have seen thousands of briefs for design projects over the years; usually they are written documents supported by market research and some visual material. But we've seen nothing like the sort of work generated by the client teams in joinedupdesign-forschools. They staged performances, created exhibitions and displays, did PowerPoint presentations, and made videos, photographs and paintings. One brief was partly delivered to music in the form of a rap.

The Foundation's project managers visited each school and advised the client teams that their briefs should include a description of the school and its history, an introduction to the client team-members, a full description of the problem, and what the benefits would be to the school were the problem solved. Each member of the client team should take responsibility for a part of the brief, so that everyone would become involved.

The client teams carried out research in their schools and went out into the community for further information. For example, pupils creating a brief for a new school uniform questioned their parents about how much they would be prepared to pay. In a school concerned with improving its reputation, the client team interviewed and videoed local shopkeepers talking about what they thought of the school.

To indicate the design style they wanted, the pupils cut up magazines, downloaded web images and researched books for ideas about modern furniture, futuristic lighting, new fashion styles – whatever was relevant to their challenge.

As their briefs developed, the client teams became clearer about what they wanted, and their enthusiasm and commitment rose. Suddenly, this was no longer a project they had been asked to do; it was their own project, and in many cases their energy for it increased dramatically. The brief became the framework against which they would evaluate the designer's response later in the process.

The pupils on the client teams, aware that they were becoming ambassadors for their peers, representing the feelings of the whole school, took ownership of the projects, increasing their sense of responsibility. Some client teams presented their developing brief in assemblies and displays to ensure the school felt involved

and aware of what was going on. They used feedback from these presentations to hone the brief still further. By this stage most teams were driving the process, though it should be noted that the lead teachers' role of guidance, organization and support was essential.

Many of the pupils were nervous about presenting their brief to the designers, especially to those who had appeared on national television. We held rehearsals to help them prepare, while at the same time we talked to the designers and explained the best way to present their credentials and receive the brief from the pupils. Our preferred structure was for the designer to make a presentation about their practice and its work, and then for the client team to present their brief in whatever form they had decided.

The young clients and experienced designers were now ready for the moment when they could meet and begin talking. The feedback we received from the designers about the quality of the pupils' briefs was very encouraging. "The young children's brief was incredible," said interior designer Ben Kelly, talking about primary-school children. "It had such vigour, life and enthusiasm. It was really stimulating. It was the key that unlocked the process." Architect Keith Priest was equally impressed. Talking about his sixth-form client team, he said: "Their brief was highly intelligent, all about light, space, environment, even acoustic separation. Very profound."

"The kids can list the problems in a school more quickly than teachers or governors. That's very important."
Sam Jacob, designer

Opposite: The client team from Plumstead Manor School, London, demonstrating how hard it is to get to the higher lockers during the end-of-day rush.
Overleaf: A snapshot of some of the briefs prepared by the client teams.

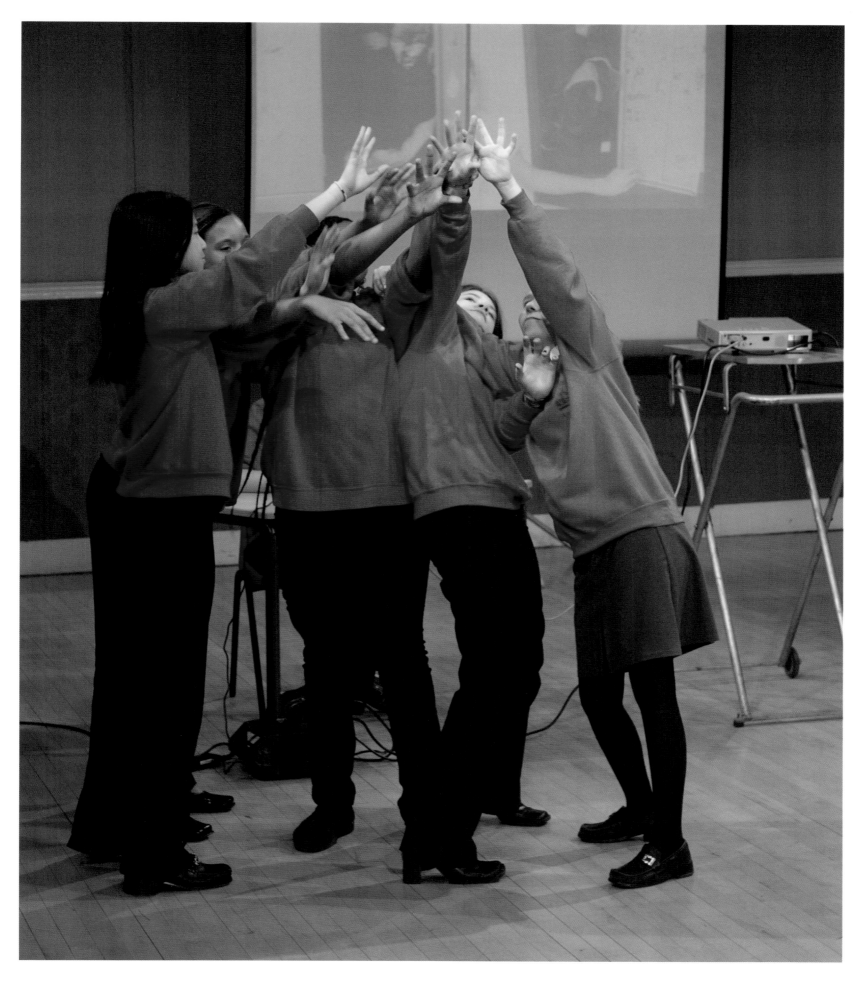

William Patten Primary School

Summer 2004

joinedupdesignforschools

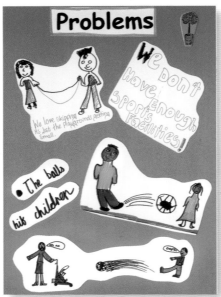

Problems

We love skipping to see the playground getting small.

We don't have enough sports facilities!

• The balls hit children

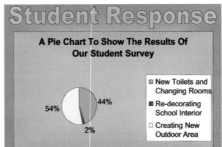

"We are looking forward to taking part in the project and we think it will be a very good opportunity for our school. We hope to learn a lot from it and we hope our school will be a better place to be in as a result of the work we will take part in."

Student Response

A Pie Chart To Show The Results Of Our Student Survey

- New Toilets and Changing Rooms
- Re-decorating School Interior
- Creating New Outdoor Area

54% 44% 2%

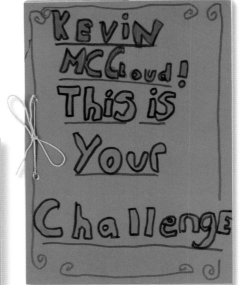

Kevin McCloud! This is Your Challenge

joinedupdesignforschools

Treviglas Community College

Brief for Marks Barfield

February 2004

"The main problem in the school we have come across is general disrespect for the environment, especially the toilets. This was identified as the main problem for many students and the fact that the general feel of the school was of a dilapidated environment and little feel of respect for the school buildings or culture. This we feel could be improved by giving us all a sense of belonging and pride for the school."

Pictures of our current Year 9 Area

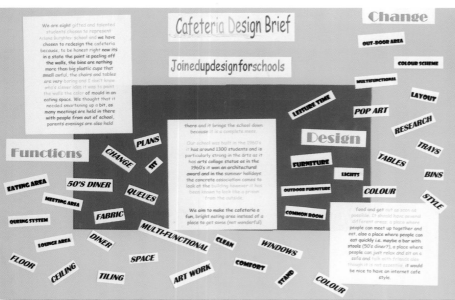

This project will improve the way we work and will give us a cleaner more suitable working environment and will inspire students to work harder.

Creating a social space will give kids a place to go when the weather is bad. It will cut down on bullying, vandalism, litter and other problems caused. The room will give kids a chance to do their homework and relax from stressful lessons. Overall the room will make the school a more interesting place to be, and that is why the project is important.

Cafeteria Design Brief

Joinedupdesignforschools

Change
- OUT-DOOR AREA
- COLOUR SCHEME
- MULTIFUNCTIONAL
- LAYOUT
- POP ART
- RESEARCH
- TRAYS
- TABLES
- BINS
- COLOUR
- STYLE

Design
- FURNITURE
- LIGHTS
- OUTDOOR FURNITURE
- COMMON ROOM

Functions
- CHANGE
- PLANS
- IT
- 50'S DINER
- QUEUES
- MEETING AREA
- FABRIC
- QUEUING SYSTEM
- LOUNGE AREA
- DINER
- MULTI-FUNCTIONAL
- FLOOR
- CEILING
- SPACE
- TILING
- CLEAN
- WINDOWS
- COMFORT
- ART WORK
- STAND
- COLOUR

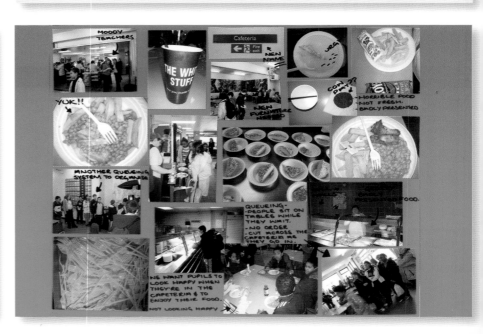

joinedupdesignforschools

Questionnaire

We are planning to develop the playgrounds around our school. We want to know what you think. Below is a list of issues that could be addressed as part of the project. Please rank them 1- 8 where 1 is the highest priority.

Issue	Rank
Colourful	2nd
Outdoor art gallery / display boards	6th
Outdoor stage	6th
Shelter	1st
Plants	3rd
Made from renewable resources	5th
Seating	1st
Apparatus for playing games	4th
Any other comments/suggestions:	

Your views are really important and we want the project to reflect what we all want. Thank you for doing this:

The Design Team

Fairfield High School

We are the client team
And we really, really beam
We are the client team
And we really, really beam

This school is really cool
And William Patten was no fool
But the playground's really small
So people get hit by the ball

We need more space
So the ball's not in our face
The P.E. in the hall
Means the door gets hit by the ball

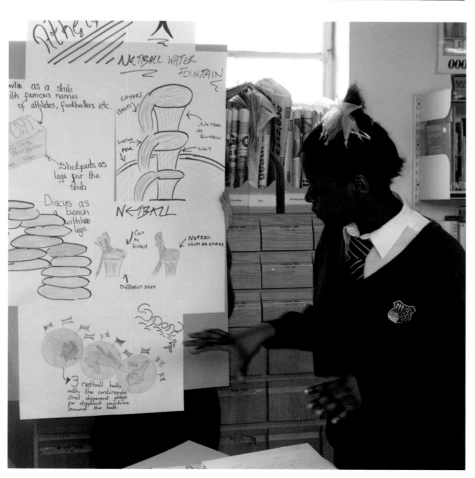

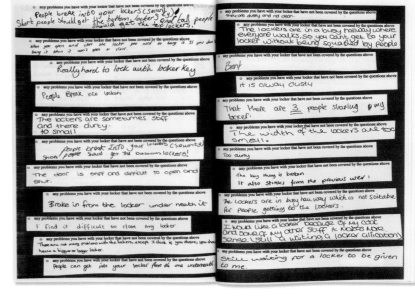

Student and adult questionnaire results

Item	Student	Adult
Ties	No	No
Blazers	No	No
Skirts and Trousers	Yes	Yes
Shirts shaped	Yes	Yes
Comfort	Yes	Yes
Individuality	Yes	Yes

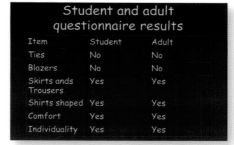

Students Views : Do You Want To Keep Blazers

- Blazers :Yes
- Blazers : No

Q4. Would you like the food being served:
Results:

Hot Food, Cold Food, Both

Timed and motion study

Activity; to discover how long it takes the average student to get their lunch and eat it.

Activity	Time
Queue forming	1 minute
Member of staff	Mr.Gaynor
Length of time in Queue	15 minutes
How long to get food	10 minutes
How long to pay	5/6 minutes
How long to eat	20 minutes

Students Views : Would You Like Ties As Part Of Your Uniform ?

- Ties : Yes
- Ties :No

Students Views : What Is Important To You?

- Comfort
- Washability
- Durability
- Price
- Individuality

Q7. What kind of entertainment would you like while eating your lunch?
Results:

Music, Video/T.v, Don't Care, Nothing

Music must be chosen by pupils

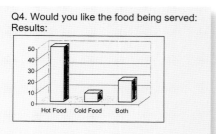

What we want the entrance to be

- The entrance should look welcoming and inviting to new comers and visitors.
- Visitors should be able to locate the school and the entrance, as it is very well hidden at the moment.
- The reception should be easier
- Better signage above the school

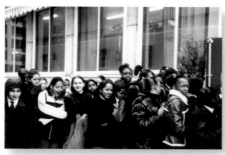

Reasons why the entrance is important

- The entrance is what people first see when they enter the school
- It gives a first impression to onlookers.
- It should encourage people to want to be at school.
- Make the school more inviting to the students who attend here everyday.

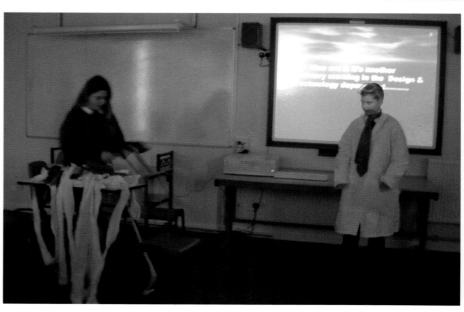

③ The Conversation

"At the start I was really nervous, but over time the designers became like friends." Client, 11

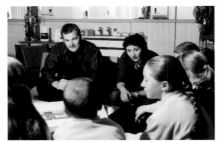
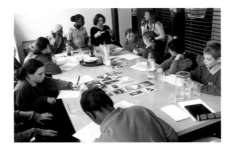

Meetings

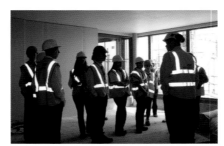

Visits

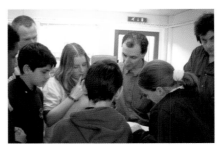
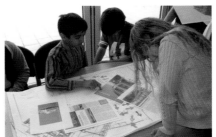

More meetings

The *conversation* was the heart of the joinedupdesignforschools programme. It was the period during which the client team and the designers, through a series of meetings and visits, worked together over several months. We chose the word 'conversation' to describe this stage because experience has shown us that a good conversation is at the heart of all successful design projects. All fruitful client/consultant relationships depend on a continuing exchange of ideas, which gradually resolve the issues and evolve into design concepts. In joinedupdesignforschools the conversation consisted of a series of meetings, brainstorms and visits to inspiring places. We asked the client teams if their teachers or parents ever talked about going to meetings. "Yes," was the reply. "They say: 'I can't talk to you now, I'm going to a important meeting!'" We told them: "Okay, now you'll also be able to say that you're going to an important meeting."

The first meeting of the conversation stage took place at the school, and was the moment when the client teams met the designers for the first time and presented their brief. The pupils were understandably nervous but,

surprisingly, so were some of the designers, who hadn't worked with children before, and hadn't been in a school for over thirty years. One described it as "frightening and weird". After the initial meeting, everyone gradually relaxed: one eleven-year-old summed up her experience: "At the start I was really nervous, but over time the designers became like friends. It's quite posh to be the client. I am more confident now. Before I didn't take part in anything, but now I'm going for it."

The conversation developed over several weeks, a number of the designers devising exciting brainstorming sessions, others creating workshops in which they generated ideas with the pupils through making models. The extensive length of the pupils' involvement with external professionals had several advantages. It allowed the pupils to get to know the designers really well, overcome their initial shyness and develop skills and learning through the gradual nature of the process. "It's a different way of learning because you're not just sitting there and getting stuff out of books," said a fifteen-year-old boy from Tyneside. "You're actually sitting there and giving your ideas."

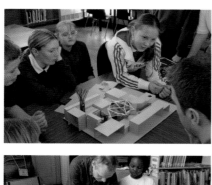
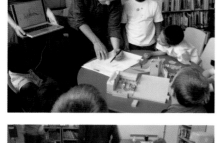
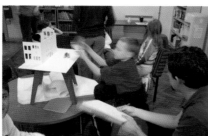

Workshops & modelmaking

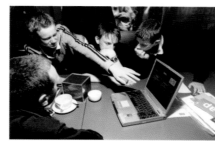

Ideas developing

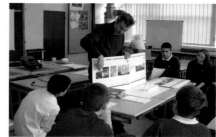
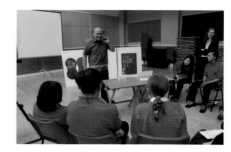
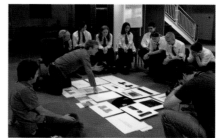

Final concepts

A fourteen-year-old boy in Cornwall agreed: "This is a better way to learn. If I had sat down in a classroom and been told all this I would have just thought it's another lesson. But this way I feel involved. I feel a part of it. It will stick in my memory" (see pp. 161–67).

Some of the biggest breakthroughs in the relationships came during visits outside the school environment. Many designers opened their studios to their client team to hold meetings and show them how they worked. The pupils often spoke about how fascinating it was to be in such a creative workplace with state-of-the-art media technology.

These studio visits were part of a planned programme of excursions that, in many cases, were the key to this stage. The rationale was straightforward: if you take the pupils to places relevant to their project, they will find ideas, inspiration and vocabulary that will help them in their conversation with their designer. The visits also raised their aspirations and developed their sense of the aesthetic. For many pupils it was the first time they had left their home town; the new experience of travelling and seeing different places was valuable in its own right.

The visits helped to break down barriers and generate conversation and debate, while food and drink was another important part of the visit experience. Many of the pupils ate food they had never eaten before. One client team, whose challenge was about the lunch-time experience, was taken to the Japanese cafeterias Yo! Sushi and Wagamama, and to a juice bar to carry out research. Armed with new knowledge and new opinions, the pupils were able to refer to these experiences in the conversation about the redesign of their dinner hall. The visits gave the client teams insight and information directly relevant to the dialogue with their designer; more meetings and more idea-swapping followed.

The designers began to generate drawings and initial models based on the conversations they were having with their clients. The client teams put up more displays of work-in-progress in their schools, and continued to survey their peers for feedback. The months of work were reaching their conclusion. Now the designers were ready to produce their final concept presentations.

Inspirational visits

Client teams made 170 visits to over 100 different locations with their designers and the Foundation team to inspire and inform them.

AK Engineering • Airside • Alternative Fashion Week
Antony Gormley Studio • ARAM Showrooms
Arup Bristol • Baltic • Bar 38
Barbara Hepworth Museum and Sculpture Garden
Base Tooting • Business Design Partnership
Bisley Office Furniture • Borough Market
British Airways London Eye • British Library
British Museum • Camden Arts Centre • Canary
Wharf Tube Station • Cartoon Network • Centre for
Alternative Technology • City Hall • Construction
Resources • Culpepper Community Garden • Delleve
Plastic Ltd • Design Museum • Docklands floating
bridge • Dulwich Picture Gallery • Earth Centre
Ed's Diner • Evergreen Adventure Playground
Explore Exhibitions • Falmouth College of Arts
Geffrye Museum • The Green Building • Hampden
Gurney School • Harrison Learning Centre
Imagination • Imperial War Museum • Private
Residence – John Young • Jubilee Waterside Centre
Juice Bar • Laban • Lisson Gallery • London
Aquarium • London Zoo • Lord's Cricket Ground
Media Centre • McDonald's, Oxford Street • Market
Place • Marks Barfield Architects • Mash • Millbank
Millennium Pier • Millennium Bridge • Millennium
Dome • National Museum of Photography Film &
Television • National Theatre • National Theatre
Studios • Natural History Museum • Newlyn Art
Gallery • Niketown • One Central Street • Oxo
Tower • Paul Smith shops • Peckham Library
Private Residence – Phin Manasseh • Pringle Richards
Sharratt Architects • Purdy Hicks Gallery
R K Stanley • The River Café • Royal Festival Hall
Royal Victoria Dock Footbridge • Sanderson Hotel
Sadler's Wells • Science Museum • Selfridges,
Birmingham • Selfridges, Manchester
Seymourpowell • Shakespeare's Globe • Sketch
Gallery • Smiths of Smithfields • Somerset House
Sony • Stardotstar • Talacre Community Sports Centre
Tate to Tate Boat • Tate Modern • Tate St Ives • Terry
Farrell & Partners • Thames Water • Theis & Khan
Architects • Think Tank • Thomas Heatherwick Studio
Tower 42 • Urbis • Vitra • Wagamama • Walters &
Cohen • Westbourne House • White Cube • William
Warren Studio • Wolff Olins • Yo! Sushi • Young Vic

This page, clockwise from top:
British Airways London Eye, Science Museum,
Barbara Hepworth Museum and Sculpture Garden,
The Green Building, AK Engineering, Falmouth
College of Arts, Evergreen Adventure Playground,
Turbine Hall at Tate Modern. *Opposite page,
clockwise from top:* sculpture in London's Docklands,
Yo! Sushi, Somerset House, Peckham Library, Camden
Arts Centre, City Hall, Millennium Bridge, Laban,
Earth Centre, Dulwich Picture Gallery.
Opposite, centre: British Museum reading room.

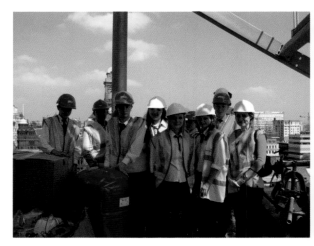

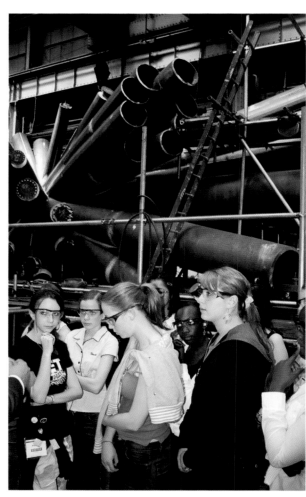

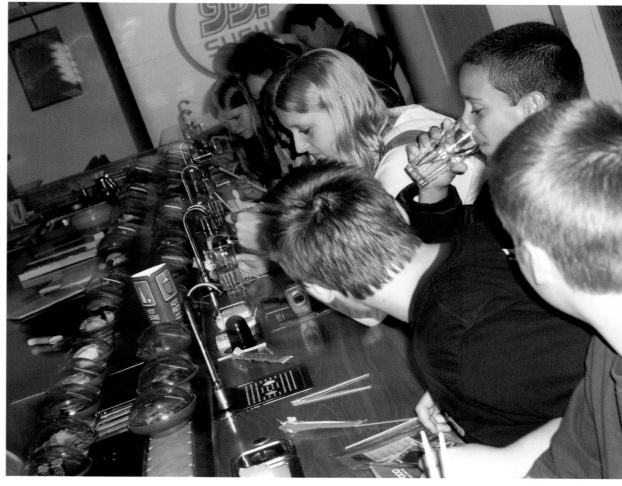

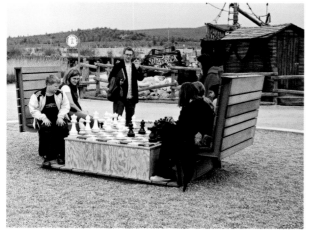

④ The Concept

*"The kids were speechless when they saw the concept.
Stunned. I think it would really put our school on the map."
Teacher*

24

The *concept* was the stage at which the designer presented his or her design proposals to the client team, who then presented the concept to their head teacher. Like the briefs, these presentations took different forms, the designers using drawings, displays, computer-animated 'fly-throughs', prototypes and models to communicate the design. Some had worked out guideline costs for implementation. In most cases the pupils accepted the proposals wholeheartedly, but in some cases they asked for changes.

The client team now had a concept they liked that responded to their challenge and met their brief. It was at this point that they took full ownership and began preparing to present the concept to their head teacher, who often invited governors and parents to listen. These presentations were special events. The pupils had become team players, articulate on their subject. The head teachers and governors were often astonished by the presentations, and impressed by the depth of the client teams' knowledge and the skill with which they handled questions. "I can't get over what the children did in their presentation," said Pamela Harris, Vice-Chair of governors at Hookergate Comprehensive School in Gateshead. "It was so amazing. So much thought has gone into this." Jane Osborne, Chair of governors at Mounts Bay School in Cornwall, was "just absolutely thrilled by how much the pupils have gained from it, and the knowledge they have. They understand all the reasons for the project and I really, really hope we can get the money together." And Nitsa Sergides, Head teacher at Grafton Primary School in London, said: "Their presentation was brilliant. I felt as if I was in a boardroom in which somebody was taking us through a very big project. I don't know how to express what I felt."

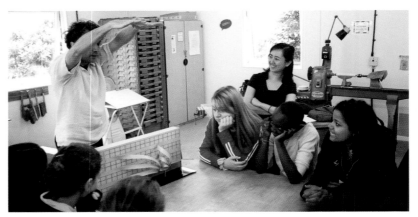

The head teachers and governors were particularly impressed by the passion the pupils were clearly demonstrating for their schools. This often inspired them to agree to try and raise the funding necessary to turn the project into reality.

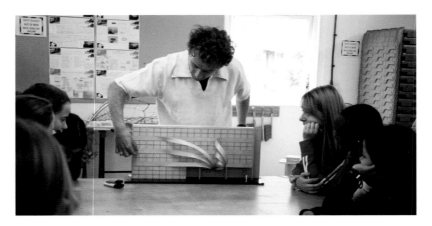

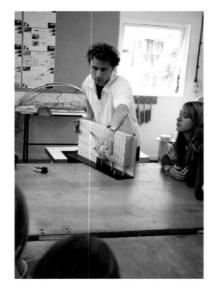 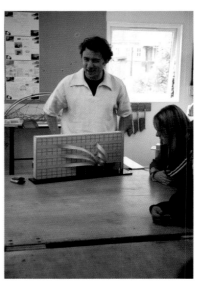

This page: Designer Thomas Heatherwick presents his concept for a new entrance at Camden School for Girls in London. *Opposite page:* The Camden client team presents the concept to the entire school.

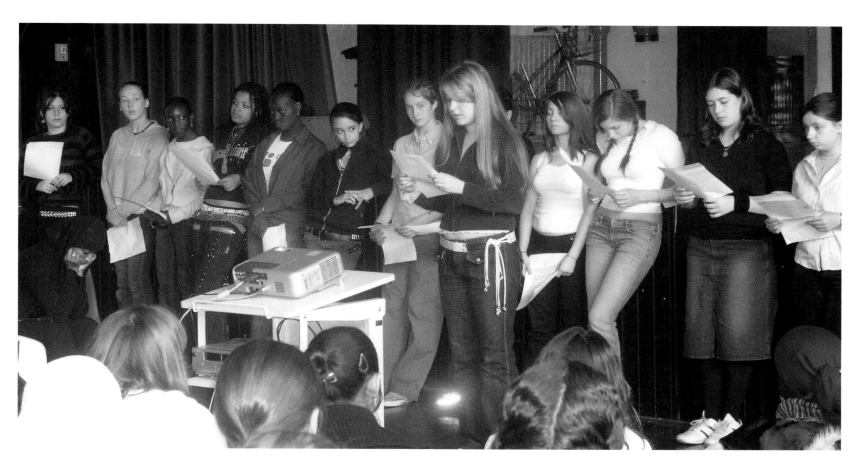

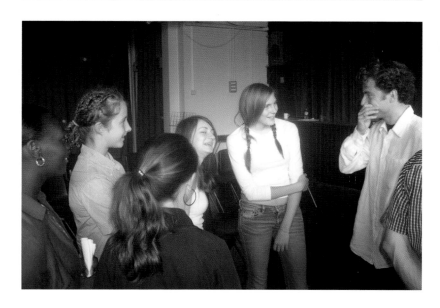

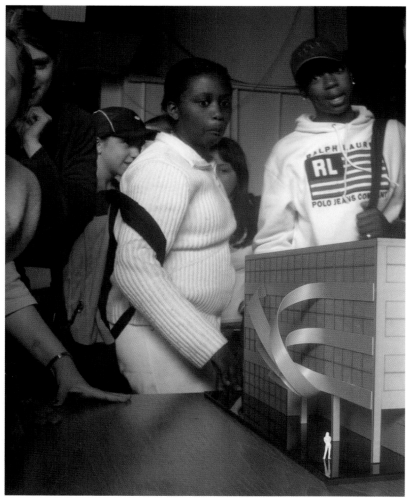

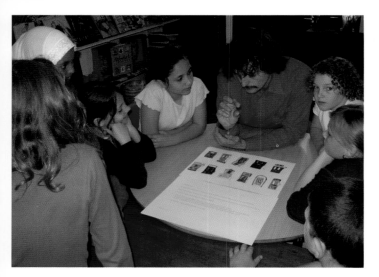

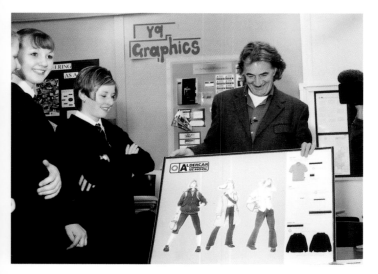

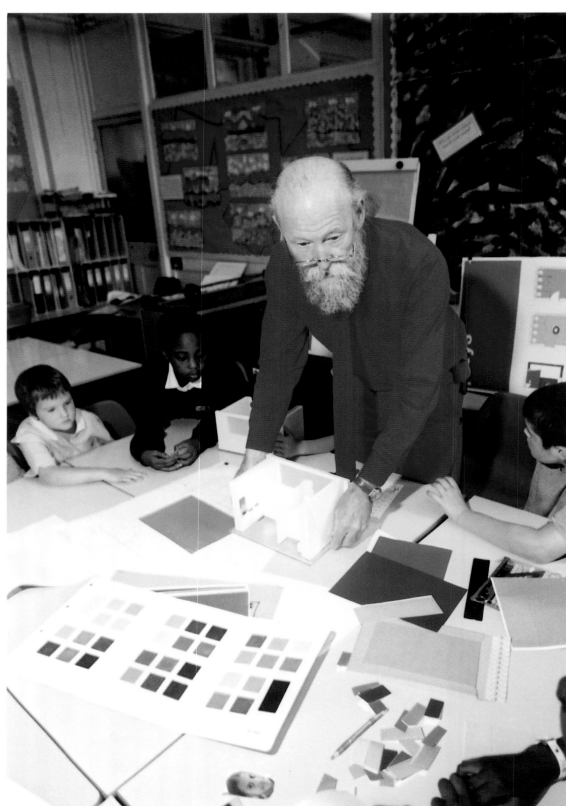

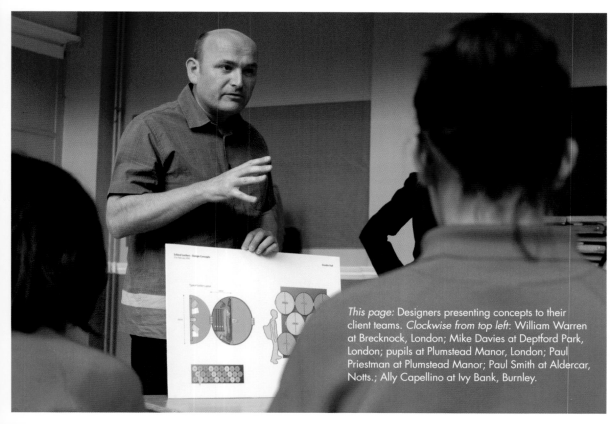

This page: Designers presenting concepts to their client teams. *Clockwise from top left*: William Warren at Brecknock, London; Mike Davies at Deptford Park, London; pupils at Plumstead Manor, London; Paul Priestman at Plumstead Manor; Paul Smith at Aldercar, Notts.; Ally Capellino at Ivy Bank, Burnley.

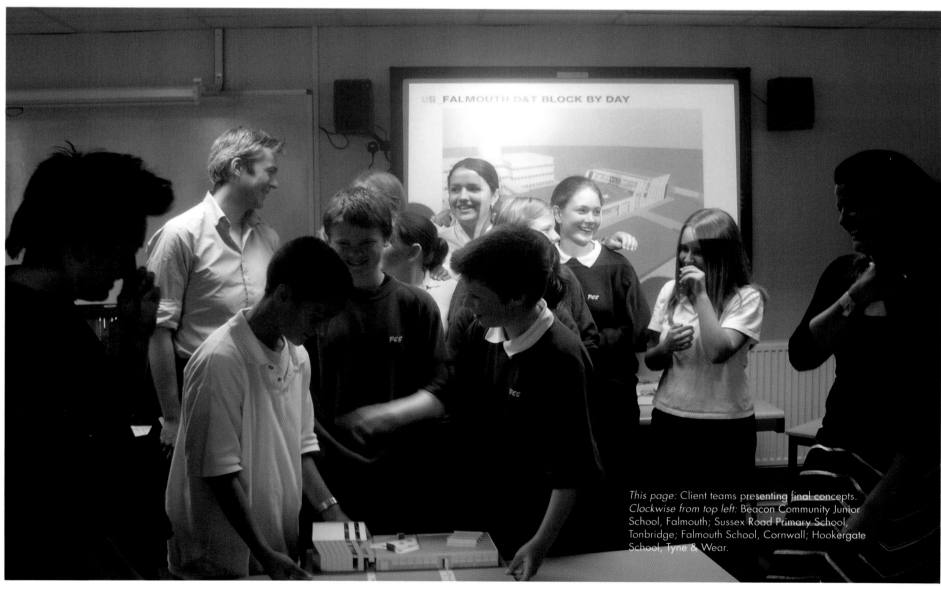

This page: Client teams presenting final concepts.
Clockwise from top left: Beacon Community Junior School, Falmouth; Sussex Road Primary School, Tonbridge; Falmouth School, Cornwall; Hookergate School, Tyne & Wear.

Follow Up

"When the client team saw the first letters going up, they felt so special. And so they should." Head teacher

Follow up is about two things. First, it is about making some of the design concepts happen. And secondly, it is about the dissemination of the learning and knowledge from the programme and the potential for schools to adopt the joinedupdesignforschools process.

Already ten concepts, shown here, have been turned into reality through the collaborative efforts of the schools and the designers concerned. In addition, the Department for Education and Skills (DfES) is partially supporting the delivery of a further, representative range of joinedupdesignforschools concepts on a match-funding basis. We hope that a selection of implemented projects will emerge to provide examples of practical solutions to common issues identified by pupils, and to offer inspiration to everyone involved in designing and delivering new and existing school improvements.

The benefit of creating a range of demonstration projects is clear; at a time when central government is investing heavily in school infrastructure through programmes such as Building Schools for the Future, schools, local authorities, architects, planners, builders and developers need as many up-to-date, live examples as possible, both as a reference and to help their thinking.

However, there are other benefits in delivering a wide range of joinedupdesignforschools concepts. Whilst not all are suitable for taking forward, many are of very high quality and present relatively low-cost small-scale solutions to core issues identified by pupils. And they have been created at no cost to the school or the Local Education Authority. Therefore they offer not just value for money but also added value.

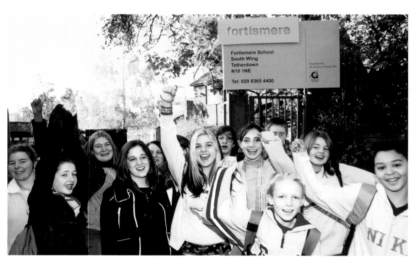

The process by which the concepts have been created means that many of them are more resolved than perhaps they might have been if developed through another process. Michael Shew, Head teacher at Acland Burghley School in Camden, London, wants to implement their concept proposal because, he says: "If the development of our dining hall had been down to the school, we'd have just patched it up. But this idea is brilliant. And it's excellent to involve the pupils – it's been done properly." In many instances the concept has so caught the interest and imagination of the client team and the wider school community of pupils, staff, parents and governors that their expectations for implementation have been raised, and everyone involved feels a strong desire to see the concepts realized.

The other great benefit from delivery is that it really does show a commitment by schools and government, not just to listen, but also to act on what pupils have to say. The uplift in pride and morale for the young people and schools whose concepts are realized should not be underestimated.

The learning and knowledge from joinedupdesignforschools is being disseminated. This book is part of a wider process of dissemination that aims to provide schools and designers with information, inspiration and guidelines to enable them to use the joinedupdesignforschools process and to work together.

Some schools are already using their experience of joinedupdesignforschools. Paul Kelley, Head teacher at Monkseaton Community High School in Whitley Bay, says: "joinedupdesignforschools has transformed our way of looking at the learning environment and the way in which we work with pupils to improve it. We took from our experience a process that has enabled us to take huge strides in changing our learning environment. Joinedupdesignforschools transformed our idea of what was possible. It did something for everyone in the school: it opened our staff's minds to what was possible as well as the pupils'. This is important from a school point of view. The whole organization has changed because of this approach. We now understand how learning can be transformed by design, and by a design process that involves everyone. It's been an education in itself."

Monkseaton was recently approached by the DfES, which asked the school to work with Alex de Rijke from dRMM Architects to develop a school for the Building Schools for the Future programme. Monkseaton used the joinedupdesignforschools process to provide Alex with a brief. Now the school will be rebuilt to Alex's design. Designers commented that the process gave them unique access to real problems in school design. "The kids can list the problems in a school more quickly than teachers or governors," said Sam Jacob, architect at Fat. "That's very important. Their diagnosis and their optimism is good." A frequent comment made by designers was that they wished their "adult clients could be so clear and direct."

The joinedupdesignforschools process is also being used as a teaching aid in schools. Gary Pennick from Swanlea School in Whitechapel, East London, said he was particularly attracted by the way in which the programme encouraged the children to 'discover' material for themselves. "In some ways it has made me a better teacher. I removed some of the teacher-led material and replaced it with development time so that the pupils could discover it for themselves, and so push themselves forward. It is challenging! Sometimes it doesn't work, sometimes it works superbly. This freedom to explore the project for themselves has improved some of the pupils quite dramatically." Head teacher Linda Austin told of how one group of pupils was asked to advise on a promotion for London Parks: "One of their designs was chosen to be one of the adverts. They were given a lot of autonomy about what design would be appropriate, and they researched with various clients in order to work out the design. I think they learned all this from the joinedupdesignforschools process."

At Fortismere School in Muswell Hill, London, it has led to the creation of a new post, corporate identity manager. Karen Allaway, who is also now the Assistant Head, says: "Joinedupdesignforschools has changed the face of the school. The pupils feel more involved, they know what the school is about and have a feel for it collectively." She has set up the school identity group, a team of pupils who meet every fortnight to discuss implementing their new identity designed by Marksteen Adamson. The team helps school departments to adopt the new identity in accordance with Marksteen's guidelines, designing book labels for the library, identity cards for the pupils, even the new livery for the school bus. "The head often comments to staff and governors about it," says Karen, "and is proud of the fact that we consult our students in the process of making this an even better school."

Fortismere School is developing a new performing arts centre and will be involving the pupils in the process.

Previous pages, left from top: New signage at Summerhill School, near Dudley; the client team enjoying new lockers at Brecknock, London; celebrating the implementation of a new identity at Fortismere, London; a page from Skoolrush, the new web game at Swanlea School, London. *Right:* Opening the new garden and outdoor social space at Islington Green School, London.

Opposite, clockwise from top left: New retail outlet at Ivy Bank in Burnley; pupils celebrating the new identity at Ivy Bank; the social space at Islington Green, London; an art class in the new reception area at Hythe Community School in Kent; pupils from Aldecar Community School, Nottinghamshire, wearing new uniforms designed by Paul Smith; pupils at Hugh Myddelton Primary School, London, show their new signage and identity.

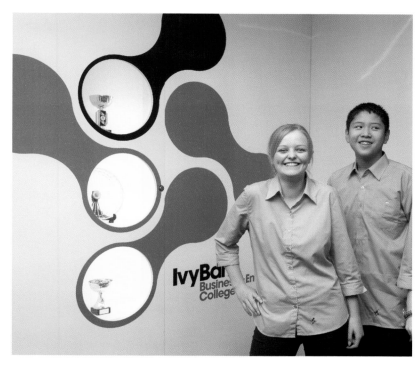

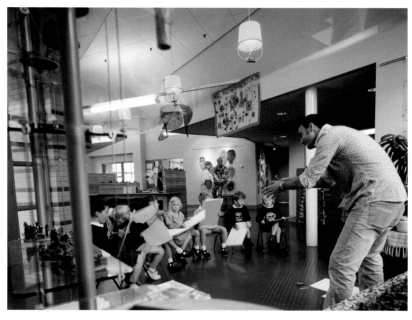

Common Issues

"This project has strengthened my view that, if you ask students their opinions and give them responsibility, then they will often surpass your wildest dreams." Head teacher

During the challenge workshops the new client teams brainstormed the major issues facing pupils at their schools. Our aim was to help them begin to see that they could have a direct impact on their school environment; that they could influence and change it. By involving pupils in the design of their environment we hoped to encourage learning that could lead to greater motivation, new skills and a sense of ownership.

We asked them to consider how their school environment impinged on them; how, for example, uniforms made them feel, or how the classrooms affected their day-to-day performance. They considered how spaces in their school could be better used, organized and managed, and how improvements could be made to the way in which their school presented itself to the local community. By encouraging this thinking, we aimed to help pupils create a brief for their consultants, which took into account the social and organizational requirements of the school.

The idea of partnership was at the heart of joinedupdesignforschools. By putting designers into partnership with those directly affected by their work, the project aimed to ensure long-term successful outcomes. Joinedupdesignforschools worked from the ground up. First it consulted the primary consumers of education, the pupils, who then formed a partnership with their designers. This usually grew to involve the entire pupil body, because in most cases the client teams surveyed their peers for opinions throughout the process. When the client team and the designers presented their final concepts, the partnership expanded once more to include teachers, governors and parents. This meant people were far less likely to feel that a design solution had been imposed; everybody in the school community had a say, and everybody had a much greater chance of developing a real sense of ownership and pride. By using consensus and partnership in this manner, outcomes can be improved and change is more likely to be welcomed. Without consensus change can be seen as sudden and unwelcome.

The challenge workshops involved seven hundred pupils discussing what they would like to improve. The pupils came back with over a hundred issues, all focused on making the learning environment more appealing. Some suggestions were pragmatic and practical: school newsletters to improve communication, planting areas

to break up drab tarmac and special mats to stop mud being trampled through the school. Other suggestions were more ambitious: wind turbines, hydrotherapy pools for wheelchair-users, mosaic floors and sculptures all featured in their wish-lists. They wanted more facilities for adventurous play, seating and shelter in their playgrounds and practical systems for recycling waste. They wanted better, clearer signage in their schools. They wanted to improve their classrooms with better use of light, space and colour, and with temperature control. And they wanted to be able to play music in their work and social spaces.

In the end we narrowed this list down to eleven common issues, plus one special issue, which form the chapters in this section. The pupils aren't asking for the earth. They only want what most adults would ask for, or indeed insist upon and feel they have the right to expect at their places of work.

What follows is a record of how the pupils resolved these common issues, using the skills of a professional design team to help them achieve their aims.

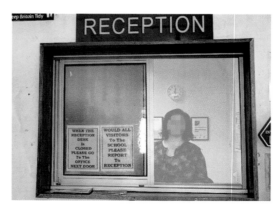

COMMON ISSUES

What Pupils Want

COLOUR
They want to brighten up their schools and use
colour to enhance atmosphere and mood.

COMMUNICATION
They want to tell pupils, teachers, parents
and the community what is going on.

DINNER HALLS AND CANTEENS
They want a civilized lunch time with less chaos
and more time to relax.

LEARNING SPACES
They want modern, inspiring places to learn.

RECEPTION AREAS
They want parents, new pupils, the local
community and visitors to feel welcome.

REPUTATION AND IDENTITY
They want to be proud of their school and
sure of what it stands for.

SIXTH-FORM SPACES
They want rooms where they can socialize and
work on their own.

SOCIAL SPACES
They want sheltered spaces to "chat and chill" during break.

STORAGE
They want secure places to put their books, stationery,
equipment, bags and coats.

TOILETS
They want toilets to be clean, hygienic and safe.

UNIFORM
They want comfortable, smart, "cool-looking" clothes
that they will be proud to wear.

WHOLE SCHOOL PLAN
They want to contribute to a vision for a new school.

Colour

"Our school needs colours. It's boring,
drab and grey." Client, 11

Colour often gets left out of the equation when buildings are designed. It tends to be an add-on or an after-thought, and is rarely a priority with architects building schools. Few consider what a dramatic effect it can have on the mood of a school building.

But most client teams we spoke to in our workshops said they wanted "bold, modern colours", "cheerful colours" and "more colours everywhere!" Colour therefore formed a big part of the conversation in many of the projects, and in some the whole school was surveyed to select a favourite colour. For example, "baby blue" was the popular choice for the dining hall at St George's Catholic High School in Westminster, and blue was selected as "most business-like" at Ivy Bank Business & Enterprise College in Burnley for their business enterprise. Often the colours were selected to "make the space calm", in particular with older pupils.

"A dining-hall space should be somewhere you actually want to eat," said one pupil working on improving the dinner hall, "but it's not very appealing when it has a mould-coloured floor."

One school concentrated exclusively on the power and use of colour to transform a space. The client team at Beacon Community Junior School in Falmouth, Cornwall, wanted to improve the hall that they used for assemblies, lunch, sports and evening events. As one young client put it: "We hate our hall because of the dull bricks, old-fashioned green curtains and tiled floor with bits of mouldy food."

We joined Beacon School with the designer, presenter of Channel 4's Grand Designs series and author of *Choosing Colours*, Kevin McCloud. "I am here because I love colour," he told the client team when he received their brief, which was full of examples of the colours and designs that they thought would improve their hall. They discussed how changes could be made, by drawing back the curtains, which were always kept closed to keep out glare from the sun. For the first time the client team saw the hall in a different light, which prompted a discussion about sunlight and the detrimental and positive effects it has on a space.

Kevin asked them to perform three experiments: to put their design briefs and ideas for the hall floor on public display in the school to enable everyone to participate in the discussion; to conduct a survey to find

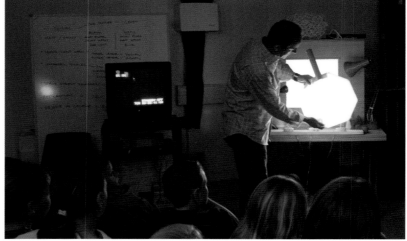

This page from top: Designer Kevin McCloud and his client team contemplate how they are going to transform the school hall; Kevin demonstrating the effect of light and colour at Falmouth College of Arts; the client team brief. *Opposite*: A variety of moods can be generated in the proposed redesigned hall at Beacon simply by changing the colour of light. *Overleaf*: The client team research colours using a massive colour chart provided by Kevin McCloud.

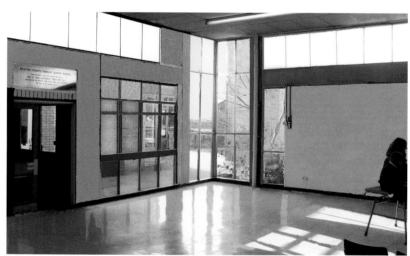

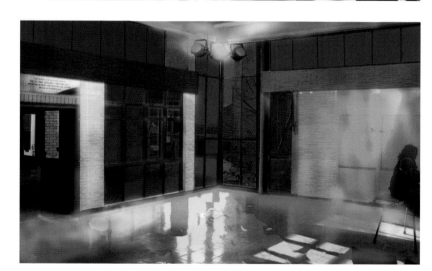

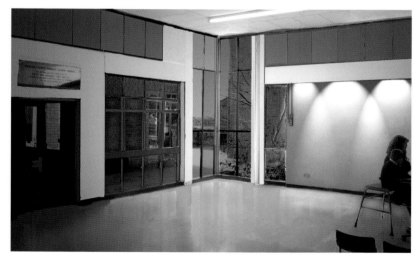

*"He came up with designs with bright colours and we said we
didn't like them ... I think we made his life hell for a while."*
Client, 9

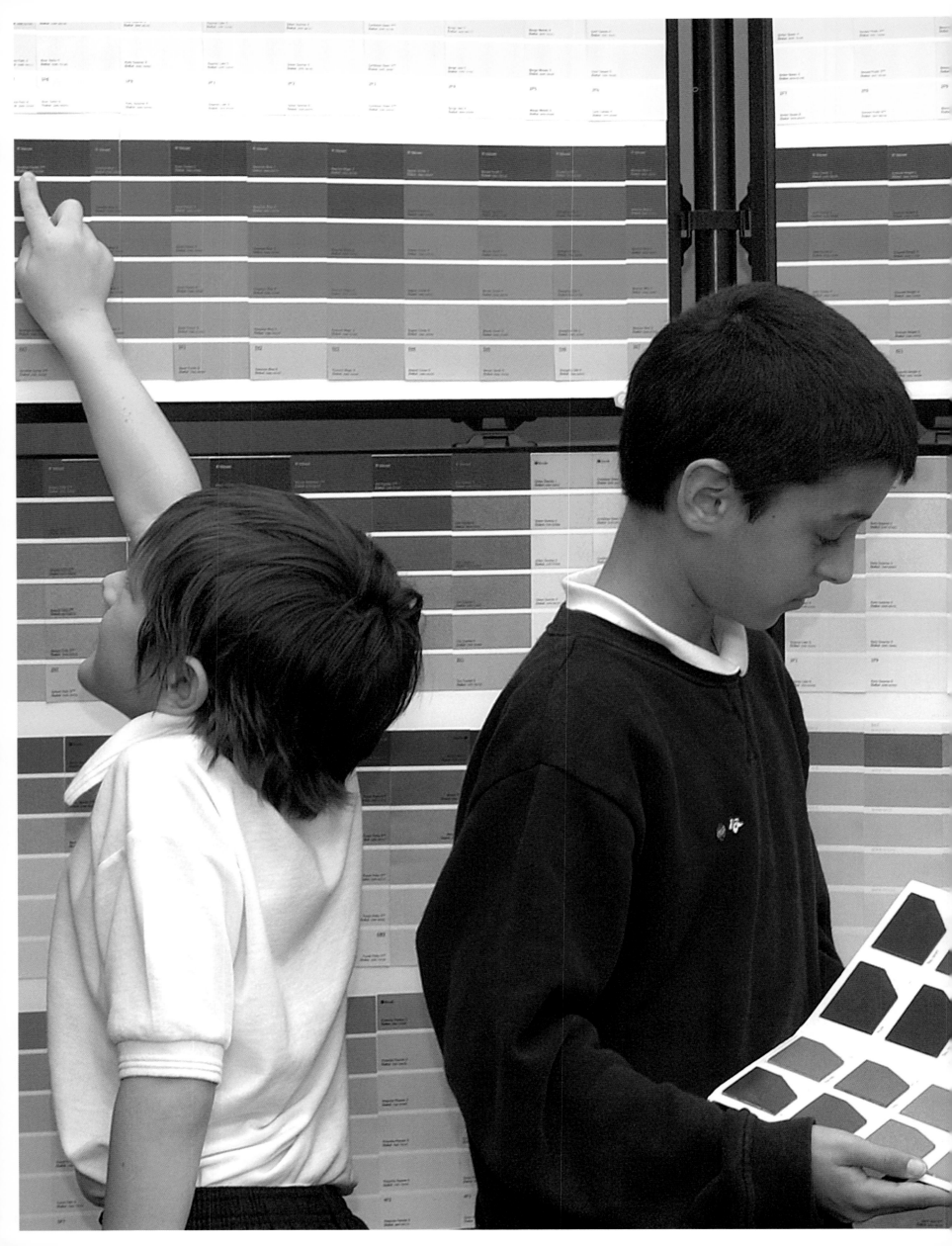

out the school's favourite colours, using a large board with seven hundred paint colours that Kevin lent them; and to experiment with different coloured Perspex to test the effect on the windows and lights in the hall.

Kevin went with the team to Falmouth College of Arts to talk to its staff and students about how light can change a space. The staff and students had prepared a series of model rooms using different coloured lights and surface textures to create different moods, and Kevin gave a demonstration to show how red, green and blue lights affect colour. The primary curriculum had covered aspects of light and colour, and this demonstration helped the pupils apply their knowledge to real circumstances. One member of the client team commented: "If we had stained-glass windows then we wouldn't need new colours on the tables." As the pupils grew in confidence, the conversations between Kevin and the team became more animated. "He came up with designs with bright colours and we said we didn't like them," said Ella, 9. "I think we made his life hell for a while."

The pupils experimented with coloured films over the windows to cut out glare and generate coloured light. As Kevin explained: "The pupils realized they could do a lot more with coloured light than they could with paint or fabrics." To answer the part of the brief that required the space to be used for evening social events, he steered them towards considering a theatrical lighting-rig that could change the ambience of the hall at the flick of a switch.

Kevin's final presentation shows different lighting effects in the hall and recommends special theatrical lights to be installed to create them. It includes a design for the floor, developed from the client team's chosen theme of a map of Cornwall, with Beacon School clearly marked, shining out with radiating beams, and proposes automatic blinds so that lighting effects can be achieved in the daytime by screening out the light. "I think there is enormous value in designers working with children as clients: it shows how it ought to be with adults, but isn't," said Kevin.

At Deptford Park Primary School in south-east London, architect Mike Davies of the Richard Rogers Partnership was briefed by pupils to make their toilets feel like a Caribbean beach (p. 148). They wanted to capture this feeling with palm trees, fine sand and dolphins leaping in the bay. Mike set up a workshop for his client team to explore different materials and colours that would work well together. The pupils wanted the floor to be sand-coloured, and spent time considering exactly which colour created the feeling of sand.

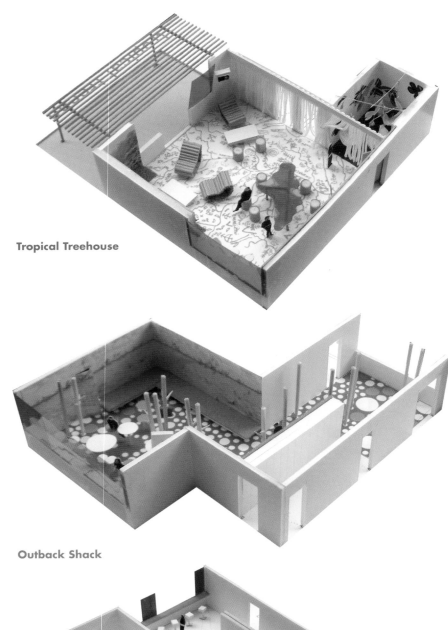

Tropical Treehouse

Outback Shack

Mountain Retreat

"If we came up here to do our English we could use our brains more because of the colours." Client, 14

Above: Sally Mackereth designed three themed rooms in which the pupils of The Ramsgate School could "relax and escape". *Opposite:* Designers Casson Mann created this inspiring, colourful retreat for pupils, also at The Ramsgate School.

At Cape Cornwall Comprehensive in St Just, Cornwall, architect Phin Manasseh used large, transparent weather canopies made out of a pink polycarbonate to cast pastel tones across a grey courtyard in response to his client team's request to do something about their "drab and boring" courtyard (p. 112).

Colour was a particularly important factor in two projects at The Ramsgate School in Kent. The school had created a series of rooms for sensitive female pupils who needed a safe space. The pupils had already chosen to decorate it in lilac and violet, because these colours made them feel much calmer: "The other classrooms make you feel a bit panicky," said Victoria, 14. Designers Dinah Casson and George Zigrand from Casson Mann worked with them to create concepts for rooms that expanded this colour theme, using deep pinks and blues. The client team was impressed by the final concept: "If we came up here to do our English we could use our brains more because of the colours," said one of the girls.

The Ramsgate School is due to be replaced by a new school in 2005 so, in order to support this transition period, we responded to their request for a second project and joined a new client team with designers Wells Mackereth, who also used colour to help improve school morale. This client team, from Years Seven to Nine (aged 12 to 15), wanted to redesign their three year-rooms. Sally Mackereth took them to Tate Modern to see

Olafur Eliasson's *Your Double-Lighthouse Projection* (2002), an installation demonstrating the power of light and colour.

The client team brainstormed designs and colours for the year-rooms and Sally refined these ideas into themes for the three rooms: 'Tropical Treehouse', a calming space in green, inspired by the rainforest, with a 'chill-out' area and model butterflies hanging from the ceiling; 'Outback Shack', in warm and vibrant colours with oranges and browns; and 'Mountain Retreat', pale, serene and calm, with white felt walls, contoured seating and blue highlights.

Trevor Averre-Beeson, Head teacher at Islington Green School in North London, where we ran a project about outside social spaces (p. 116), had already begun to use colour to affect mood in his school. He told us he had introduced pale lilac and violet colours into the corridors to create an atmosphere of calm, and reported that it had been very effective.

Schools recognize the power of colour and are beginning to use it to beneficial effect. For example, pupils at Monkseaton Community High School in Newcastle conducted a study on colour, which concluded that violet "takes the mind to a higher level and encourages reflection and meditation".

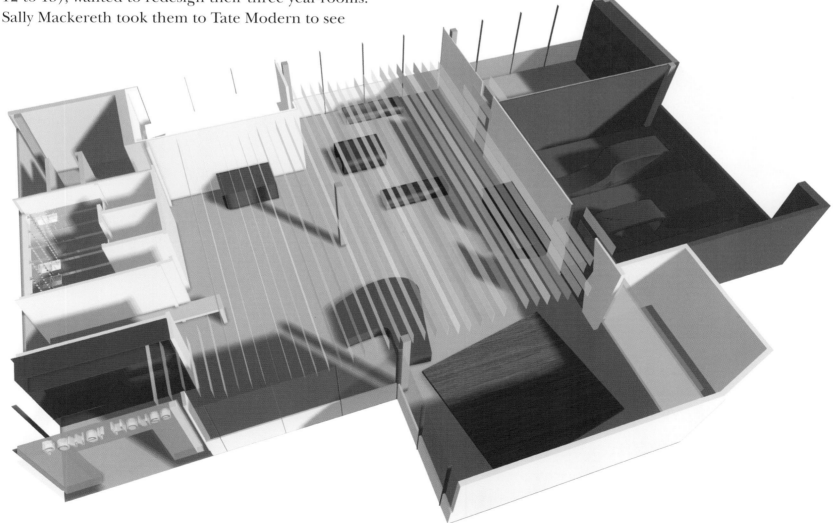

Communication

"No one knows what's going on!" Client, 14

"There's not a lot of communication between parents, teachers and pupils, and there should be," stated the brief from pupils at Finham Park School in Coventry, identifying a problem that is common to many schools.

Schools are communication hubs, collating and disseminating educational information as well as organizing hundreds of pupils, staff, parents and visitors. These are demanding tasks that need to be done efficiently. School communication is complex and multi-layered, and new ways are needed to provide effective formal and informal communication, which accommodates different languages and develops an appropriate tone of voice for each audience.

School websites were the subject of much discussion in our workshops, and it is clear that pupils understand their potential as a key tool for communication but were often damning about their design. As well as setting briefs for websites, the client teams that focused on communication wanted modern, well-designed school magazines, new sign systems and environmental installations.

At Park View Academy in Haringey, North London, where seventy-five per cent of the pupils speak English as a second language, the client team worked closely with designers Simon Waterfall of Poke and Andrew Shoben of Greyworld. The team's brief was to create an effective messaging system that worked like texting; the pupils wanted a means of communicating with each other directly and clearly. Duncan, 13, said they did a lot of research to try to find the best solution: "We went on loads of visits to see how others did it, and came up with a lot of ideas like radio, text messages, plasma screens. But we needed something cheap, efficient and basically indestructible."

The client team and the designers explored possibilities for the best location for the message board; the Street, the school's busiest central thoroughfare, was chosen as the place where every pupil went every day. Taking inspiration from the 'flickerdot' information displays at railway stations, the designers conceived a device that enables pupils to write or draw a message on a piece of paper, so avoiding keyboard and language problems, to identify themselves by fingerprint, thus preventing people putting up offensive messages, and then to post the paper into the screen.

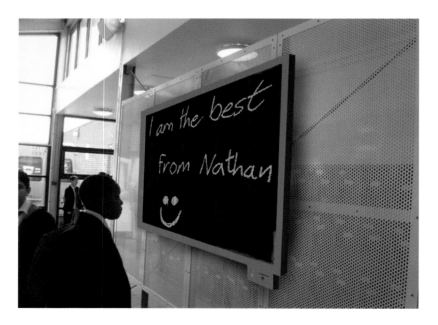

Above, from top: Simon Waterfall on 'the Street' with pupils from Park View Academy in North London; a pupil writes his note; posts it into the screen; it's enlarged and put on display. Pupils identify themselves by fingerprint technology. *Opposite and Overleaf:* The new Art & Technology department at Summerhill School, near Dudley, features giant colourful signage by Graphic Thought Facility.

The machine scans the message and displays it on the big screen for thirty seconds before replacing it with another or repeating an earlier message; messages can be over-ridden by the caretaker in an emergency. The proposed system is silent, an important factor in the noisy Street, cost-effective and produces no mess as it retains the paper notes for recycling. The client team is delighted with the concept. Nathan, 15, said: "Simon came back with this amazing design that was just so wonderful. We told him what we wanted, he went away and thought about it, and came back saying, okay, this is what I've come up with, what do you reckon? And we were just like, whoa! It was such a good design that we would never have thought of for our school."

At Summerhill School, near Dudley, the pupils were moving to newly built premises and, as Anita, 15, explained, the new school's appearance was a little off-putting: "When we found out it was going to be made of breeze blocks we thought, oh no, every day we'll have to get up and go to jail!" The client team wanted to brighten up the breeze block and at the same time help the pupils find their way around the new space. In short, they wanted clear signage.

The brief insisted the signs be multilingual and informative to all, reflecting the school's specialist status as a language college. It said the signs should project the school's character, use different colours for the different departments, that they should come in a range of sizes (from large weatherproof outdoor signs to small removable door signs) and be vandal-proof.

Andy Stephens and David McKendrick of Graphic Thought Facility (GTF) responded to the challenge, commenting on how well the clients articulated their needs and developed their arguments during the project: "They learned how to guide adults: we found that really good. It demystified the process of dealing with professionals." Steven, 14, appreciated the opportunity to work on something that had a tangible outcome: "It was a real change working with people who know their stuff. It's one thing to talk about these things in DT, but it's not the same as doing it, as we have done. And you learned about costs as well."

The designers developed a giant sign system using bold colours painted directly on to the corridor walls. The client team enjoyed working with them on the creative process, putting forward ideas and exploring possibilities: "I'm really pleased with the designers," said Rhian, 15. "They've taken our ideas and put them into something that is practical and colourful, making the school better and more interesting to learn in.

We learned not to say, 'Oh, there's not much we can do with this'. We learned that by looking more carefully you can come up with solutions."

In 2003, GTF helped the school to implement the project. Head teacher Jill Stuart is delighted with the results: "Part of the Design and Technology curriculum is to learn to articulate what you want. This project has put that process into a real context where they work with real professionals. They've learned about making a building work, about the power of graphic design and how to work within tight parameters. I think it's been brilliant."

"We have a lot of different visitors here to see the new building and everybody loves the letters. They all want it." Jill Stuart, Head teacher

"At the moment, *Dunraven News* is just an A4 piece of paper with information that's really just for our parents, not for us," said one young client team member from Dunraven School in Streatham, south-west London, of their current school magazine. We joined them with Vince Frost and Zoe Bather from Frost Design London, who took them to West Ferry Printers in London's Docklands to see how national newspapers and magazines are produced. The pupils were delighted with the way the designers extended their knowledge: "It was great working with professional designers because it was more advanced than what we usually do. We worked with professional equipment," said Louis, 14.

"Asking children what they want is such an open-minded approach to commissioning design," said Vince. The concept is a contemporary, easy-to-use template package that the pupil editorial team can fill with copy and images created by the school journalists. Designer Zoe expressed surprise and pleasure at what the engagement had given her: "You can't get a more honest client than a child. They either like it, or they don't. It's refreshing, and also terrifying. Adult clients don't say what they mean, they're more cautious, but with children you show them something, and you get an instant response. Such directness can only improve your design work."

The communication medium of choice for most schools was a website. At Finham Park School in Coventry, the client team brief said they wanted "to create a fascinating school website that would allow pupils, teachers and parents to communicate efficiently". We joined them up with Pete Everett, David 'Gravy' Streek and Greg Edwards from Playerthree, a design company specializing in interactive games.

The concept, 'Finham Fantasy', encourages pupils to improve their mental and virtual physical skills in a series of educational fact battles. The better they perform, the higher they rise in the score table. Pupils can challenge people above them in subjects where they are strong, and so improve their position. They can even compete with their teachers, attacking them in their weaker areas. And if they need to improve their own skills in, say, history, they can go to the virtual history department for help. One client team-member extolled the game's communicative power: "I like the fact that you are learning but you don't know you are learning. You'll be learning through the game." Designer, Gravy, believes the game will help pupils develop communication skills: "I envy them – we never get to be clients. They've learned early how to be a client and control a set of professionals. It's a very maturing process."

At St Cuthbert's Catholic High School in Newcastle, the client team wanted to create an interactive site that would communicate the school's high performance to future employers, prospective parents and other schools. They also wanted to celebrate their science school status and make their community connections clear.

The team's brief asked for "gallery space, sports results and fixtures, revision help, a forum for debate and anecdotes, and a news 'ticker' for important announcements". They wanted to explain to prospective pupils the way the school worked, including school rules and uniform and equipment requirements.

We joined them with a large design team from Digit, Daljit Singh, Scott Lyons, Andreas Constantinou, Willow Tyrer and Clemmie Barth von Wehrenalp, who invited the client team to their studio in Hoxton, London, and to an exhibition at the Design Museum, where they viewed the latest multi-media, web and interactive design.

Digit's concept is for a fun, informative website that communicates with a range of audiences who are presented with an easy-to-navigate, clear, informative and inspiring site, showcasing pupil achievements. The pupils have a log-on service, where they can navigate an animated St Cuthbert's World, access up-to-date curriculum and after-school information, and a chat room.

In Leeds, pupils at Mount St Mary's Catholic High School wanted a website that would "let people know the work our school does for other people as well as ourselves. We also want to give new pupils the low-down on the school." We matched them with Jonathan Sands and Richard Palmer from brand identity specialists Elmwood. They worked for the client team to devise a website in which virtual pupils could guide visitors around the school.

Teacher Lindsey Martin said it was a very powerful educational experience: "I picked a team of kids of all different ages who didn't know each other. Frankly, it was difficult at first, and they were afraid to speak. Now they're organizing their own meetings; they don't need me!"

Elmwood proposed creating the virtual pupils by digitizing the faces and voices of the pupils, making them into animation web characters. The pupils wanted two distinct areas: one more formal area, directed at adults, would include such things as the school history, Ofsted reports and exam results; the other less formal and more colourful for pupils and potential pupils. "It was strange telling adults what to do instead of them telling us," said Lianne, 13. "It made me feel older. It's the first time in my school experience that this has happened."

"I think the pupils have got a lot out of the project. We've trusted them to come up with something strategic for the school. I think it's marvellous."
Paul Grant, Head teacher

Pupils at Robert Clack School of Science in Dagenham, Essex, wanted an accessible website for a broad audience. After researching a wide selection of websites they wrote a brief requesting homework help, revision help and links to revision websites. They wanted parent pages, cartoons and good representations of the school's science status and sports success. And they wanted it to be easy to load and use, featuring a clear, uncluttered layout.

We joined them with Natalie Hunter, Alex MacLean and Richard Hogg from Airside, who listened closely to the client team's brief before inviting them to their design studio. There, they looked at the website for the Wellcome Wing at the Science Museum in London. They then visited the museum to compare the website with the real thing.

Airside's final concept combines educational and informative content in an animated representation of the school. They also identified a content management system that can be easily updated. A lot of learning about communication came from the process. The final presentation by the pupils and designers to governors, staff and parents received a round of applause and a commitment to make it happen from Head teacher Paul Grant. Emmanuel, 12, said: "I enjoyed it because we learned how to represent other people and to think about other people's ideas instead of just our own."

The client team at North Manchester High School for Boys wanted to improve communication inside the school through an intranet because they felt pupils would be more likely to access a website aimed directly at them than any other form of media.

We joined them with designers Phil Skegg, Dave Simpson, Sue Strange and James Quail from Love Creative in Manchester, who proposed a secure, state-of-the-art website, using a chat-room format. Pupils would enter the virtual school, walk into classrooms and chat with teachers and pupils who are also visiting online. For example, they can go to the virtual art department to meet other art enthusiasts, check the walls for schedules about art events, look at recently posted artwork and then go outside to the virtual playground to play interactive games with other students, such as online chess.

The whole school became involved in the project as the client team repeatedly surveyed all parties for their needs and reactions. Client team-member Daryl, 13, said: "The style is great; much more interactive than in a normal website. It is easy to talk to people." Teacher John Midgley said: "They've got loads out of doing it. Working with an outside company has been great. They've learned how to organize themselves, how to do presentations, how to function as a mixed-age group."

At Swanlea School in Whitechapel, East London, the client team wanted "to tell the story of the school in a way the community can understand. We want others to have fun finding out about us." We joined them with Deepend designers Simon Waterfall, Pete Everett, Gravy Streek and Nick Holmes. The project, which had begun as a brief for a website, evolved over time into a web-game. The concept presented by the designers was called 'Skoolrush', designed to communicate the life and energy of the school in a way that any culture or age could understand. Each player chooses a character, a 36-pixel high image based on photographs of the pupils and staff, including the red-headed head teacher. They compete to win by running round the virtual school, the format of which is based on plans of the real school, completing missions set by the Head teacher character and answering questions based on their curricular studies. This might be the only game in existence in which children can opt to participate as the character in a wheelchair.

"The game was ultimately their idea," said Simon. "It was the language they chose to communicate their message. And the game is one of the best things we've ever done. It was a labour of love, but it was well worth it." Head teacher Linda Austin thought the project "a wonderful opportunity for youngsters to practise their understanding of games and the web. I wish we had more space in the curriculum for projects like this." The project helped Swanlea secure Business and Enterprise status and the game is now used to introduce younger pupils to IT and to the school itself. Skoolrush was implemented in 2002: to view log on at skoolrush.com.

This page from top: Swanlea School in London's on-line game, Skoolrush; a character from the game; client team, Head teacher and Deepend designers; work-in-progress. *Overleaf:* Characters with Head teacher Linda Austin in their on-line game, Skoolrush.

"The game was ultimately their idea; it was the language they chose to communicate their message. And the game is one of the best things we've ever done. It was a labour of love, but it was well worth it." Simon Waterfall, designer

Dinner Halls & Canteens

"The problem with the canteen is that it's horrible."
Client, 15

"You queue in the rain for most of your lunch break and have to wolf down food you don't like in about five minutes." This comment was from a client team-member who wanted the lunch-time experience to be more civilized. Most of the pupils we spoke to expressed concern about the decor, layout, queuing system and food and hygiene standards in their school canteens. Many felt that the lunch-time experience was a period of rushed, noisy chaos. They wanted to turn lunch into a relaxing break with time to socialize. They didn't want to waste their precious free time queuing, they wanted more food options, for example, a choice between cold snacks and hot meals, they wanted options to serve themselves, and they wanted the environment to be more appealing.

Acland Burghley School is a large inner-city school in Camden, north-west London, where fewer than half the pupils use the dining facilities because of the condition of the dinner hall and the choice of food available. The younger years are required to stay in during lunch, while the older pupils go out to eat from the various fast-food places on the busy high street nearby. "We get big groups of people hanging around on the street," said one client, "which is not very nice for the public walking through, and the fast food is not healthy either."

The client team began by saying their aim was simply to improve the dining space, suggesting to their architects, Addy Walcott, Neil Hogan and Dan de Groot from SHH, that a café built in the style of a 1950s American diner might attract more people into the canteen. The team produced nine design boards full of ideas about how to improve their dinner hall. But as they took inspiration from a series of visits to leading restaurants in London, including the Japanese cafeteria Wagamama, and the new McDonald's in Oxford Street that had been designed by SHH, their views began to change. Through a series of client/consultant meetings, a new approach began to emerge under the general title of The Hub, which suggests the canteen becoming a major social centre in the school.

The final design concept from SSH proposes splitting the dining room into different areas. The Internet café area features spill-resistant keyboards, flat screens and plenty of seating. A snack zone is included, where pupils can buy from vending machines and stand at high tables while chatting, storing their bags beneath.

The main eating area has round tables with comfortable armchairs, and a new three-till check-out area to make paying faster. By claiming some land just outside the dinner hall, the dining area is extended to include an outside eating and study area, featuring tables and covered seating pods, which offer weather protection. The design even proposes windmills for generating electricity, and raised vegetable beds so that pupils can learn about growing healthy food.

The concept solves the queuing problem and offers a choice of dining experiences, inside and out, in a colourful, stimulating, multi-purpose space. The Head teacher, Michael Shew, concluded: "This project has helped to strengthen my view that if you ask students their opinions and give them responsibility for coming up with solutions, then they will often surpass your wildest dreams."

"I never realized they hired people to do interiors. Now, I notice restaurants are planned specifically: where the lights go, how tables are set out, your first impression as you walk in." Client, 14

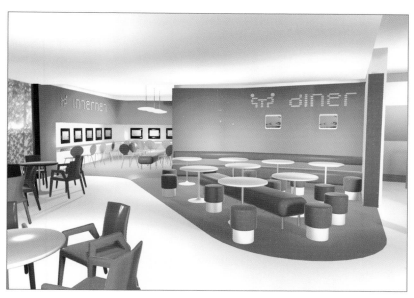

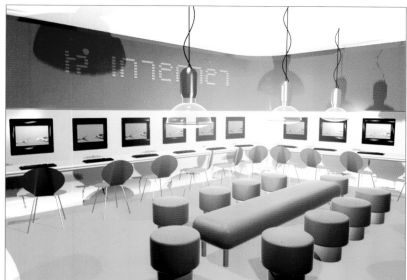

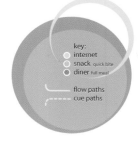

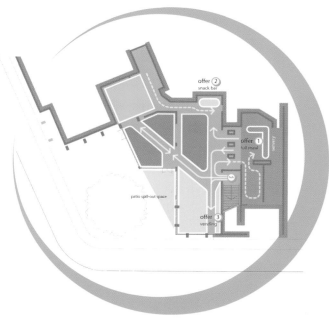

Opposite: Uncomfortable chairs, cramped conditions and unhygienic mess can be a problem in many school dinner halls and canteens. *This page:* Acland Burghley, London. *Clockwise from top left:* The proposed 'Snack Zone'; main eating area; garden seating, eating and study area; plan view of the concept; the proposed Internet café.

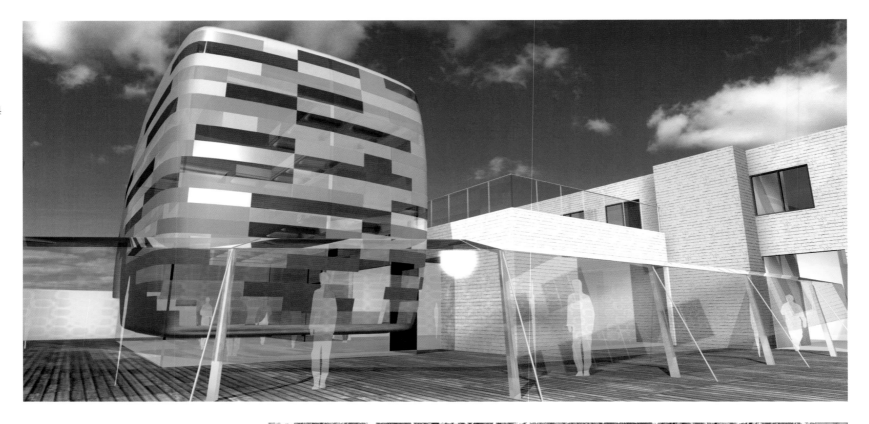

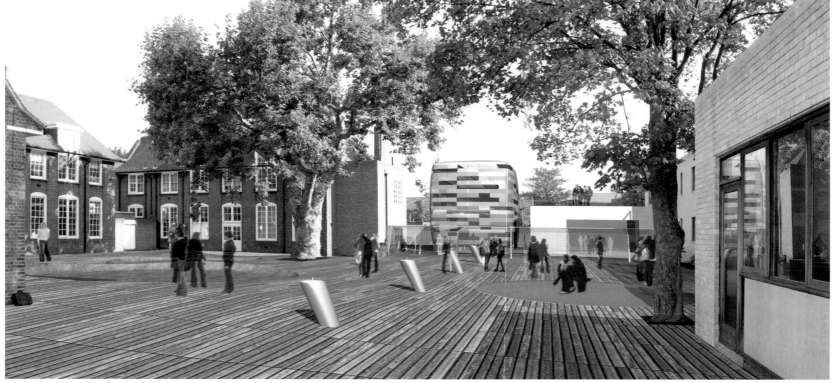

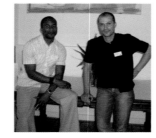

Above from top: The proposed transparent walkway at Clapton Girls', London, provides shelter while pupils queue for lunch; proposed refurbishment to the playground outside the dinner hall; designers John MgBadiefe and Paulo Ribeiro; client team members. *Opposite:* Ben Kelly in a meeting with his client team from St George's School in London.

At Clapton Girls' Technology College in East London the pupils told us the dining hall was overcrowded and there was a need for more social space. The two eating areas in the school are small, and there is little room to move amongst the fixed seating. In order to reduce crowding, the school has broken lunchtime into three half-hour breaks. "I don't want to spend my half-hour queuing up to eat and then spend five minutes eating and that's my lunchtime," said Saskia, 14. The result, said the pupils, is that some skip lunch and find other areas to meet up with friends, often in off-limit spaces. The lack of social space has contributed to a problem with integration between groups that the pupils call tribes, which has been the cause of some conflict.

We joined the school with designers John MgBadiefe, Sarah Godowski and Paulo Ribeiro from Bisset Adams, and between them they concluded that the solution needed to be a larger space that could be used for both eating and socializing. They took particular inspiration from a visit to the *Earth from the Air* exhibition at the Natural History Museum, which showed them breathtaking ways of viewing spaces from a new perspective; they discussed furniture at the Design Museum near Tower Bridge; they walked down the spiral at the new City Hall nearby to help them understand the issues of visibility and supervision.

The final concept presented by Bisset Adams includes a new extension to the existing buildings with refurbished dining spaces and social and learning spaces on upper levels, as well as a roof garden. It proposes improvements to ventilation and heating, and a transformation of the uninspiring, covered walkways with transparent canopies. The concept also includes a central kitchen to serve both dining areas, the replacement of the fixed furniture with moveable chairs, and a pre-order menu system. The proposal promises to make a big difference to the pupils at Clapton Girls and to take major steps towards solving some of the social issues.

"My main hope for the project is to make going to lunch a pleasure – an enjoyable experience."
Client, 16

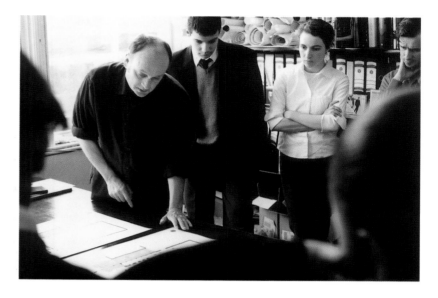

Similar problems were faced by the client team at St George's Catholic School in Westminster. "I'd like to see a nice modern lunch hall with music, better food (no offence) and some better tables," said Jimmy, 16. "I would like to have a better standard of eating, all in all." Richard, also 16, agreed: "I would like to see a transformation of the hall, which would make it appealing to the students, teachers and visitors to the school. My main hope for the project is to make going to lunch a pleasure – an enjoyable experience for the one-hour period."

We joined St George's with Ben Kelly, Patrick McKinney and Lucie Hospital at Ben Kelly Design. The pupils conducted surveys throughout the school and were clear about what they needed: "Five hundred and fifty students need to have their lunch and leave the hall with time to digest it, all inside an hour. The queue into the hall can be very long, and sometimes students get bored and act stupid. The servery gets very congested. Sometimes the kitchen staff pull down the shutters if it gets unmanageable." The pupils said the problems didn't end after you were served: "When people get their food they find they have nowhere to sit, and most of the time the stools are broken or too small. Getting in and out of the hall can be difficult." On top of queuing problems and seating difficulties, there were other complaints: "The trays are usually wet and they smell. Sometimes people don't get the food they expect from the menu and it take ages for them to decide what else to eat." The disposal area, which was right beside the diners, was "splattered with food". These are not problems unique to St George's; many school pupils we spoke to talked of similar problems.

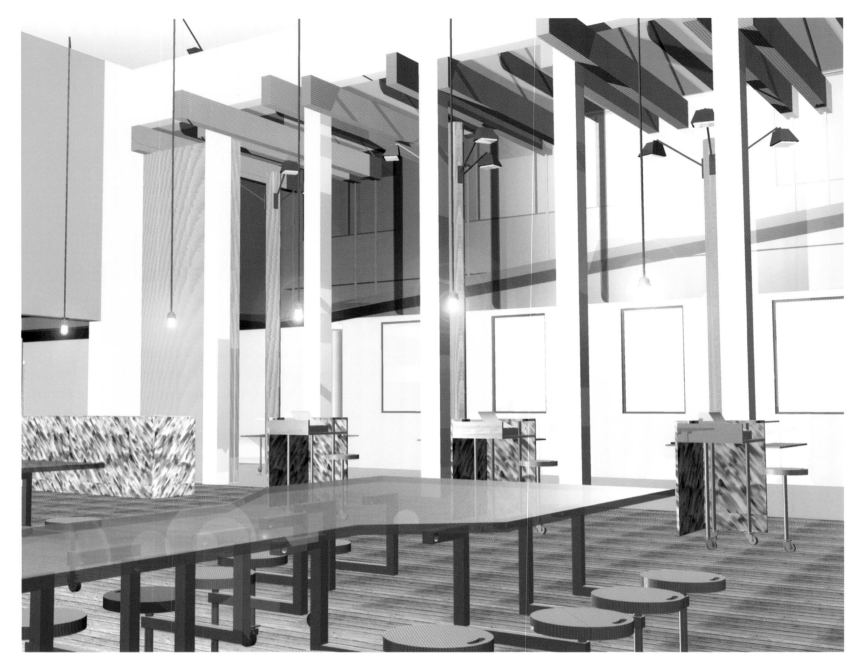

Ben Kelly's final concept proposes transforming the school hall to provide more space, daylight and colour. It changes the flow of diners to speed up queuing and includes designs for unique, lightweight dining tables and seats that can be stored flat up against the walls, so the space can quickly be cleared for other activities. Ben also proposes a glass-roof foyer space between the main building and the school hall, providing a covered queuing area, which can be used as a drama space.

"Ben took our ideas and improved them in many different ways. I thought this project was great."
Client, 14

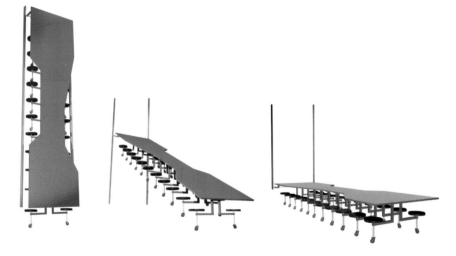

Above, from top: Concepts for a new dinner hall, with daylight, colour and an innovative new table and chair system for St George's School in Westminster; the tables fold away against the wall to create more space.

The LOUNGE/GARDEN is an informal indoor 'garden-space' where students can wait for their lunch sittings and lounge around during break time and weekends. It also serves as the tuck shop area and has an exhibition wall for students and hobby groups to display their work or school trips.

The TUCK shop is part of the service wall and opens on to the lounge/garden.

The SERVERY is reconfigured to accommodate different flows of use and allow for easier access to different types of meals.

The DINING HALL is reorganized with a new seating plan and lighting scheme to be adapted to suit different events and change the nature of the space. Ventilation is provided through the new SERVICE WALL and natural light is introduced via rooflights and the slots between the existing beams.

The FUNCTION ROOM can be booked by students and teachers for meetings, lunch parties or exclusive dinners. The room can be screened off for privacy and served privately from the kitchens.

The corridor is converted into a COMPUTER WALL for e-mail access, which frees up computers in the library for work.

The STUDY CAFE can be used during breaks, free periods, after school and at weekends, to meet friends, relax and do homework in a comfortable environment and with easy access to the hall, terrace room and e-mail stations.

The TERRACE ROOM can be opened to the outdoor terrace in the summer or closed off in winter and at night.

The new timber decked TERRACE allows for summer eating on outdoor tables.

In Bishop's Stortford, Hertfordshire, the fifteen- to sixteen-year-old pupils of Hockerill Anglo-European College, a high-achieving day and boarding school, were addressing their own queuing problems in their refectory. "We spend almost the whole lunchtime just trying to get lunch," said Andrew, 16. "We've got some really nice grounds and facilities, and when you're taking a visitor into the refectory it's embarrassing," said Danielle, 16. "It's so dark and drab. It is actually disgusting as it is now. It brings the school down so much." Jack, also 16, complained the refectory was outdated: "It's a miserable place to eat."

They surveyed the school and found that there was a strong consensus to improve the circulation, introduce more light, modernize the space and make it "a place we can be proud of". A further problem identified by the team was the congestion created by narrow corridors leading to the refectory. We joined them with Jose Esteves de Matos, Matt Dearlove, Angus Morrogh–Ryan and Damien Lee, architects from De Matos Storey Ryan. They took the client team on a tour of London restaurants. They visited the five-star Sanderson Hotel in London's West End and Wagamama in Soho to see different styles of dining areas, and to understand how a range of materials and colours could affect the atmosphere of a space.

De Matos Storey Ryan's final concept proposes bringing daylight into the area by introducing skylights, modernizing the servery and introducing colour to the table tops and walls. New seating and benches replace the noisy metal-framed chairs. It also includes a study café and an Internet area, with a chill-out space alongside. To solve the queuing problem they propose developing a service yard outside the refectory to create a covered queuing space, a garden and a gallery of the pupils' art. As one pupil said: "That yard is the worst part of the school, and we're turning it into a lounge garden – the governors will like that."

The opinion of the governors was paramount, and the client team spent a long time discussing with their designers and the Foundation team how best to present the proposed £500,000 budget for the refectory improvements. One pupil proposed comparing it to the cost of a local semi-detached house, with the added advantage that this new building work would be of benefit to hundreds of people. They suggested they could gradually recoup the investment by hiring out the new space for evening events. But they felt the clinching argument was that the school declared it wanted to be the best of its kind in the world. "To be the best we need to have the best," said one pupil.

The architects also proposed that the improvements could be phased in to spread the financial load. "I think this will give ideas to other schools and broaden their horizons," said Andrew. "I think they'll follow us. It will be good for our publicity." His colleague, Jack, agreed: "I think one of the best ideas is the study café, and it's going to be a place where students can stay after school. They're going to come to a new, modern place to research and read. It's going to be a nice atmosphere."

The Principal of Hockerill, Bob Guthrie, thought the work was a "fantastic opportunity, certainly one of the best things our youngsters have ever been involved in." He loved the fact that it was what he called "a real project", and was immensely impressed by their learning. He said he was "pleased that their design solution wasn't some great work of art that looked very good but actually in practical and commercial terms couldn't be realized". He thinks the contrary is true: "What they came up with was actually a very sensible reconfiguration of space, which I feel that a college of our size could easily move towards in a short period of time, and I hope we're going to do that."

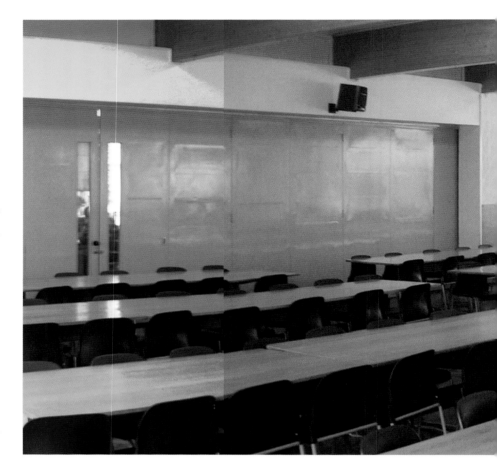

Before After

"This was a fantastic opportunity, certainly one of the best things our youngsters have ever been involved in."
Bob Guthrie, Head teacher

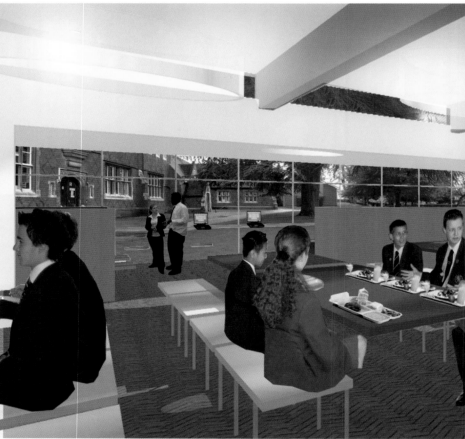

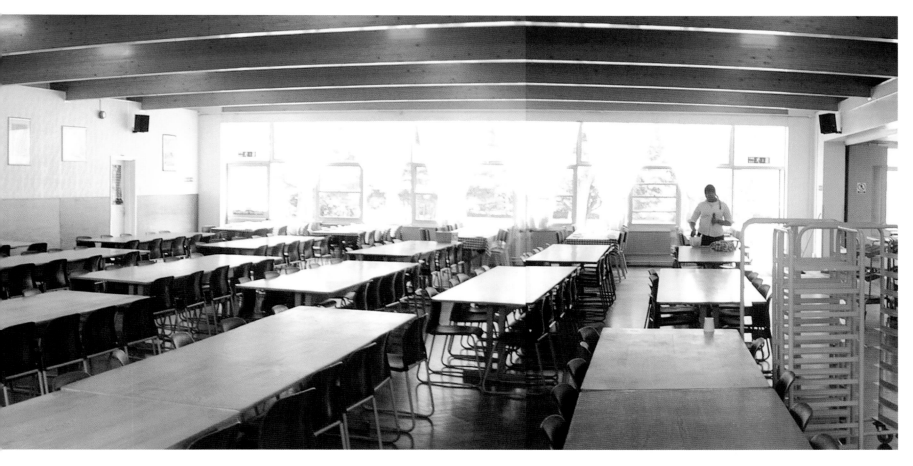

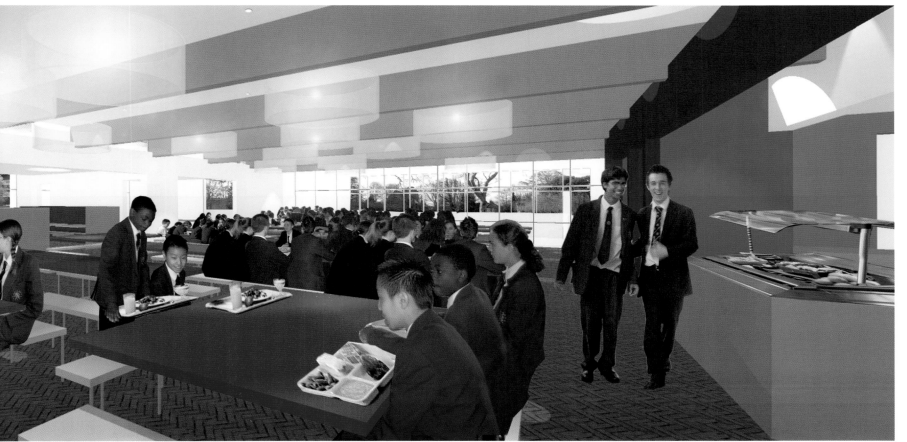

Learning Spaces

"We want classrooms that will inspire us to work harder."
Client team brief

Pupils felt very strongly about the rooms they learn in. They told us that they needed plenty of light, and "fresh and clean air" that wasn't "smelly". They also said they found it hard to concentrate in temperature extremes and wanted their rooms warm in winter and cool in summer. Some said they should have air-conditioning. They wanted their learning places to be decorated in cheerful, calming colours (see pp. 36–41). They wanted variety; they didn't like having lots of classrooms that looked the same. Views were important to them; they wanted to see the seasons changing outside their windows. Storage was a big issue; they said they needed space for their bags and coats, and wanted a place to store their work safely (see pp. 136–43). They also wanted the means to display their work. In summary, they wanted spaces they would *want* to go to and learn in; spaces that would help them concentrate.

At Falmouth School in Cornwall, the pupils wanted to update their Design and Technology department. "The D&T department is very cramped together; you can't separate your bags from your work. It's not a very inspiring atmosphere." The team's lead teacher, Jasmine Moon, summed up the problem in the D&T block: "The work benches are bumpy. There's all the noise and dust of a workshop environment. You can't draw and read very well in such a space. The kids have a million reasons to complain as soon as they enter a D&T classroom, completely distracting them from what they're meant to be doing. And we can't blame them. Their legs can't even go under the tables without hitting the vices. Furthermore, there's no division of space, no storage space, no cloakroom space, so straightaway we're talking about health and safety hazards."

We joined Falmouth with architects Alex Mowat, Ray Cheung, Diana Cochrane and Caroline Kemple-Palmer of Urban Salon Architects. They created a design tour booklet to help the team explore their ideas on a London visit to see modern design icons.

At Tate Modern, among other things, they saw how the glass box on top of the old power station combined the old and the new; at Peckham Library they considered what coloured glass could do to a façade, and how isolated learning pods could provide calm and clarity in a busy environment. They went to two furniture showrooms to look at possible furniture for the space:

at ARAM they saw works by leading designers such as El Ultimo Grito and Ron Arad, and at Twentytwentyone they viewed quality products for limited budgets. The pupils returned to Cornwall with a deeper understanding of the ideas they wanted to pursue.

Urban Salon enjoyed an exciting exchange of ideas with the team, far better, said Alex, than many of his normal clients. "Maybe because the pupils are all on a level, in a way, they were able to listen better. They were much better at achieving consensus. Also, they were really, really good at juggling the high-end aspiration for the project with the day-to-day nitty gritty. They were able to jump from the big end to the little end almost instantaneously, which is what normal clients don't do."

The conversation generated four proposals to fit four budgets, ranging from £150,000 to £450,000. 'Blobs' is their first concept, a £150,000 project proposing circular extensions to each of the existing workshops that work as small design studios free from noise and dust. For £250,000 they offer the 'U-shape', which connects the main school to the D&T block and provides a long gallery with a design studio and access to a "secret garden", providing an outdoor learning space amid greenery. The third idea is the most favoured by the client team, inspired by the American illusionist David Blaine. The 'David Blaine' box, which could be implemented for £350,000 as a two-storey, steel-framed coloured glass box that sits over the existing building, is every bit the "design statement" the pupils are looking for. It features workshops and prototype studios on the first floor, drawing and presentation rooms on the upper floor, and a rooftop garden complete with planters/seats where they can sit to look at views across Falmouth harbour. The fourth concept, the 'Table Top', costing £450,000, is a structure to cover the existing building in the form of a high-level design studio in a glass dome. All options use solar panels

61

Blobs

U-shape

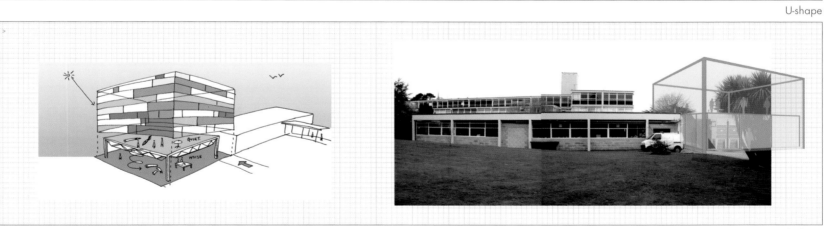

David Blaine

Table Top

Above: Urban Salon's four design options for the D&T department at Falmouth School, Cornwall. *Opposite:* Urban Salon's guide for their client team on getting the most out of their visit to London.

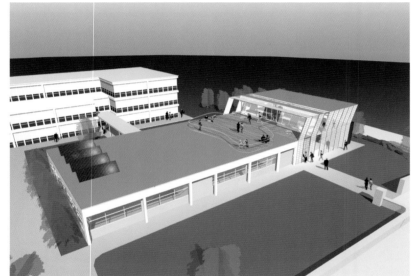

for power. Falmouth was one of several client teams to consider environmentally friendly power sources.

 Christine, 15, describes the advantages of the David Blaine concept: "We've got work space upstairs where you can't hear what's going on downstairs. We'll actually have space to think; the new block will really help us to concentrate a lot more than we do right now." "We've had designers in recently and they've built new extensions and they've upgraded buildings," said Deputy Head Ian McLachlan. "I don't think at any stage we consulted with the real client group – the kids who will be in those buildings. In future I will be looking for ways to get the youngsters involved, not just because it's good for them, but because I think we'll end up with a design that would mean more to them, because they will have ownership."

"If it was built, it would help the school a lot. I think more people would be interested in the school as well. I think it would change the school." Client, 15

Urban Salon's concept for Falmouth School's D&T department. *Above, clockwise from top left:* Ground-floor design studio; the new library; exterior view of the concept; the client team present the model to their audience; the roof garden. *Opposite:* The proposed new D&T department by night.

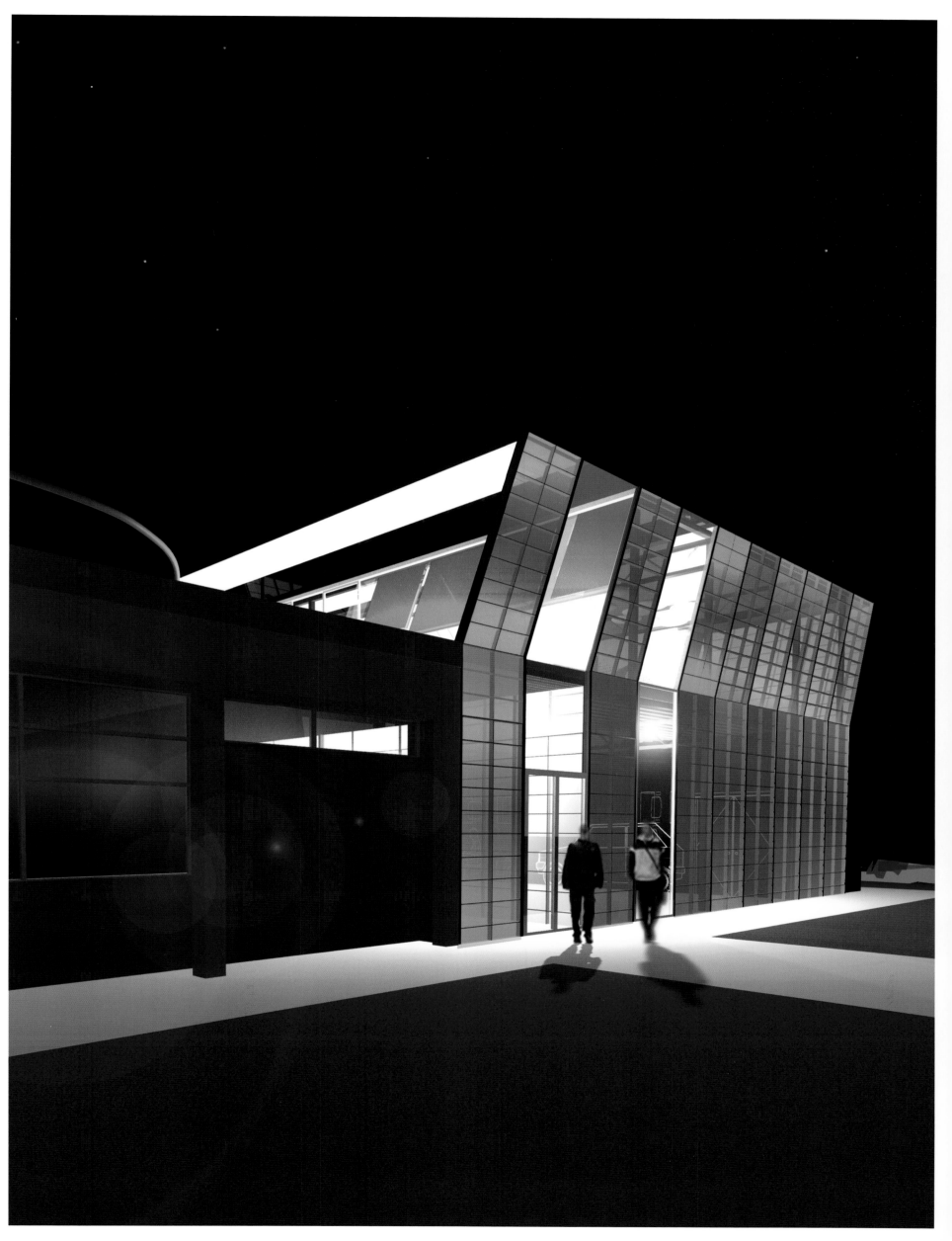

Pupils at Quarry Brae Primary School in Glasgow wanted to increase the learning space inside their classroom. The school, like many Victorian school buildings, features classrooms with high ceilings and limited floor space. "Sometimes the classroom can be a little bit squashed and a little bit hot and it can be a little bit annoying when there's no room," said one eight-year-old client. They felt that the classroom contained enough volume, but a lot of it was in the ceiling. They wanted to make better use of the space and create an inspiring area where pupils could sit apart to read or play.

While preparing their brief they came up with a brilliant idea: "First we thought of another floor, with a spiral staircase, but we decided we didn't want it because it isn't as much fun as a tree house. It was fun to give our own ideas and for the design to work." As briefs go it could hardly be clearer, and Janice Kirkpatrick and Ross Hunter from design consultancy Graven Images saw no reason to depart from it. Their final concept proposes a central 'trunk' with an integral spiral staircase, leading up to a platform with a slatted timber canopy. The trunk is covered with padded material, printed with a bark pattern, making it comfortable to touch or lean against. The platform walls have interchangeable panels that can be decorated and illuminated, and three video-display screens can be viewed from the classroom. Under the platform there is a quiet study space. The space works as a calm retreat as well as an enjoyable place to be. Janice was impressed by the pupil's creativity: "They had pretty strong ideas about what they wanted. Some were really great, especially the tree house idea. We would never have come up with tree houses as a solution without them."

The client team at Speedwell Technology College in Bristol reported similar problems with their Art and Pottery room. Their brief was full of quotes from the pupils they surveyed: "I want an imaginative and inspirational workplace, a place where students can go during and after school for work and leisure." A new art room would "improve the way we work and give us a cleaner, more suitable working environment. And it would inspire students to work harder". They wanted "practical storage space" and a room that "is easy to keep clean". The storage issue appeared again: "We would also like a cupboard to put our coats and bags in for safe keeping. There need to be plenty of suitable storage cupboards for all our utensils and equipment – preferably with locks." The fourteen- to sixteen-year-old client team concluded that better storage and a more inspiring space would "encourage Speedwell students to want to learn more about art because it will be a nicer environment to work in". They also wanted to attach a "chill-out" space to the new art room "for kids to go into in their free time". They felt such a room should be "a modern, colourful and interesting place to be [that] can be used for homework, playing games and relaxing". They argued that "creating a social space will give kids a place to go when the weather is bad. It will cut down on bullying, vandalism, litter and other problems."

We joined them with London architects Sam Jacob and Sean Griffiths from Fat. Sam thought the client team's directness was the key to the project's success: "If they didn't like it, they would let you know. The honesty was fantastic. Adult clients tend to be too polite, sometimes, and you can't be sure what they are thinking."

Fat took the pupils to their London studios. The informal workspace helped the team relax and express their ideas freely. The conversation generated an innovative and eye-catching building. Dubbed the 'Fat barrel' by the client team, the final concept presents a free-standing art gallery, social space and outdoor shelter, located in the playground and attached to the current art room by an aerial walkway. The building mimics the shape of a kiln and would be clearly visible from the road outside, which was important to the client team who wanted to use the building to boost the public image of the school. The upper room is a contemplative gallery space, its inner circumference fitted with a curved bench, the centre dominated by a big table. The windows, cut in a variety of decorative shapes, create an ambient natural illumination. Special display alcoves are used to present pupils' artwork. The floor below solves the problem of playground shelter and seating.

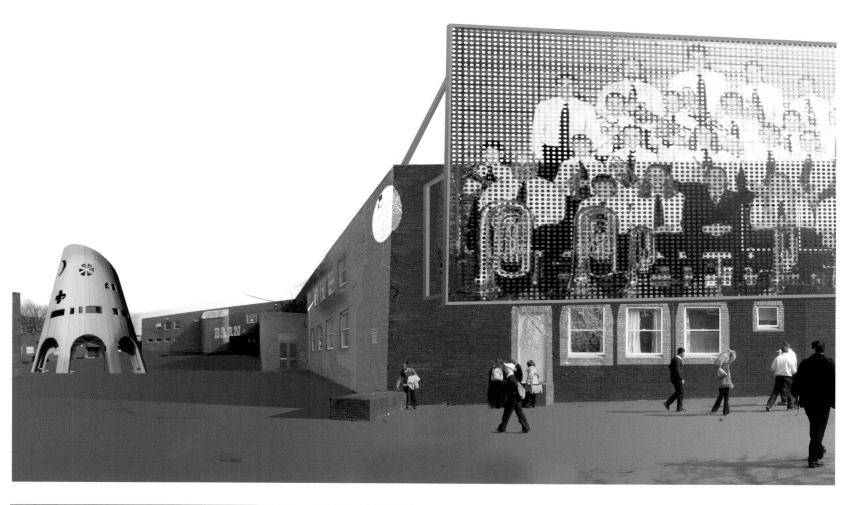

"It's given us a confidence boost all round. It would make us proud of our school. For the first time we've given something to the school." Client, 14

"I think this project would do an immense amount for the school if it was realized. We'd give ourselves something that would be outstanding, different, and in which we could have pride." Ian Greaves, Head teacher

Opposite: The proposed tree house at Quarry Brae, Glasgow. *Above, clockwise from top:* The proposed 'Fat barrel' at Speedwell, Bristol; 3D model; interior of the gallery space.

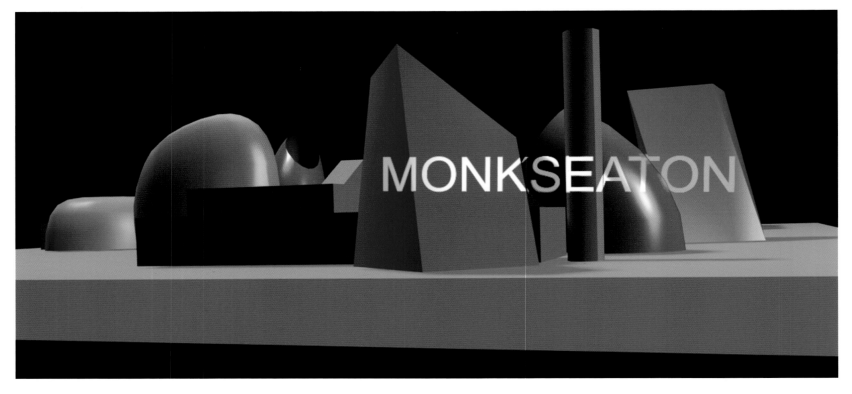

MONKSEATON

At Monkseaton Community High School in Newcastle, the sixteen- to seventeen-year-old client team worked with Fletcher Priest Architects. Their challenge was to design "the classroom of the future". But rather than go for a high-tech, high-budget solution, they generated an ingenious concept that could be applied to many schools. Architect Keith Priest was impressed by the Monkseaton brief, saying it was "highly intelligent. It was all about light, space, environment, even acoustic separation, very profound. Their creative input was great too." The pupils concentrated on their English department, which they said was "in need of a make-over". They said that "improvements would benefit the majority" and "lead to better performance. Hopefully they'll enjoy lessons more if the area is fun."

They wanted Fletcher Priest to consider lighting, storage, atmosphere, colour, flooring, heating and furniture. They wanted "lots of natural light via large windows", and preferred spotlights to strip-lights, "which are too harsh". They wanted "roller blinds" rather than curtains or vertical blinds because they could easily be rolled out of the way, and they wanted bold and bright colours that "work well with natural light". They also wanted coloured flooring – in fact they said that "colour could be used to separate areas", and proceeded to analyse the pros and cons of various colours. They had sophisticated ideas about furniture too, arguing that ergonomic furniture aids concentration: "We don't like hard plastic chairs, dirty desks and wobbly legs." They wanted the seating to be "more comfortable, with adjustable height, and able to recline", with "soft cushioned seats". They insisted that "tables should be adjustable" and proposed "folding tables, which can be easily moved around, with storage beneath them". They suggested that desks should be easy to "move into a semi-circle to encourage discussion". On the subject of storage, they wanted to "maximize wall space", create display cabinets and give more storage to pupils and teachers.

The final concept takes the form of exterior 'pods', colourful, circular spaces that can be joined on to existing classrooms, creating anterooms lit from above with large skylights, well equipped with modern furniture and flexible storage systems.

Above, clockwise from top: Fletcher Priest's classroom 'pod' design for Monkseaton School in Newcastle; Keith Priest and his client team present their model; the client team visits the Vitra showroom in London; existing school building. *Opposite pictures:* The new retail outlet at Ivy Bank School, Burnley, featuring their community-inspired symbol.

A completely new type of learning space has been created in Burnley, Lancashire, by Kevin Gill and Ric Mather of JudgeGill, working for Ivy Bank Business & Enterprise College. The school was one of the first in the UK to be granted Business & Enterprise Specialist School status. As part of its bid for this status, it came up with the innovative idea of running a learning environment that included a retail outlet within an enterprise unit.

The brief created by the client team asked JudgeGill to consider how to make the best use of the building, and to work on the school's identity to reflect their new business and enterprise status. The client team surveyed the school on what sort of image they would prefer to portray. "We want it to stand out," said the pupils; their school is one of three that share the same plot of land and have similar uniforms and badges. Michael, 15, said: "We decided we wanted to look business-like, so our brief asked for formality. We needed somewhere for the business manager to have offices and somewhere to sell the new uniform."

A central feature of the new identity is a new, business-like symbol featuring interlocking, hourglass shapes. This sits proudly on the wall of the new retail space and on the uniform clothing and sports kit. The business building and retail training area features special seating, designed so articles of the uniform can be laid out for inspection; clothes racks; and the 'corporate' blue decor, a colour scheme selected by the client team following their school survey. The learning space successfully reflects the school's new business classification, while communicating that Ivy Bank is an exciting place to be. As a client team member put it: "We wanted to look serious and exciting."

The project was implemented in 2003 and the impact of the building has been dramatic: "Since this has all come about we feel much prouder of our school," said one pupil. "I don't see school as a burden anymore. I see it as a stepping-stone to the future. This has given me something to aspire to." Lead teacher Gill Broom was equally enthusiastic. "Last night I stood in the new business centre and thought that without joinedup-designforschools we would never, ever have got a design like this. It's had a real impact. The pupils understand now that it's not my school or their school, it's *our* school, and they feel they've made a major contribution. And so they have."

At Mounts Bay School in Cornwall, the twelve- to fourteen-year-old client team wanted an attractive space to spend time in during breaks and after school: "There's not much to do in Cornwall in the evening," said one pupil. But they wanted it to be inspirational, a place where they could learn and create. "We wanted a building in which we could do social stuff in the wet and dry," said George, 14, "and that would be a classroom for inside and outside."

It amounted to a complex challenge, and architect Phin Manasseh travelled down to Cornwall from London on a weekly basis to meet it. The brief developed with the conversation. "It became clear from a series of mood boards they'd created that their ambitions were huge, and what they really wanted was a flexible space for group learning, creative assemblies, a space to do homework, or show films," explained Phin. "It had to be linked strongly with the outdoors; it had to address inside and outside. That was the biggest challenge." After considering a number of alternatives, the site they chose was a piece of grass next to the head teacher's office ("the choice revealed they had a very positive relationship with the head," said Phin).

The group had good visual and communication skills and were dynamic from the word go. Ideas started flowing even before they made an inspirational trip to London, to visit places including the National Theatre in the South Bank complex, and artist Antony Gormley's studio. "This was when they really began to take ownership of the project," said our project manager. "They found themselves showing sketches and ideas and getting really encouraging feedback. In fact one director started criticizing his own institution's creative space. The pupils just grinned more and more. They found themselves thinking they'd got a unique idea that professionals in London would die for!" Their energy prompted Phin to conclude: "I can honestly say they were the best clients I've ever worked with, irrespective of age. If all clients were like that, we'd have very different results!"

The result of this collaboration is impressive. The 'Creative Barn', as the pupils call their final concept, has three levels, featuring a grassed roof terrace, an Internet café, and a large high-ceilinged main space surrounded on the second floor by a gallery for displaying the pupil's creative work. Walls can literally be folded up, making the space extremely flexible. The proposed floor is rough and wooden, the sort of floor you can spill paint on and it not be a disaster. "We don't want to be precious about it," said one pupil. The design includes a lift for disabled access and two toilets, and the building will be self-

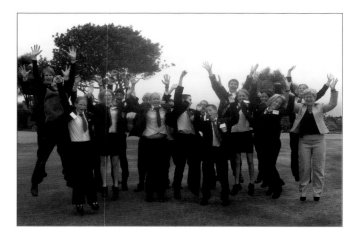

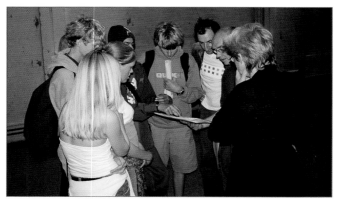

contained, independent from the rest of the school. The large main space leads out to a covered outdoor area through two massive 'barn doors' which can be flung open so that an audience, half-inside and half-out but still under cover, can watch a film projected inside the building. Tall, narrow windows provide sweeping sunlight inside the main hall, and smaller windows act as peepholes to inspire a playful use of the space and light.

This new learning space offers a blank canvas in which to socialise, study and create. Speaking about the impact of the project on her pupils, Head teacher Sara Davey said: "They now clearly see themselves as people of worth, who are going to go out there and do something in the world. And I think everyone, to a person, has been influenced in this way. It's just fantastic! It's what we are about in education; it's just wonderful."

"We were given the task to produce something that we wanted, instead of something the teachers decide. We'll be able to say: 'I did this, I made this happen.'" Client, 15

Above: the client team from Mounts Bay School in Cornwall after the concept presentation; at the National Theatre, showing Phin Manasseh's ideas to the theatre director. *Opposite:* model of Phin's design for the 'Creative Barn' and a ground elevation.

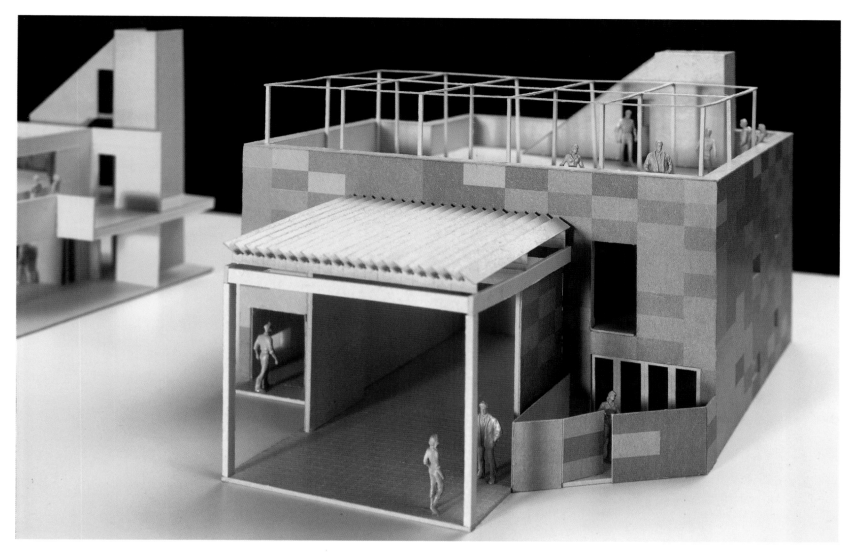

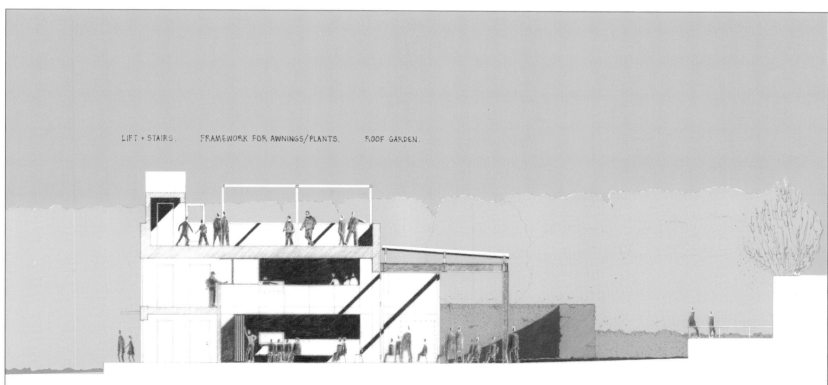

LIFT + STAIRS. FRAMEWORK FOR AWNINGS/PLANTS. ROOF GARDEN.

PATH UP TO FRONT DOOR;
LIFT, STAIRS, WC'S;
GALLERY OVER·LOOKING
MAIN SPACE.

MAIN SPACE (DOUBLE HEIGHT);
'SOCIAL' BEYOND + ON GALLERY;
SLIDING FOLDING DOORS +
SHUTTERS.

'BIG' DOORS CONNECT MAIN
SPACE WITH OUTDOOR
COVERED SPACE.

EXISTING HEDGE FORMS
ENCLOSURE TO THE SOUTH
AND WEST OF OUTDOOR
SPACE.

EXISTING TERRACE + BUILDINGS

CROSS SECTION

Kaskenmoor School in Oldham, Lancashire, is bidding for Performing Arts status, so the client team wanted to transform its hall into an inspirational, multi-purpose, learning and social space.

Their brief to architects Terry Farrell and Toby Denham from Terry Farrell & Partners said the hall was a "poor environment", and complained that tall windows made the space too hot in summer, which meant they had to keep the "awful curtains" closed all the time. But the school budget to transform the hall could not effect the changes they wanted. So the client team agreed with the designers that they should draw up a masterplan for the school that could be implemented incrementally.

"We set about looking not only at the school hall, but also the playground and the school entrance. One of the problems was the reception area; every time I visited the school the taxi driver missed the entrance," said Toby.

Toby took the pupils on a visit to London. Deputy Head Rachel Quesnel said the visit to Laban, the centre for contemporary dance in Deptford, south-east London, blew their minds: "One girl saw people her age doing dance and decided she wanted to start dance lessons. It was like she suddenly saw a way ahead. It was a hugely aspirational motivator – showing that school can actually lead somewhere." The pupils' enthusiasm for the project grew as Terry and Toby took ideas from their discussions on the visits and fed them into their design.

Their final concept proposes opening up the hall and making the whole space more accessible. It includes a Belcher seating system, which folds flush into the wall, making the space more flexible. To solve the problem of sunlight, the concept proposes replacing the glass south wall with a solid wall decorated with bold, bright colours on the inside and an external climbing wall outside. An Internet café makes use of corridor space on the north side of the hall, featuring video displays in the floor and a multi-coloured glass screen that runs out on to the front of the building, linking the main road with the building and the Internet café in a conceptual plane. The theme of Internet connectivity is reflected in the ribbed structure of the new, lower ceiling which, when illuminated, will look like "a neural network". "Schools so often build in a haphazard way with no overall strategy," says Toby, "but now Kaskenmoor has a vision that it can implement as funds become available."

"It would have a huge impact if this design were realized," said Rachel Quesnel. "It would make the children feel proud of their space and give them a feeling that they owned it."

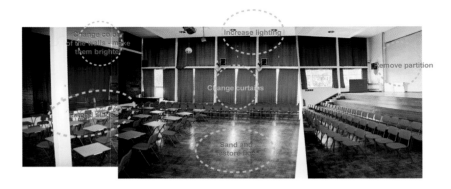

"The kids were speechless when they saw the concept. Stunned. I think it would really put Kaskenmoor on the map." Rachel Quesnel, Deputy Head

Above from top: The current hall at Kaskenmoor, Oldham, with areas marked out for redesign; the client team visiting The Green Building in Manchester to get insight into ecologically friendly architecture; designer Terry Farrell with his client team. *Opposite:* A view of the design, showing the Internet café with coloured glass illuminating the hall, and an exterior view showing the new hall roof.

In Stoke Newington, North London, pupils at William Patten School were experiencing problems with a shortage of sports facilities and the size of their playground. The primary-school children complained that in the playground there wasn't really "enough room to skip", let alone do PE and play football. "The ball hits children," and "parents and visitors have to dodge the footballs as they come in," said the client team in their brief. PE would often have to happen in the hall, which made it "very noisy in the classrooms" nearby.

The school had recently obtained an old factory, which they hoped to develop cheaply to solve some of these problems, but it turned out to be dangerously derelict. The client team, with an average age of nine, presented all these problems to architects Patrick Theis and Soraya Khan, from Theis & Khan, to music in the form of a rap, and suggested the solution might be to convert the factory into a sporting facility, paid for by a sports funding body. But the architects found that there simply wasn't enough room to put in official-sized indoor courts. This provoked a lengthy discussion about the way forward, and resulted in a mission to remodel the outside space and make the factory useful to the whole school.

The client team studied how ball games caused problems and where the best places were to sit and relax. "Together, we switched the whole site around," said Patrick. "They had a normal tarmac playground surrounding the school and they had a garden some distance away. We proposed turning the garden into a hard-surface sports facility and brought the garden round the school." The original garden area proved large enough for five-a-side soccer (and skipping), so the team proposed a transparent fence to protect visitors from balls (and skipping ropes).

The final concept includes turning the factory into a multi-purpose creative learning space, complete with library and art gallery. The 'Pavilion', as it is known, has a roof-top garden with a child-safe pond. The plan is to open the Pavilion to the community, and perhaps provide adult learning facilities. "It was a complete joy working with the children," said Soraya. "They were so clear thinking and creative; despite their age they were just fantastic, full of ideas, no side to them, they just spoke their mind. It was easy to address their problems."

"It was a complete joy working with the children." Soraya Khan, designer

The seven-to eleven-year-old pupils at Hinde House School in Sheffield said they wanted to study science in an exciting, interactive way. To do this they wanted an outdoor classroom with gardens, because in their current playground they said they couldn't "even find an ant; not even a leaf!" So they began preparing a brief full of ideas for attracting nature to their school. Robyn, 9, said: "The idea of the magnifying table is so that if a class is doing a project on habitats, they can look at all the different types of animals under the magnifying glasses that are part of the table." Robert, 10, wanted "to build a mosaic wall that needs to be colourful, eye-catching, inviting and fun". Gemma, 11, pointed out that "kids tend to make a lot of mess. I think it would be a good idea to have recycling bins". And Jen, 11, suggested: "It would be amazing to have a walk of fame. This would go all around the garden. It means that everyone involved in the design could leave their mark for future pupils to see." The brief also asked for "a safe pond with insects in and surrounded by lovely flowers".

We joined Hinde House with designers Michál Cohen and Bozana Komljenovich from Walters & Cohen, and landscape designer Anne MacCaig from The Nature Room, to answer their challenge. The client team was taken to the Walters & Cohen offices in London and to London Zoo, where they were allowed to handle creatures such as African snails, cockroaches and stick insects. They also went on a woodland walk with a wildlife expert, and soon the pupils were referring to their challenge as the Little Beasties project, discussing how straw, log piles and dry-stone walls can attract a wide variety of wildlife, including insects, hedgehogs and birds. The group talked about different soils, different plants, the best location for different habitats and how they could recycle rainwater to feed the plants. They worked on creating an outside learning space complete with clear glass and suspended nesting boxes.

The final concept proposes a three-stage implementation, tied in as closely as possible with curriculum learning requirements. The first phase sees the creation of an outdoor classroom with storage boxes, ant farms and a water-collection device. This is to be followed by the creation of a chill-out space with herb gardens and flowers, maintained by an in-house gardening club and members of the local community. The third phase includes the outdoor science lab with pond and seating.

The client team was impressed with the designer's responsiveness: "they did listen to what we said," said one team member, "and they came back with this plan

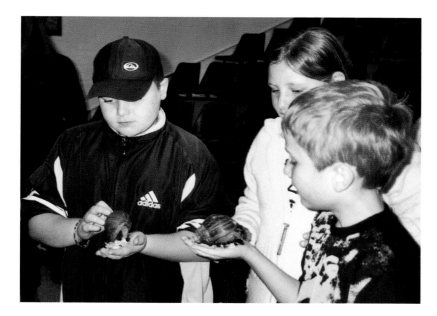

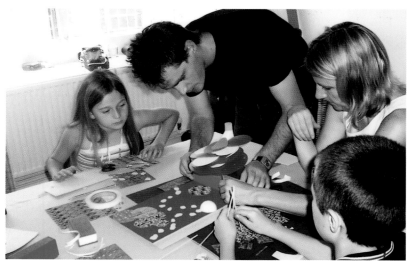

that was exactly what we wanted. You feel like you're more important because you get to know design secrets and plans and you get to take part in it. So I felt kind of special." The designers were equally impressed: "They've been so enthusiastic," said Michál Cohen. "I wish we had more clients like that. They had to take responsibility for the planting and maintenance. It was great to see their development of a sense of responsibility and care for their environment."

Nick Thomson, Acting Head, said: "As teachers we direct children all the time. This project, by making the children clients, allows them to direct themselves, to explore and develop a project important to them and this environment."

Opposite from top: Model for William Patten, London, by designers Theis & Khan; client team see the model for the first time; members of the client team discuss the design; the client team contributes ideas. *This page:* Client team-members from Hinde House, Sheffield, at London Zoo holding African snails; Walters & Cohen and the client team working together in a model-making workshop. *Overleaf:* Walters & Cohen's final concept was presented in the form of a wall poster.

Walters and Cohen + The nature Room + Lucy, Robyn, N

Client's Design Brief = Robyn: otdoor teaching + **Robert:** mosaic wall + **Gemma:** recycling bins + **Jen:** walk of fame + **Redd:**

| Cucurbita Pepo Courgette | Fragaria x Ananassia Strawberries | Phaseolus Coccineus Runner Bean | Raphanus Sativus Radishes | Salvia Pratensis Meadow Clary | Salvia | Helianthius Annuus Suflowers | Trifolium | Trifolium Pratense | Bellis Perennis Daisy | Fritillaria Meleagris | Fritillaria | Fritillaria | Ranunculus Acris | Lonicera | "Grah Ho |

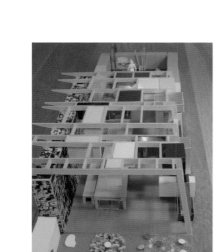 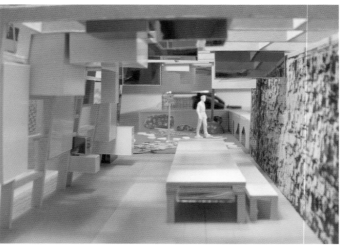

Model Photographs

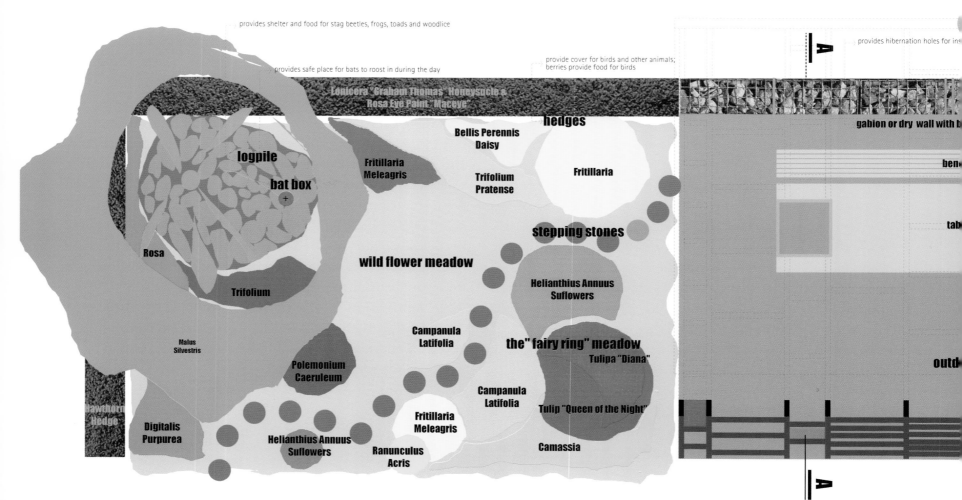

provides shelter and food for stag beetles, frogs, toads and woodlice

provides safe place for bats to roost in during the day

provide cover for birds and other animals; berries provide food for birds

provides hibernation holes for ins

Lonicera "Graham Thomas" Honeysucle & Rosa Eye Paint "Maceye"

gabion or dry wall with b

hedges

Bellis Perennis Daisy

logpile

Fritillaria Meleagris

Trifolium Pratense

Fritillaria

ben

bat box
+

stepping stones

tab

Rosa

wild flower meadow

Helianthius Annuus Suflowers

Trifolium

Malus Silvestris

Campanula Latifolia

the" fairy ring" meadow
Tulipa "Diana"

Polemonium Caeruleum

outd

Campanula Latifolia

Tulip "Queen of the Night"

hawthorn hedge

Digitalis Purpurea

Helianthius Annuus Suflowers

Fritillaria Meleagris

Ranunculus Acris

Camassia

A

The Sorrell Foundation: Joinedupdesignforschools

HINDE HOUSE SCHOOL : Ga

...bert, Gemma, Jennifer, Redd, Jed, Daisy, Zoe, Amber, JJ

...ter & decking + Jed: toad stools + Daisy: mini beasts + Zoe: magnifying table + Lucy: pond + Amber: flowers + JJ: vegetable

| ...as" | Achillea Ptarmica | Anemone Blanda | Campanula Latifolia | Digitalis Purpurea | Lavandula Angustifolia English Lavander | Geranium Pratense | Polemonium Caeruleum | Rosa Eye Paint "Maceye" | Rosa | Lysichiton Americanus | Nymphae Escarboucle | Osmunda Regalis | Corylus Avellana Hazel | Malus Crab Apple | Malus Silvestris |

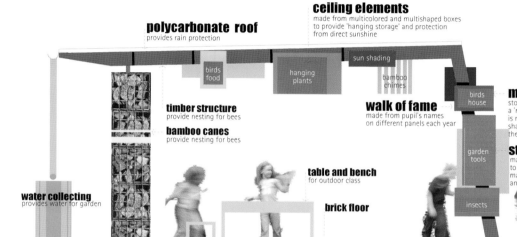

polycarbonate roof
provides rain protection

ceiling elements
made from multicolored and multishaped boxes to provide 'hanging storage' and protection from direct sunshine

birds food

hanging plants

sun shading

bamboo chimes

timber structure
provide nesting for bees

bamboo canes
provide nesting for bees

walk of fame
made from pupil's names on different panels each year

mosaic wall
storage boxes are used to create a 'mosaic' effect - each storage box is made in different colour, size and shape; some have lockable door and the others a glass display door

birds house

table and bench
for outdoor class

garden tools

storage elements
made from multicolored boxes used to store insects, ant farms, portable magnifying glasses, gardening tools and birds food

water collecting
provides water for garden

brick floor

insects

Lucy Robyn
Robert JJ
Jennifer Redd
Jed Daisy Zoe
Amber Gemma

Elevation 1:25

Cross Section AA 1:25

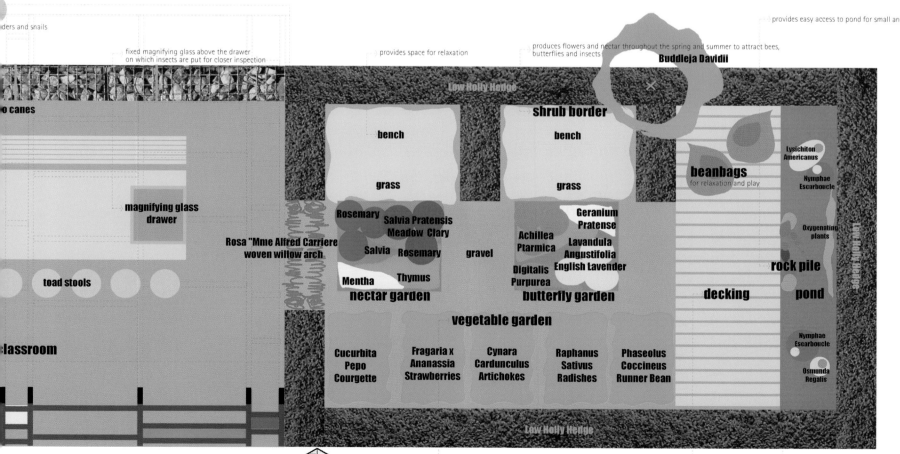

...ders and snails

fixed magnifying glass above the drawer on which insects are put for closer inspection

provides space for relaxation

produces flowers and nectar throughout the spring and summer to attract bees, butterflies and insects...
Buddleja Davidii

provides easy access to pond for small animals

Low Holly Hedge

...o canes

shrub border

bench

bench

beanbags
for relaxation and play

Lysichiton Americanus

magnifying glass drawer

grass

grass

Nymphae Escarboucle

Rosemary

Salvia Pratensis Meadow Clary

Geranium Pratense

Oxygenating plants

Rosa "Mme Alfred Carriere woven willow arch

Salvia Rosemary

gravel

Achillea Ptarmica

Lavandula Angustifolia English Lavender

rock pile

toad stools

Mentha Thymus

Digitalis Purpurea

decking

pond

nectar garden

butterfly garden

vegetable garden

Nymphae Escarboucle

...lassroom

Cucurbita Pepo Courgette

Fragaria x Ananassia Strawberries

Cynara Cardunculus Artichokes

Raphanus Sativus Radishes

Phaseolus Coccineus Runner Bean

Osmunda Regalis

Plan 1:25 North

provides nectar for insects and seeds for birds, as well as fresh ingredients for cookery

provides a habitat for frogs, newts, toads and aquatic invertebrates

provides a relaxation space as well as 'observation gallery' for pond life and platform for 'pond safari'

...den + Outside Classroom

Reception Areas

It's easy to underestimate the importance of designing a school reception area well. They are highly multi-functional places, coping with the passage of hundreds, sometimes thousands, of people a day. Although the functions of primary and secondary school reception areas can differ, in both cases they usually provide space for the school's administrative hub, act as the meeting and greeting area, and are where sick pupils are cared for. Many of the pupils we spoke to said their reception spaces were too poorly designed to offer these facilities efficiently. "We have a confusing entrance; it's really unwelcoming," said a pupil from Camden School for Girls in north-west London. "There isn't enough signage, and it's short of space. And the gates outside make it feel like a prison." Such comments were widely echoed in the schools we visited; many pupils felt their reception areas were "drab" and "boring". Pupils wanted the reception areas to express their school's values in a cheerful, welcoming way. Reception is where visitors form their first impressions of the school; the pupils seem well aware that first impressions are lasting impressions.

At Hythe Community School in Kent, the pupils wanted a lively new reception area that would welcome the community. The opportunity for this came about because the school was building a new extension. Hythe is a Reggio Emilio primary school, where staff believe in child-led teaching from an early age. The client team was aged 4 to 7, making them the youngest in the joinedupdesignforschools programme, but that did not stop them from communicating to designers Ben Kelly, Michael Westhorp and Patrick McKinney of Ben Kelly Design exactly what they wanted. Hythe staff dedicated five curriculum days to help the pupils prepare their brief and all 185 pupils at the school were involved in the project, planning, investigating, and collecting data. The youngest pupils went to the beach to collect stones and driftwood to illustrate the feel they wanted. The older pupils created drawings, paintings and montages, which indicated that the new reception area should be bright, full of art and with plenty of room for visiting parents with prams and buggies. They presented all this to Ben and Michael in an exhibition that filled the school hall. "Their brief was incredible," said Ben. "It had such vigour, life and enthusiasm. It was really stimulating. It was the key that unlocked the process. They

communicated in the way that young children do best, by chucking a load of stuff out from within themselves: drawings, paintings, models, collages, written stuff, tons and tons of it, all over the walls!"

To celebrate the pupils' creativity, the final concept translated their brief into a reception area that is also an art gallery, complete with an area for an artist-in-residence to work with the pupils. Administrative staff are placed at the heart of the school, at a reception desk made from recycled wood and plastic, which varies in height from waist-level up to shoulder-level. The higher section acts as a partition, giving the administrative staff some degree of privacy. All Hythe Community School's human traffic goes through the new reception area, which provides comfortable seating for informal meetings and shelter for waiting parents and visitors. The concept includes yellow bucket lights by product designer Michael Marriott, to reflect the school's seaside location. The whole space is light and airy, decorated with plants and art: "The idea was that it should have a sense of humour; it should break the ice," said Ben.

"This was the richest curriculum experience I have seen in this school for many years," said the Head teacher, Carolyn Chivers. "The children were doing what they wanted, taking the lead, while teachers were busy with reflective planning, looking to exploit learning opportunities through what the kids wanted to do. Every area of the curriculum was covered by just setting the children a problem to solve. And every child in this school worked for long hours; the concentration had to be seen to be believed!" To the delight of all, the scheme was implemented in 2004.

"This was the richest curriculum experience I have seen in this school for many years."
Carolyn Chivers, Head teacher

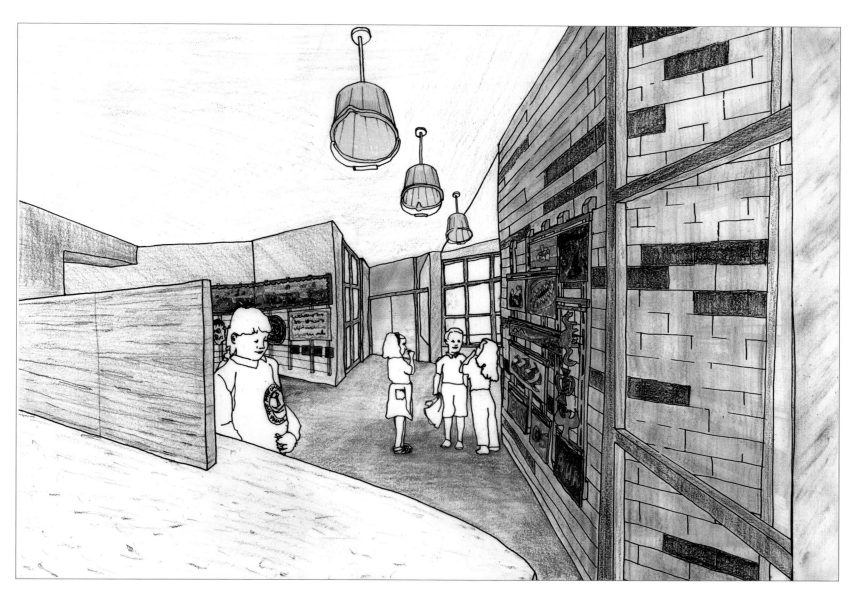

Top: Ben Kelly's drawing of his concept for Hythe Community School, Kent. *Above, from left:* The former entrance to Hythe; the client team investigating materials; designers Ben Kelly and Michael Westhorp. *Overleaf:* The implemented design.

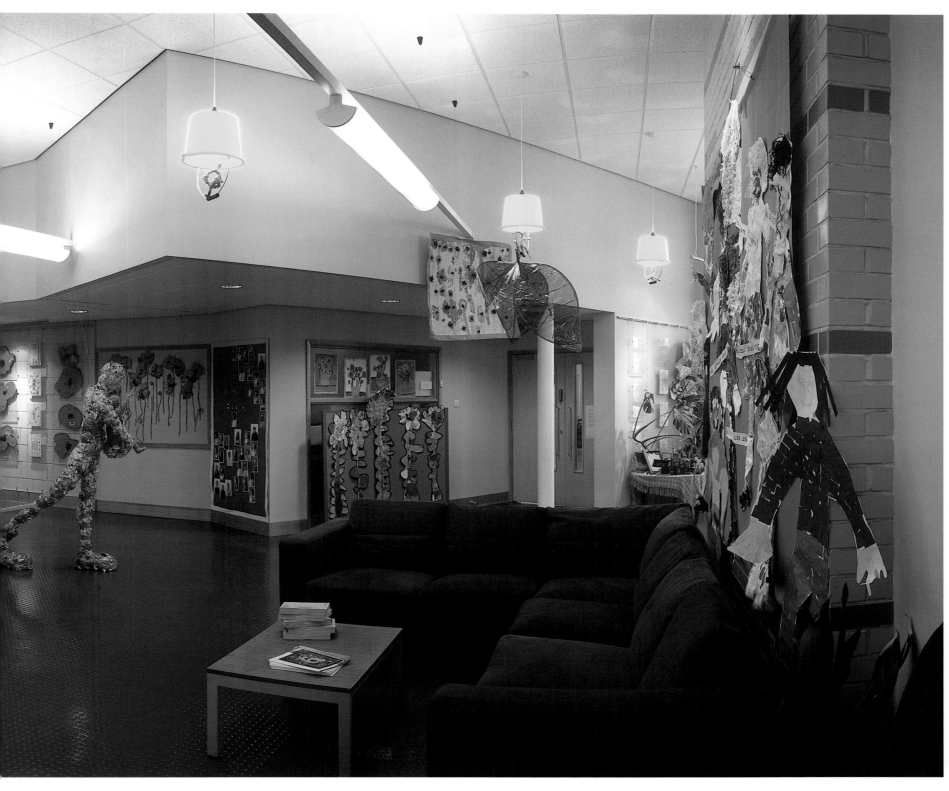

In Sheffield, the eight- to twelve-year-old client team at Porter Croft Church of England Primary School challenged their designers to create "a welcoming new reception area". Their brief said they needed a new entrance because the existing one "doesn't look very nice and needs to be more friendly". The pupils also felt it was too small. "It's used for welcoming, a sick bay, the head teacher's office, photocopying, parent-waiting, a place to hear children read, and for information boards," said their brief. They wanted a light blue colour to make it brighter, "like in *The Simpsons*", and were interested in a water feature because they loved the feeling of freedom and light that water could bring. They also wanted to include "a chill-out area; a place to relax, read, chat and chill during breaks". They wanted a sound system, comfy seating, books, pictures and interesting lighting. They asked for "interesting plants, works of art, brighter colours, a fish tank and football results". The pupils argued that such a space "would make the school cheery and happy, and would be a nicer place to rest when you are ill". They said: "If it is comfy it will not be scary. It should show everyone who visits our school what good work we do here and that we are proud of our school."

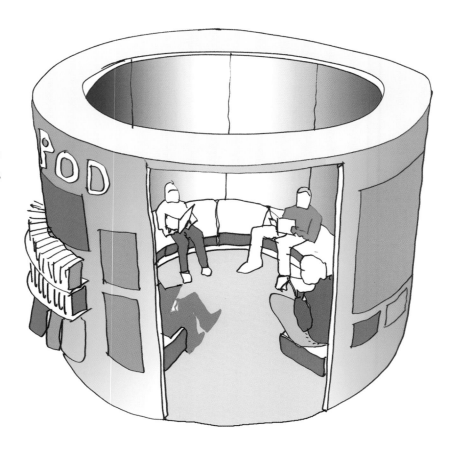

We joined them with architects John Pringle, Penny Richards and Ian Sharratt of Pringle Richards Sharratt, who took them on an inspirational visit to the London Aquarium, where they explored the use of water and colour and found themselves fascinated by light reflection.

For reasons of safety and practicality, the final concept does not give them a water feature, but it includes something close. Visitors entering the school gates walk along a meandering blue 'river-path' to the reception. Inside they see a drum-like library and reading room colourfully clad with bookshelves and pupils' artwork. The interior is painted in beach colours, with a shimmering foil ceiling to create watery reflections, as a sound system plays ambient music. In an adjacent room there is a separate learning and relaxation space equipped with computers. The new waiting area is an exterior pod, created by knocking through a tall window, with curved seating. The ceiling has a glass roof so that, if it rains "it's like being underwater". Javeria, 10, said: "Children will be in a better mood if they come into a nice, bright entrance hall, especially on rainy days."

This page: Design concept for new library and reading room at Porter Croft; existing reception area; the client team and the designers present their model to the school. *Opposite, from top:* Drawings by Pringle Richard Sharratt of the new reception area at Porter Croft; plan drawing of the concept, with labels by the client team.

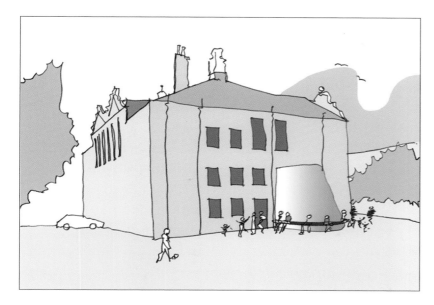

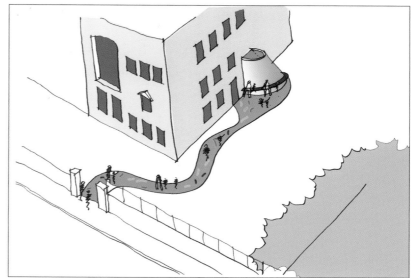

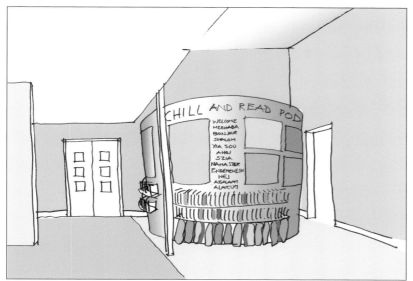

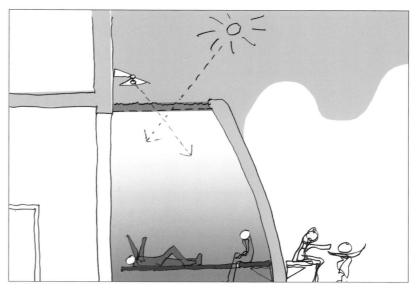

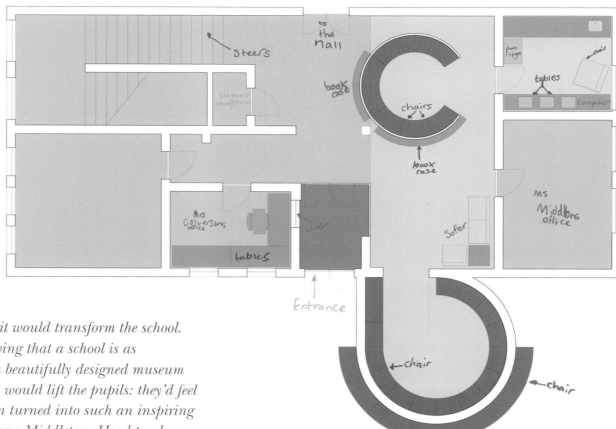

"If this design were implemented, it would transform the school. It would increase its status, showing that a school is as important to the community as a beautifully designed museum or art gallery. But, most of all, it would lift the pupils: they'd feel so proud that their work had been turned into such an inspiring entrance and working space." Jayne Middleton, Head teacher

"We want our school to stand out within the community," declared the brief from pupils at Leasowes Community College near Dudley in the Midlands. They were concerned that their school was getting a little lost, precisely because it was such a centre for local people: its sports hall, theatre and library are often open to the public, and the adult learning centre handles 20,000 adults a week.

The client team wanted to identify clearly the school as the main institution, while making all visitors feel welcome. "We want a library, a modern reception counter, clean toilets, a learning centre, a coffee corner with computers, and an art gallery," they told designers John Harvey and Jacquie Burke of Din Associates. "We want bright colours, like a kingfisher. We want it to be futuristic. And we like atriums." That was just the inside. "Outside we want tinted glass, security cameras, lighting, decoration and signs." And they wanted it large: "Reception at the moment is too small; we want it so that many people can pass through. We want it to encourage people to come in." They told the designers they would like interactive computers at which the public could ask: "Where is the sports hall and what will I find there?" The pupils stressed it had to be a very flexible space, because its functions changed according to the time of year and the time of day.

Designers John and Jacquie took the team to London to see one of the UK's leading displays of interactive design at the Science Museum. They also went to the Harrison Learning Centre at the University of Wolverhampton to get ideas on modern learning spaces. John enjoyed the novel experience of working with a client team of pupils. "They expanded the project enormously. Their ambitions were very high. We had to try to edit down their aspirations and prioritize their needs. But it was an interesting process because they wanted to do so much. The school and the governors started getting involved, and we had a real fear they would say the scheme was too big but, in fact, they came fully behind the idea and are pushing to get it realized."

The designers and the client team brainstormed the whole concept of welcome and visitor experience and gradually began to focus in on the essentials. Their final concept is for an entrance full of transparency and light, a striking, glass-fronted, modern façade communicating openness and accessibility. Clear signage directs visitors to the various facilities (some of them new), including the library, the exhibition space, the theatre, the sports hall, the adult learning centre, and the tutorial rooms.

"The resulting designs were absolutely fantastic!" said Head teacher John Howells. "Walk-through areas, social areas, individual working spaces, all incorporating the latest IT technology. Fabulous ideas." But can such a school entrance really be built? "I think the ideas are realistic. In fact, they are the ideas we *have* to do. People want education to function against best practice in the market, and yet they give us buildings that are sub-standard. With these designs you'd *want* to come to school, you'd want to carry on learning after 16."

And what did the pupils think? "The big glass windows – they are exciting," said Puja, 12. "We're going to have artwork put up to make it even more welcoming. I enjoyed the fact that we were improving and helping the school." Josh, also 12, agreed: "The best thing was making the whole building moderner and better. Din didn't make us feel that we had to do everything – they helped us along. They listened to us."

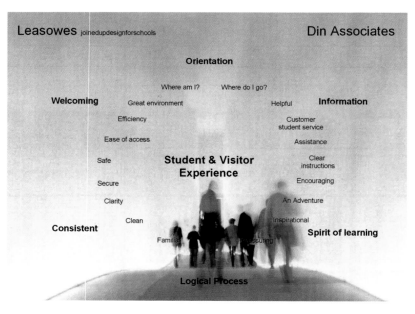

"The resulting designs were absolutely fantastic! ... With these designs you'd want to come to school; you'd want to carry on learning after 16." John Howells, Head teacher

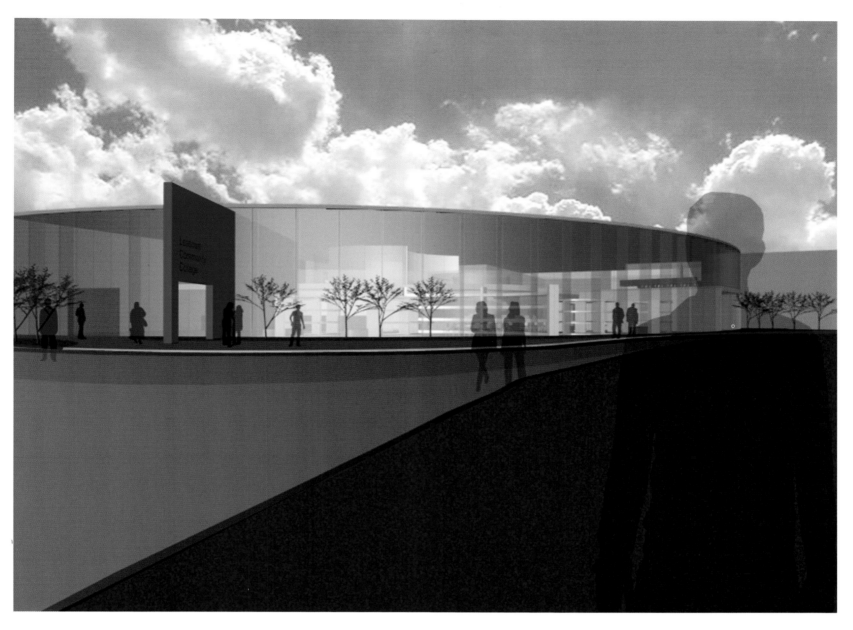

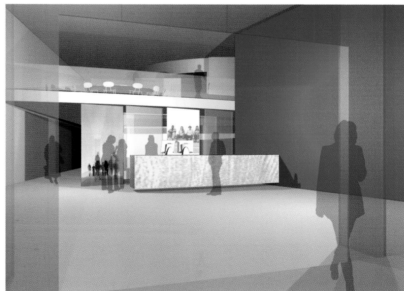

Opposite from top: The existing school entrance to Leasowes, near Dudley; Din's analysis of the student and visitor experience. *This page:* Exterior and interior views of the concept for Leasowes' new entrance and reception area.

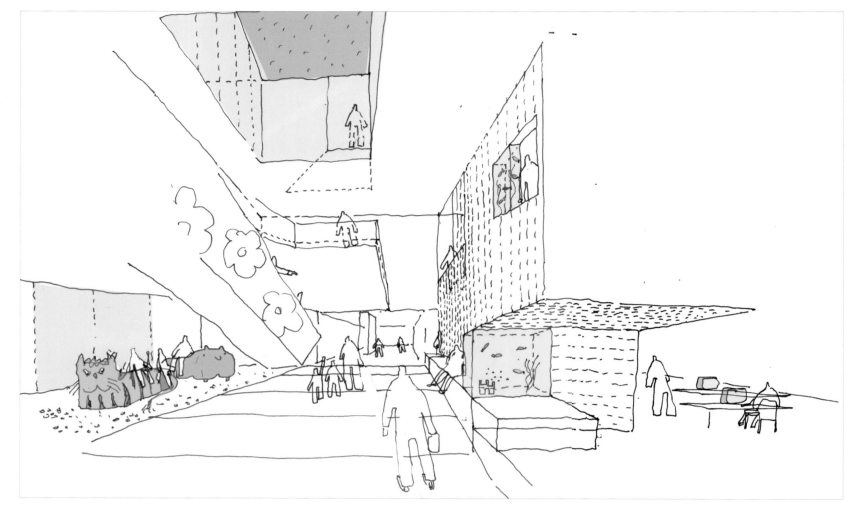

"I want to change the entrance because when visitors come to the school they think: 'I don't want my child coming to this school, it looks boring,'" said Bethany, 8, from Sussex Road Primary School in Tonbridge, Kent. Luke, 9, felt that the old entrance was "very dark and narrow and visitors don't like it". Jessica, 9, said: "The reception area is far too small for the amount of things that go on here."

The problem arose at the school, which was built by the Victorians, when it was decided some years ago to create a new entrance to replace the separate boys' and girls' entrances. The new entrance area included a hallway, toilets, reception and the headmaster's office, all packed into a tight space. Sophie, 9, summed it up: "I have always disliked the entrance to the school since the first day I visited and I still dislike it today. There is no sense of welcome or of the wonderful things we do in school, as there is nowhere to display our beautiful work. It feels very squashed and parents have to queue up to see someone and poke their heads through the reception hatch, which is not very friendly. The photocopying room is a tip! There *must* be an answer to that. Most of all I think that the main entrance area should have a room for parents and families to come in, have private meetings or discussions, share problems over a cup of tea.

"The pupils have learned so much. Self-esteem has risen, confidence has risen. They've learned to ask and frame questions and be free with their creative thinking. They've also learned that they've got a real voice."
Nigel Amos, Head teacher

After all, we are a community school and should be all working together." We joined the client team with Julian Lewis, Judith Lösing and Grant Shepard of East Architects, who have a history of working on community projects. East ran a model-making workshop to help familiarize the team with the design process. "The best thing was the session where we just put bits together on the design and decided which ones were worth keeping," said Jessica. "You get to say which bits you don't like and which bits you do like."

East took the client team to the Dulwich Picture Gallery in south-east London, and Camden Arts Centre, also in London, where they took photographs and talked to Camden Arts Centre architect Simon Jones about how traditional buildings can benefit from contemporary additions. The day ended with a discussion that generated an outpouring of creative ideas. These ideas contributed directly to the final concept.

East's concept is a dramatic extension to the existing reception, which they call the 'Box of Tricks'. It consists of a two-storey cube placed at an angle to the current building, with walls clad in a variety of textures, materials and murals, complete with built-in sheltered seating. Inside, the ground floor features a two-storey sky-lit atrium, a staircase leading up to meeting rooms on the first floor, and a tiger bench that 'roars' when you sit on it. To reduce congestion, the toilets are moved and the downstairs administrative and photocopying room is given an exterior door for deliveries. In the atrium an aquarium marks the 'check-in' area and conceals a 'secret' staircase that leads up to the head teacher's office. Pupils can also 'secretly' look out on to the playground through a two-way mirror window. On top of the Box of Tricks is a roof garden accessible through a glass gazebo.

Head teacher Nigel Amos was very impressed by the project. "The pupils have learned so much. Self-esteem has risen, confidence has risen. They've learned to ask and frame questions and be free with their creative thinking. They've also learned that they've got a real voice."

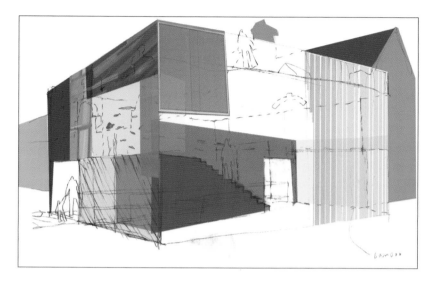

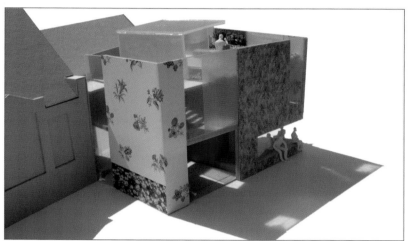

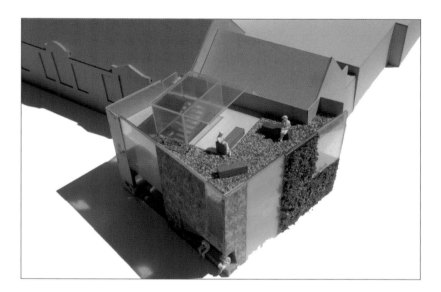

Sussex Road Primary School, Tonbridge. *Opposite from top:* Drawing of the interior of the new reception area; the client team during a visit to Camden Arts Centre. *This page, above:* Drawing of the exterior of the new reception and views of the model. *Left:* Client team-members.

The entrance to Camden School for Girls in north-west London is unattractive and too confusing, reported the fourteen- to sixteen-year-old client team. "Visitors should be able to find the school and the entrance, which is very well hidden at the moment," said their brief. "There should be better signage above the school." The client team felt that "the entrance is important; it's what people first see, and it gives a first impression to onlookers". They wanted it changed, to "encourage people to want to be at the school", and to "make the school more inviting to the students who attend every day".

We joined them with sculptor and designer Thomas Heatherwick, who was completing a major landmark for Manchester, entitled *B of the Bang*, to commemorate the Commonwealth Games. They told him and designers Maisie Rowe, Max Heine-Gelden and Ingrid Hu, that they wanted "a decorative, bold, creative and interesting entrance", and suggested it should include "a better display of our work as a reflection of our school and students".

The client team and Thomas agreed that the reception area needed more space. Thomas began redesigning the foyer and trying to create an exterior art display so that the pupils' artwork could literally be hung on the outside of the building. The clients were enthusiastic until they went to Sheffield where *B of the Bang* was being made.

Taller than the Statue of Liberty and two-and-a-half times the height of Antony Gormley's *Angel of the North*, this massive steel starburst represents the instant at which a race starter's gun is fired. It is set to be one of the most dramatic 'welcome' sculptures in the world. The visit stunned the client team and completely changed their minds about Thomas's design proposals for their school. Now they felt his idea for an exterior art gallery was "too primary school". They now wanted a design that was unmistakably Heatherwick.

"We had produced a proposal where our work was subservient to showing their own work," said Thomas. "They looked at that and said, 'No! We commissioned you because we want something that's what you do, something different, something exciting, that is your best work!'" Thomas was delighted: "I laughed when they rejected our proposal. In design processes you need somebody else to say what you kind of know somewhere inside you; you need them to open that door for you. We sincerely believed in what we'd presented to them, but I laughed because I felt: 'fair cop; good point!' The mark of good people to work with is that everyone accepts a good idea. If it happens to be your own, great. If it

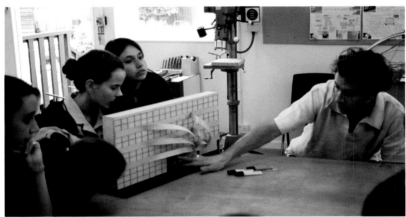

happens to be someone else's, great." The final concept includes reorganizing and expanding the reception area internally, generating more office space and creating an area to display the pupils' art. A dramatic sculpture was also created for the front of the building. "There are thousands of buildings like this one up and down the country," said Thomas. "We've just taken these dull bands of glass and concrete and peeled them off the building. We've then curved them down and pushed them all through the entrance. Now there's no confusion about where the entrance is and the whole building is like a vortex that sucks you into the school."

The idea caught everyone's imagination. "I think I learned that anything's possible in the design world," said Gaby, 15, "and it's good to work with professionals to see how it's done."

"The presentation was just amazing! The design for the front entrance was awesome. Nothing I could have imagined would have been so captivating. It's a great reflection on the creativity of the school, the high status we place on art; it's just magical."
Anne Canning, Head teacher

86

Welcome to our School!

Did *you* feel welcome entering today?

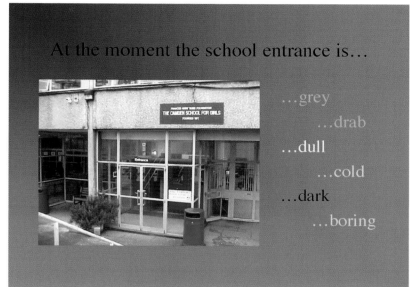

At the moment the school entrance is…

…grey
…drab
…dull
…cold
…dark
…boring

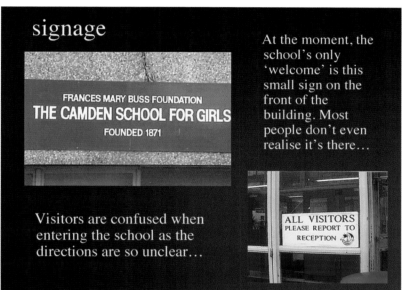

signage

FRANCES MARY BUSS FOUNDATION
THE CAMDEN SCHOOL FOR GIRLS
FOUNDED 1871

At the moment, the school's only 'welcome' is this small sign on the front of the building. Most people don't even realise it's there…

Visitors are confused when entering the school as the directions are so unclear…

ALL VISITORS PLEASE REPORT TO RECEPTION

Prison?

Not only does the school look like a prison but it feels like one - thanks to the new railings. The bikes make the entrance look shabby and altogether it is quite unwelcoming.

Seating

This is the entirety of seating in the entrance. Due to the new building work, we have close to no greenery or places to sit. What will we do in Summer?

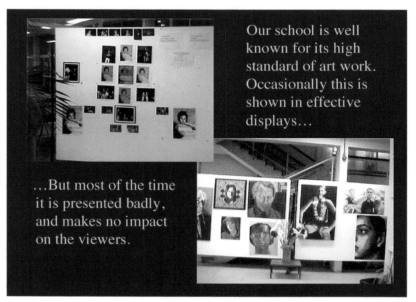

Our school is well known for its high standard of art work. Occasionally this is shown in effective displays…

…But most of the time it is presented badly, and makes no impact on the viewers.

Opposite from top: The Camden School for Girls' client team used their brief to introduce themselves to their designer; Thomas Heatherwick presenting to his client team. *This page:* Details from the Camden client team's comprehensive and demanding brief. *Overleaf:* Thomas Heatherwick's final concept.

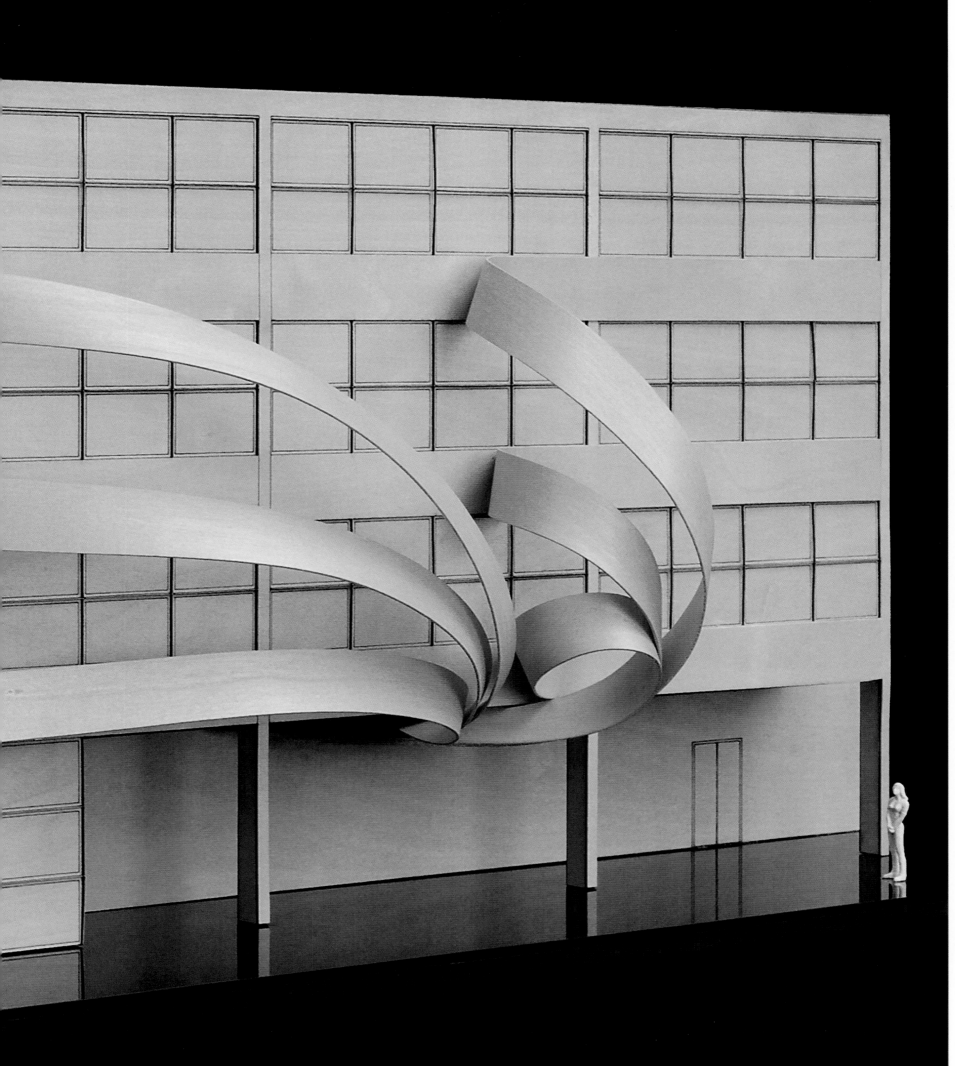

Reputation & Identity

"My school has a bad reputation, which is totally wrong, because it's actually quite a good school." Client, 12

"We want to improve the reputation of our school for ourselves and for the wider community," declared the brief from one of the joinedupdesignforschools client teams. Many pupils expressed how they were proud of their school but frustrated at how it was perceived by others. Schools, like companies, need a clear set of values and a strong sense of purpose, which everyone understands. Pupils in schools, like adults in companies, also need to feel a powerful sense of belonging. They understand that corporate reputation relies not just on visual imagery, but also on behaviour, environment and communication. The pupils that we spoke to were informed and well tuned to the nuances of identity. They knew that badges, mottoes, colours, songs and uniforms had traditionally played a part in projecting a school's image, but they sought new, up-to-date ways for their schools to be seen in the best possible light. We were impressed by the passion of the six client teams who chose identity and reputation for their focus. They were committed to helping their schools succeed and to be seen as successful.

The client team at Hugh Myddelton Primary School in Islington, North London, wanted their school to feel more welcoming. Their brief spelled out the problem: "New children and visitors get confused and lost. We have some scrappy signs. We want new ones that help pupils who speak Somali, Turkish, Spanish, Bengali, Arabic, Portuguese, Albanian, Polish, Twi, Yoruba and Urdu as well as English." They were concerned about their school symbol, a drawing of Sir Hugh Myddelton. "The picture is not very clear and doesn't look good on our sweatshirts and T-shirts. It's quite hard to see what or who it is."

We joined the school up with designer Marksteen Adamson from ArthurSteenAdamson. The client team told him that they wanted a new symbol to "show the name of our school and the person it's named after, but it should also show what our school is like". Marksteen ran workshops with his clients to investigate the history of the school and discuss what was special about it. They told him all about Sir Hugh Myddelton, who had been responsible for bringing fresh drinking water to London. Marksteen developed the idea of fresh water as the theme for the school identity: fresh water is the source of life, and the school could be seen as a sustaining fountain of knowledge.

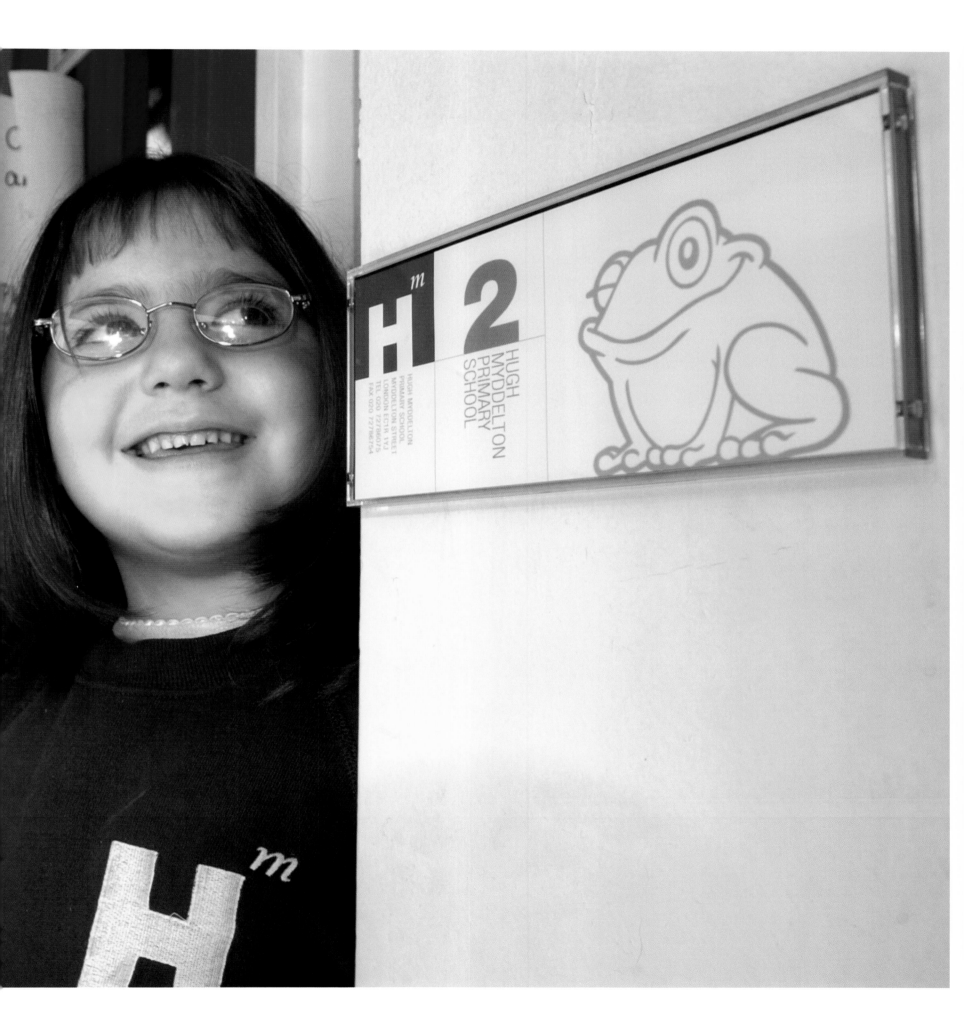

He also suggested Hugh Myddelton's initials could be used as a new symbol, H^m, like the visual form of H_20. Reflection, he suggested, should be part of the visual identity, with the school address written below the symbol to look like a reflection of the symbol above. He asked the pupils to choose images of water creatures such as ducks, dragonflies, frogs and fish, to replace class names and overcome language barriers: "We drew some animals that we liked," said Tania, 9, "We drew some frogs, and said we should have ladybirds for the infants, so *we* could keep the frogs."

Marksteen's concept was implemented in 2003. He produced a set of rubber stamps with the pictures of each class's animals on them, so they could personalize their schoolbooks. New signs, sweatshirts and stationery have been introduced and, in addition, Marksteen has designed labels for plastic water bottles, which are filled with water straight from the tap.

The Head teacher, Pam Gormally, was impressed by the impact the project had on the young client team: "It got us buzzing with ideas. It inspired creativity because the children felt there was a real purpose to their work. And they've got an audience of the whole school interested in what they are doing." The client team celebrated the project and their new knowledge about water and the history of the school by producing a special play about Hugh Myddelton, the school's founder. This was performed to an audience of the entire school, staff, governors, parents and special guests, including a representative from Thames Water.

"New children and visitors get confused and lost. We have some scrappy signs. We want new ones that help pupils who speak Somali, Turkish, Spanish, Bengali, Arabic, Portuguese, Albanian, Polish, Twi, Yoruba and Urdu as well as English." Client brief

Opposite: Designer Marksteen Adamson created a set of rubber stamps for Hugh Myddelton School, London, so the pupils could personalize their schoolbooks.
This page: The School now bottles its tap water, which comes through the water system originally put in place by their namesake and founder.

So many pupils at Fortismere School in Muswell Hill, North London, wanted to be on the joinedupdesignforschools client team that Karen Allaway, lead teacher on the project, decided to create a job application form.

Pupils were asked in particular to say what they would bring to the team if selected. The pupils selected were clear that they wanted to focus on the issue of identity. They pointed out that, although they didn't have a school uniform, they had a strong sense of pride in their school. However, the physical layout of the school, with two main buildings far apart, was a problem. "The school has two separate wings, so it's not very united," said Megan, 13.

Marksteen Adamson, then of Interbrand, was given the brief to "unite the school as a whole so that students and staff have a sense of belonging to one school". Marksteen set up a series of interactive workshops that analysed the problems at Fortismere, and showed how a common identity could join the physically disparate parts of the school together. He developed a visual identity that consisted of a series of different elements. A distinctive stencil typeface is used for the new Fortismere logotype and for other aspects of the identity. It is combined with a secondary typeface and a colour scheme that can be used throughout the school environment. As one pupil said: "The idea is that the school is the stencil, and the children and the teachers are the colours that fill it." Phrases to describe different aspects of the school, which is in Muswell Hill, were also proposed by Marksteen: 'Learn it on the Hill' for the school and, for the departments, 'PE on the Hill', 'Perform on the Hill', 'Art on the Hill', 'Science on the Hill', and so on.

Fortismere has already introduced new stationery, signage and other aspects of the new identity. This has been managed by Karen Allaway in the recently created post of Corporate Identity Manager. Originally the lead teacher on the joinedupdesignforschools project, Karen has since been promoted to Assistant Head. "It would not have been so successful without the Head's support and belief in the team. It is now in the school plan! And represented at senior management level, would you believe it? The Head has often talked about it to staff and governors, and is proud of the fact that we consult our students in the process of making this an even better school. It was he who insisted that there was a steering group set up, consisting of pupils and teachers from different departments to move it forward."

"The pupils contributed and so feel a part of the new identity," said school governor John Abrahams. "The work advertises our professionalism to the community."

fortismere

school of technology

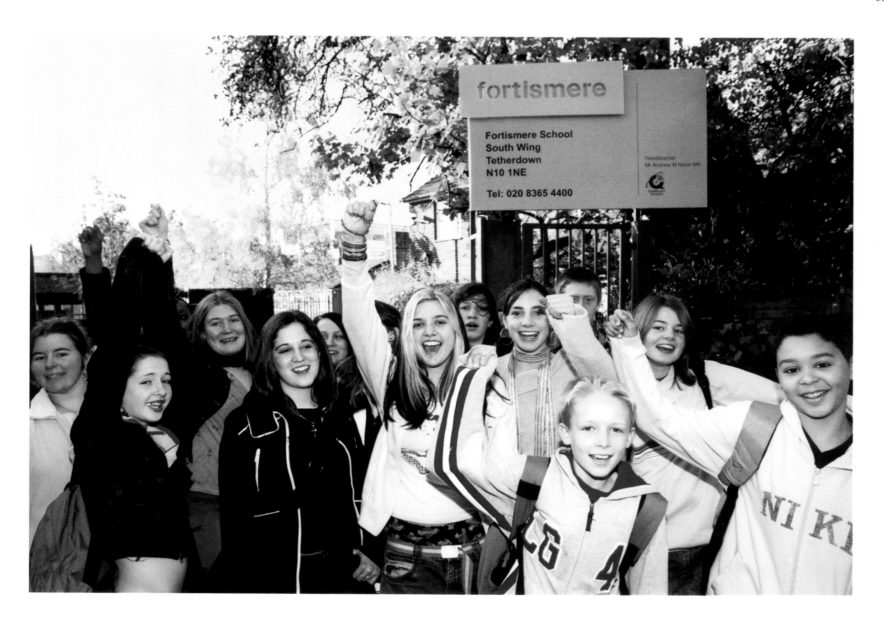

"The involvement of young people in the development of their own institutions by working with leading external companies is a very healthy model, which has been borne out by our wholly positive experience." Andrew Nixon, Head teacher

Opposite from top: Concept for a specially made stencil for Fortismere's new identity; the new descriptive phrase; concept for a school stationery set. *This page from top:* The new school logotype; the client team celebrating the new signs installed throughout the school; concept for a welcome pack.

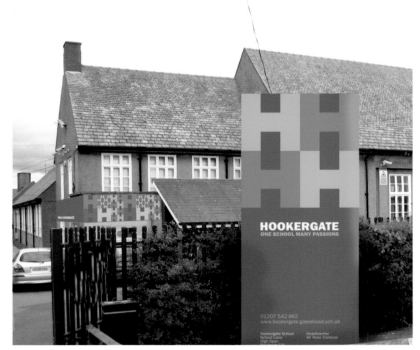

"When I'm asked what school I go to, I'm embarrassed. People have said: 'Our mum has told us not to mix with kids from Hookergate,'" said one pupil at Hookergate Comprehensive School near Gateshead. "We're allowed to walk into the village shop to buy Pot Noodles, but the shopkeepers don't like it. We're not welcome."

The Hookergate client team's brief set out to attack these issues head on. "We want to improve the reputation of our school, for ourselves and for the wider community," it declared. "We want to celebrate what's good about our school."

We joined the team with Elmwood Design. At their first meeting with designers Graham Sturzaker and Jayne Workman, the client team was given disposable cameras and asked to record what they thought was good about their school. Two weeks later they met for a workshop. The designers had produced boards covered with all the photos; images of great computer facilities, of artwork in their first-class arts department; wonderful views across the lush countryside; newspaper cuttings of past pupils who had become famous; and lots of pictures of the current pupils and their friends. Graham explained how reputations can become damaged, and how they could then be repaired by creating positive, instead of negative,

perceptions. The team and their designers visited Baltic, the centre for contemporary art, and the new Marks & Spencer in Gateshead, to help the discussion, especially about innovative use of colour and signage. Elmwood's concept presented the idea of 'Hookergate: One School, Many Passions', which represent the subjects taught at Hookergate. For sports there is the phrase: 'A Passion for Sport'; for arts there is 'A Passion for Art', and so on. The school logotype became the letter 'H', made into a pattern of smaller 'H's to represent the different passions and people at Hookergate.

"I want to be proud of this school instead of thinking that nobody likes it," said Matthew, 15. Joanna, 15, agreed: "It was great seeing the design and thinking about the impact it will have on the school. It will help the community see how the school is improving."

Teacher Zoe Grey was equally impressed: "I think the outcome is amazing. I could feel the adrenalin going through my body as I watched the final presentation. You could see how it would make the changes we need. I could hear the staff saying the same sort of things. The concept is so simple. Because it's simple, it will work. Hookergate will become something different. It's going to be so effective. I'm so excited!"

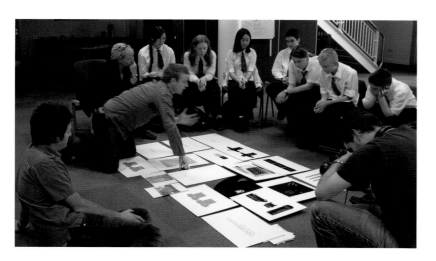

"This school has a bad reputation," said Dean, 12, a member of the client team at Kingsmeadow Community Comprehensive in Dunston, Gateshead. "Everyone thinks it's the place where everyone goes if they're not accepted at Emmanuel." We joined the twelve- to sixteen-year-old client team with branding agency SPY Design, whom they briefed to "make us and the community feel better about our school". They wanted to present their school as an "inspiring, forward-thinking place to learn".

A visit to the South Bank complex in London was carefully planned, and Ben Duckett and Simon Clark of SPY produced a booklet for their clients to provoke a discussion about the branding of each landmark they would visit: the British Airways London Eye, the Royal Festival Hall, the National Film Theatre, Tate Modern and the Design Museum. At Tate Modern they were introduced to Jane Wentworth, who had worked on rebranding the gallery. The visit helped to clarify ideas about icons, symbols and logotypes, and the team quickly grasped complex concepts about identity. Before long, they were discussing the problems with some of the brands; their failure to communicate. This thinking led directly to a discussion about the character of Kingsmeadow School. They agreed the image they wanted should represent the school as "dynamic, contemporary, new and cool".

SPY developed a design proposal, including a chevron symbol, suggesting movement, direction, energy and intelligence: "SPY's design was everything we wanted. It's got double meaning; the flying chevrons also look like 3D squares," said Lauren, 14. "It was a really interesting design; it made the school look very modern and business-like." SPY and their clients brainstormed ideas for a phrase to use as part of the scheme, and the words 'Inspiring Minds' were chosen. This works on three levels: first to communicate that the school's mission is to inspire its pupils; secondly that the pupils can inspire the community; and thirdly that Kingsmeadow is the place to find people who have been inspired.

"It was a wild moment when I saw the presentation," said Head teacher Simon Taylor. "I stood back, gasped and took a deep breath. I thought this was quite exceptional and inspiring. Quite a 'wow' moment. I'm very, very proud of the client team. The way they presented themselves was a credit to themselves and the school. When they unveiled Inspiring Minds, everything clicked into place."

Opposite: Elmwood's concept for a new identity for Hookergate, near Gateshead. *This page:* Kingsmeadow's new identity; Ben Duckett presenting concepts to the clients.

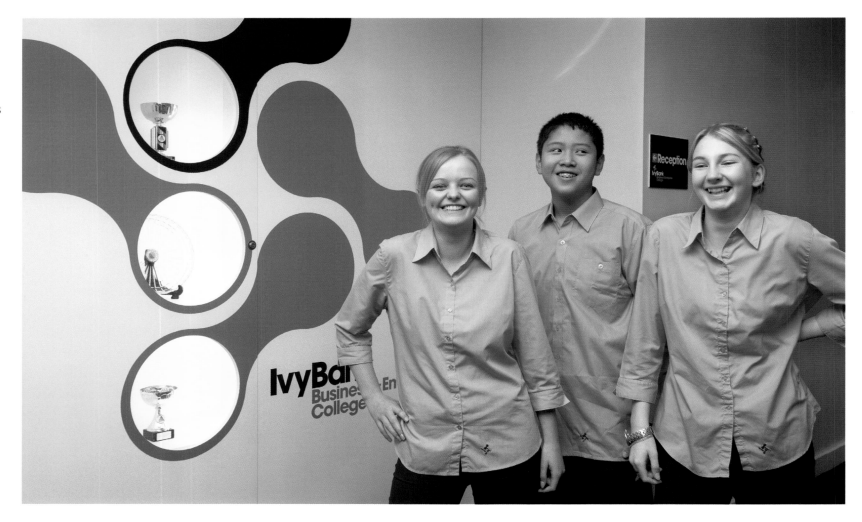

At Ivy Bank Business & Enterprise College in Burnley, designers Kevin Gill and Ric Mather from JudgeGill, worked for their client team to create a new identity and a business-like retail training centre. There are three other schools in the area with similar uniforms, and the client team wanted to make their new identity stand out. They surveyed the school and chose a corporate blue for their colour palette, briefing the designers to create a school badge design that was simple enough to be embroidered on to their new uniform.

In their final concept JudgeGill proposed a simple interlocking logo. The dark blue element represents Ivy Bank, and the light blue the surrounding countryside. The new identity was implemented in 2004. "This has really lifted the school," said Michael, 15. "We've got a new identity and a business centre now, a centre for the community."

Teacher Gill Broom remarked on how proud the pupils were to make such a powerful mark on the school, and how unifying the new identity had been: "It has had an impact on behaviour in the school; there's far less confrontation in the corridors."

"This has really lifted the school. We've got a new identity and a business centre, a centre for the community." Client, 15

Above: Pupils at Ivy Bank, Burnley, with their new identity. Opposite and following spread: Wolff Olins's concept for a new identity for Abbeydale Grange School, Sheffield.

"My school has a bad reputation, which is totally wrong because it's actually quite a good school," said a pupil at Abbeydale Grange School in Sheffield. We joined up Abbeydale Grange with Ned Campbell and Charlotte Hopkinson from Wolff Olins who told us: "The thirteen-to fourteen-year-old client team was very good at being clear about what was important to them, and the issues that were most important to them were about the environment, the interior of their school and the uniform. One of the big problems was to get them to realize that to make change, it was incumbent upon them to change their own behaviour."

The pupils made it clear in their brief that they felt they had been "unfairly labelled by other schools and some people in the community", and really wanted to improve their reputation. This wasn't their only problem. There are forty-six languages spoken at Abbeydale by over fifty different nationalities. The client team wanted to find a way to bring the whole school together whilst repairing their reputation. Ned and Charlotte invited the client team to the Wolff Olins headquarters in London, where they held a lively role-play workshop to explore identity issues in the school. Some pupils played reporters, asking other pupils, who took the roles of teachers and parents, why they would recommend Abbeydale Grange as a good school. The session was structured to help them identify the positive aspects of their school.

They visited Tate Modern, where they saw Wolff Olins's work for Tate's identity. The students were amazed at how the old power station had been transformed into something ultra-modern, and started to believe they really could change Abbeydale Grange's reputation and present a new image to the community.

Wolff Olins's concept focuses on the school working to support the local community, with projects such as 'Brighter Sheffield', a campaign to clean up local parks, led by pupils from Abbeydale Grange. This idea was projected through the theme 'you, me, us, we, together', to bring a sense of inclusiveness to everyone in the school, and set the school in a community context.

The concept includes extending this to a new school identity, incorporating new graphics on school signs, stationery and a CD-ROM for parents of prospective new pupils. As one member of the client team said: "The best thing about this project is that it could change the school into a better place."

together

Sixth-Form Spaces

*"We want it to be cool, calm, with lots of spaces to
relax and get inspiration to work." Client team brief*

"The existing sixth-form common room is a box-like space with clusters of disaffected-looking teenagers sitting around the periphery of a rather sad-looking table football," said architect Piers Smerin. "It is all rather miserable and déjà vu – it hasn't changed much in the last thirty years. It doesn't do anything for the atmosphere of the sixth form as a place to work or relax."

Piers, Nick Eldridge and Sophie Ungerer from Eldridge Smerin were considering the brief they had received from the client team at Heart of England School in Coventry. Pupils across the UK may recognize this description, and agree that a more inspiring study and social space would offer a bigger incentive to stay on at school after Year Ten. Schools now compete for sixth-form pupils, and those that offer attractive facilities are likely to have an advantage over schools with similar academic records. Pupils we spoke to considered the final year at school to be the time when they needed the best possible facilities. And those facilities, they argued, should reflect their age and tastes and anticipate a more independent status. With exam pressures at their peak, they needed common-room spaces to be inspiring, social and suitable for study. They also felt that an attractive common room would act as a real incentive to stay in school during the day, rather than "bunking off into town".

At Heart of England School, a high-performing school with a good reputation, the client team wanted "a flexible sixth form space attractive to new pupils". They wanted a space that helped them deal with academic pressures by developing new ways of working and learning.

The client team presented a brief that proposed breaking up their existing upstairs room into quiet study areas. They discussed study methods and the need for silence when working, but concluded that the background noise of people chatting, working together and listening to music was most conducive to study. "They didn't want the sterile quiet of a library or the isolation of their bedrooms," said Piers, "or a space like their IT laboratory, which is a kind of school-controlled place. They wanted to work in a relaxed way. They also wanted their own place to eat their lunch, away from the younger pupils."

As they brainstormed with their architects, their vision expanded and their ambitions outgrew the original space, so the client team approached the Head teacher and asked if they could expand into the old technical drawing room on the floor below and access the garden outside.

The final concept from Eldridge Smerin includes an ingenious structure for uniting the two rooms and transforming the 1960s architecture. A bright orange porch, marking out 'The Sixth' as a special place, surrounds the main door, opening on to a blue band which folds into a series of blue study booths before flowing "like a ribbon" up the wide stairs to the first floor. The stair design was inspired by pictures of European students using the steps of railway stations as a social hub. It allows people to sit on them to chat and read, while others walk up and down.

Adjacent to these stairs, the blue ribbon loops into a series of low tables and benches, and emerges in a sheltered seating area in the garden. Upstairs, it develops to provide more study booths before forming a first-floor balcony. The concept also includes a set of stairs rising to a glass crow's-nest that allows the students to sit at roof level and look out across the grounds while working or chatting.

"The project has had a big influence on me," said Chris, 17. "I'm now thinking of doing design or industrial design."

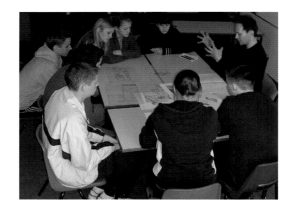

Before

After

"I think the idea of treating pupils properly as equals, treating them as real clients, is very valid."
Piers Smerin, designer

Opposite: Piers Smerin in conversation with his client team at Heart of England School, Coventry. *Above:* Before and after – proposed development for the sixth-form building. *Overleaf:* Design for the sixth-form space, showing study booths, the split staircase and innovative seating.

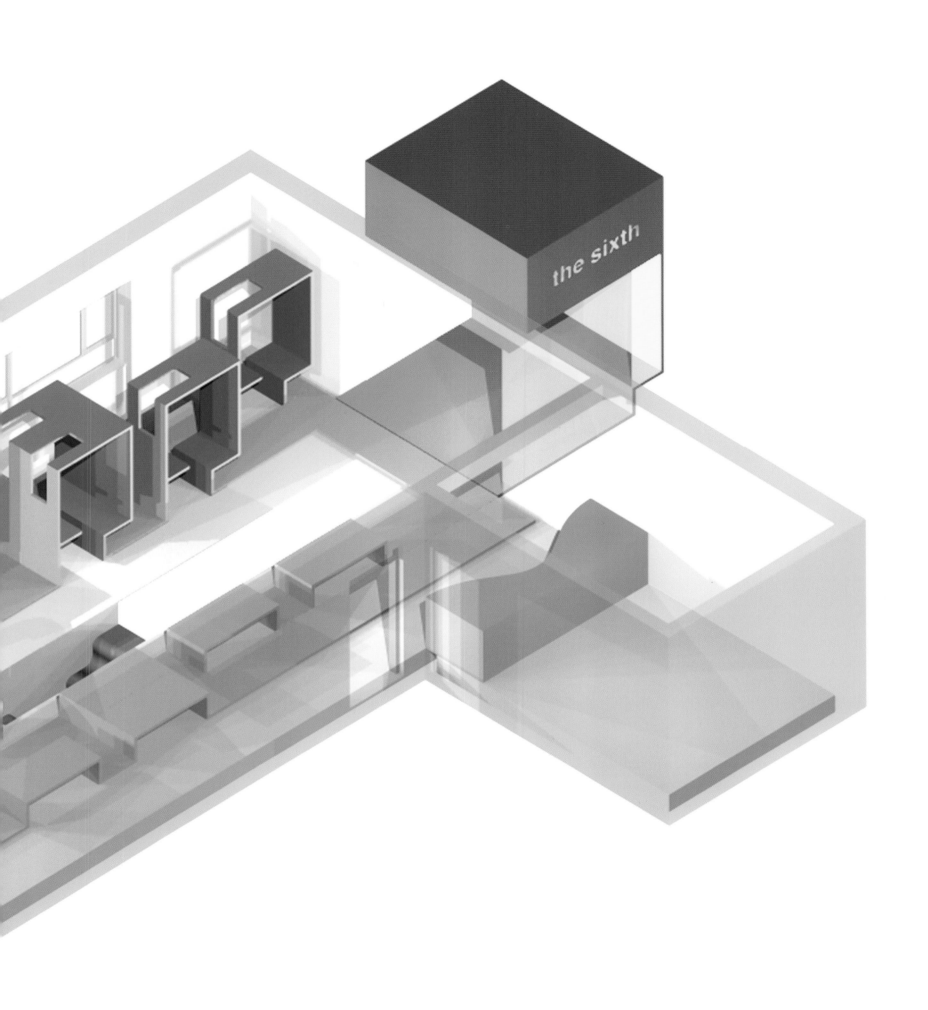

the sixth

Another highly innovative solution to sixth-form space was conceived for Hartcliffe Engineering Community College in Bristol, where the fourteen- to sixteen-year-old clients worked with Adrian Fowler of Alsop Architects. The brief identified that the team wanted "a social and study centre for pupils in their final year". They had in mind pupils preparing for GCSEs, but acknowledged the principles of their brief and the final design also applied to students doing A-levels. They wanted a personalized learning environment where they could study and also escape from the pressure of exams, a place that would be inspiring and relaxing, where they could recharge.

Adrian took them to see a number of Alsop buildings, including the award-winning Peckham Library in south-east London, which they described as "amazing". The visit to London included a flight on the British Airways London Eye, and lifted their aspirations. They decided they wanted a design statement that would help Hartcliffe stand out as a beacon on the edge of what is a notorious estate in an area of significant social deprivation. "I didn't appreciate it before," said Adrian, "but they clearly needed somewhere to go after a lesson or after school, or even before school; somewhere they could read their books, study and relax, or even get away from home. They wanted a space within a space."

As the conversation developed, their ambitions and their abilities to contribute grew as well. Alicia, 15, found that working with a professional architect changed the way she thought: "I'm more open-minded now, whereas before I was one of these people who thought buildings and technology weren't interesting. Now I have a different view, and I can visualize things much better."

Adrian found the client team very creative: "They generated new ideas themselves and surveyed fellow pupils to get more ideas. It was interesting to watch the new ideas evolve and to witness the building take a form none of us had expected."

The concept is a stand-alone structure centred around a large, central, soundproofed atrium, to act as a room for study and, in the evenings, a space for parties. It features a vast media wall on to which the clients want to project film, video and artwork. This core is mounted by a strikingly shaped facilities capsule incorporating toilets, lockers, vending machines and student artwork. At the opposite end is a block for lifts and stairs. Yellow-painted ramps lead up to a roof garden and on to balconies at all levels, with areas to sit and look at the view. The most dramatic idea is the transparent, exterior curtain that pulls back in summer to let in the cooling breezes, but closes in winter to ensure warmth on the exterior balconies and roof garden.

On the school side of the building the client team elected to construct a hydroponic wall, so that fruit and flowers could grow in special containers from the bottom of the building to the top. The building is packed with novel ideas, including massive doors that open into the central core.

"This is a fantastic piece of architecture," said Head teacher Malcolm Brown. "The school and community would benefit enormously from such a level of provision. This whole project is about saying to our young people: 'We value you.' It's important to show young people that you value them, and one way of doing that is to make their environment an attractive, stimulating place."

Alicia, 15, felt that if it was built, it would be a proud moment for her. "To be honest, it won't make me feel different about my school, but if I stand in that building I will feel better about myself, knowing that I've had some impact on the final outcome. I know that it would make life better for the students who use it. I think it would make a big difference." Joe, 15, agreed: "It's quite extravagant. All our buildings are concrete blocks, but this is very good; completely different."

Above from top: The client team from Hartcliffe, Bristol, visit Peckham Library, which was designed by Will Alsop; Adrian Fowler with his client team. *Opposite:* The transparent exterior curtain. *Overleaf:* The final concept includes a roof garden, balconies and ramped walkways.

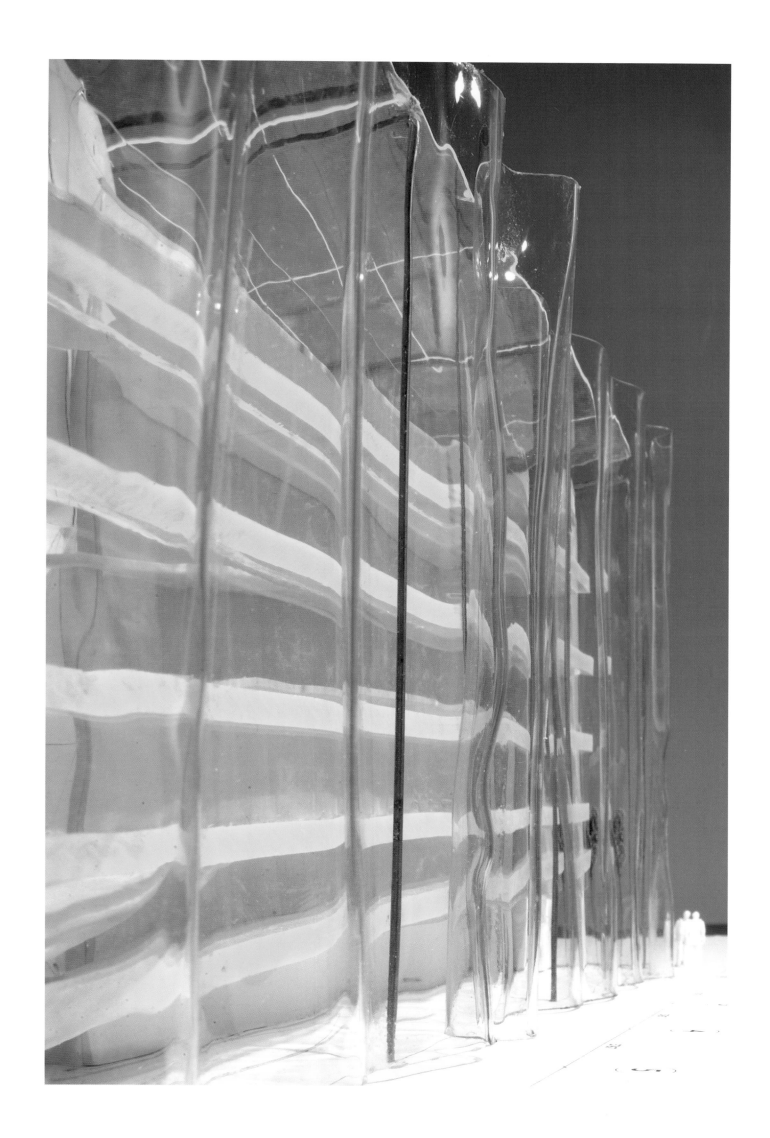

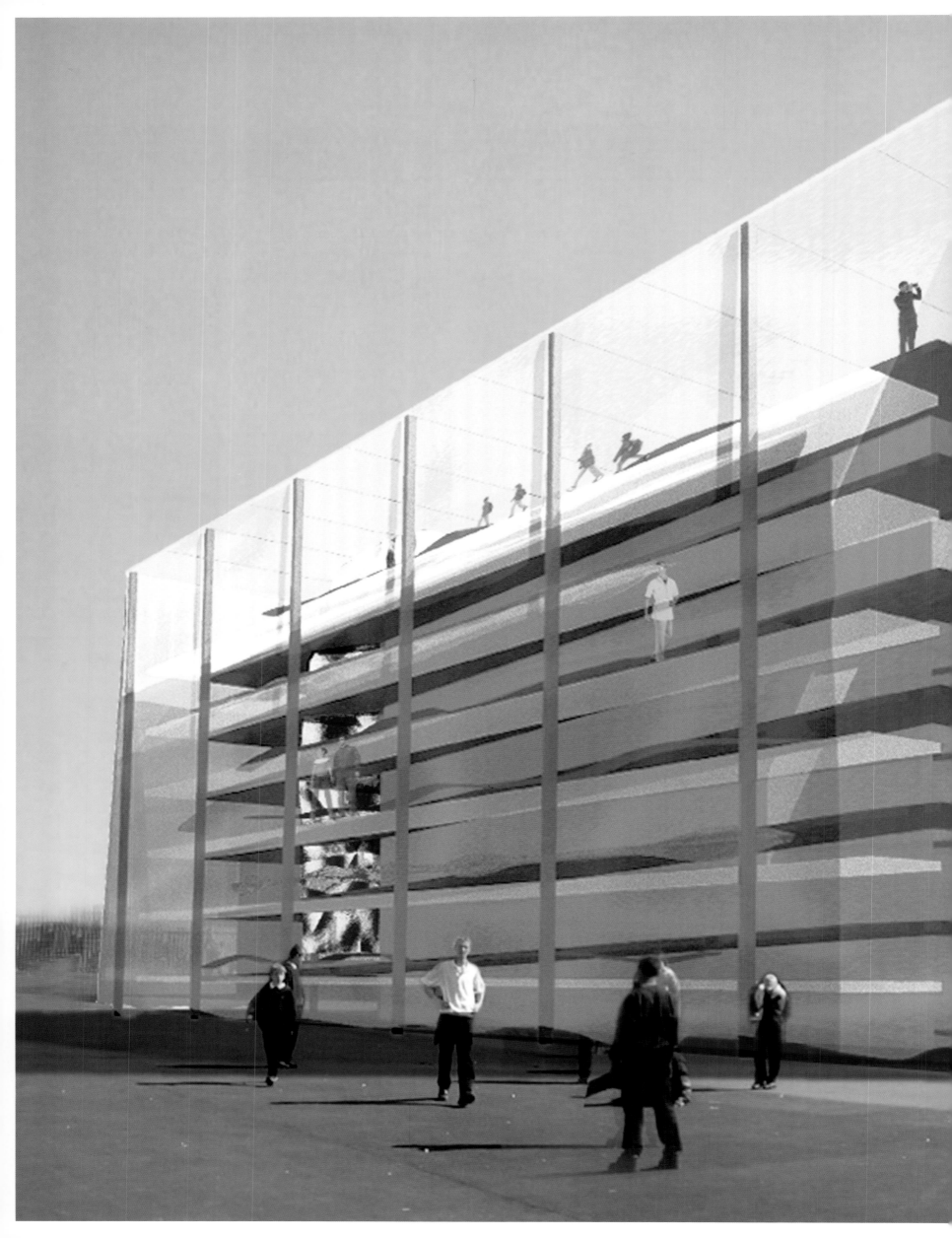

Social Spaces

When it came to deciding what they really wanted the designers to change in their school, social spaces was the pupils' most popular common issue, making it the longest chapter in this section. The pupils really wanted to improve their break times with places where they could "chill and chat".

Schools have very few dedicated indoor spaces for break and lunch times, and frequently have undeveloped playgrounds. Pupils told us they need space to relax away from the pressure of the classrooms; somewhere with shelter from the weather, somewhere to sit down. They want a place in which they feel secure, but that also feels more like their own space than the teachers'. At the very least they want shelter and seating during their break time; they feel their playgrounds are too exposed, too open to the elements and too drab. Where pupils do not have dedicated spaces they create them, in places not designed to be social spaces, such as under the stairs, in the toilets or in the corridors. And, having made them, tension can arise from the desire to keep others out of their space.

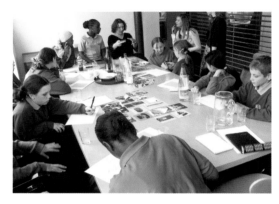

Thomas Tallis and Kidbrooke, neighbouring schools in a challenging area of south-east London, have merged to form A2 Arts College. Pupils from both schools joined together to create one client team. The pupils asked architects Fletcher Priest "to create a common space in which the two schools can meet and work together". They wanted to have a versatile community arts space that was safe and engaging for everyone. The combined client team quickly identified the need for a neutral space that didn't belong to either school, but at which pupils from both schools could feel safe and relaxed. Greenwich Local Authority offered an empty building not far from both schools. The client team visited the site and created a brief that asked for a space full of light and curves that felt welcoming. But they were not hopeful. "The space was rubbish," said Bimpe, 13, from Thomas Tallis. "It was dark, and smelled funny." Fletcher Priest architects Ruth Lonsdale and Anne Rumestch found it hard going at first: "The two groups took some time to mesh," said Ruth.

The architects took the client team on a trip to Tower 42 in London (formerly the NatWest Tower), where they showed them how they had converted an unused space into an attractive bar with a unique view over London. The visit helped bring the pupils together, and they became more positive as they grew in confidence. They revised their original brief when they realized that too many curved surfaces would limit their use of the space for mounting exhibitions and storage.

Fletcher Priest's final concept transforms the former retail unit into a flexible arts space for making, displaying and performing arts projects. The designers created large screens that could be used for storage, furniture and to display artwork. At the rear is a café area and computer terminals. Tara Lucas, teacher at Kidbrooke, thought it was excellent for both sets of students to come together on such a project. "A lot of them have been fairly blown away by it. It's a unique and very positive experience and I for one feel privileged to have been a part of it."

"I think it will make the school better. You'll have somewhere else to go, instead of hanging round on the streets. People do bad things on the streets. But now we'll have somewhere we can go and socialize." Client, 13

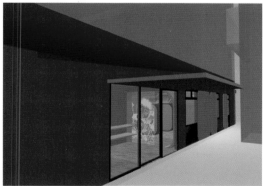

Opposite: The former retail unit near Thomas Tallis and Kidbrooke Schools; the client team discuss materials at Fletcher Priest's London offices. *Above:* Concept for the A2 Arts College, showing the flexibility of the space, including movable screens that can double as storage units and furniture.

Pupils from Cape Cornwall Comprehensive in St Just, Penzance, wanted a social space for younger pupils from Years Seven and Eight (aged 12 to 14) who weren't allowed into town during break time. They also wanted the space to be protected from the dramatic weather rolling in off the Atlantic. We joined the client team with architect Phin Manasseh, who was briefed to develop a neglected courtyard between the classrooms. "The problem is that it is horrible," said Belle, 12. "Whenever you look out on it, you don't feel that it's nice and that you want to go out there." The brief, which incorporated ideas from a whole school survey, asked for a sculpture gallery, shelter, seating and a water feature, which pupils could relax in or look at from the surrounding classrooms. Most importantly they wanted a "peaceful place", where the younger pupils could eat their lunch surrounded by "murals made by both pupils and local artists". Phin Manasseh commented: "They thought the courtyard was incredibly grey and dull. They wanted masses of things, but the most important thing was shelter. But they didn't want to block out the sun."

To explore ideas of how art can be displayed, Phin took them to the Barbara Hepworth Museum and Sculpture Garden, Tate St Ives and Falmouth College of Arts. His concept includes canopies that cast a pink light across the area and offer protection from rain and sun. Or as Jeremy, 13, put it in his newly acquired vocabulary: "The translucent polycarbonate UV resistant canopies will prevent sunburn." The team affectionately dubbed the canopies "sunglasses". Under their cover Phin created benches, planters and a water feature: "Water is organized to move in shallow trays over river-washed pebbles to run through the courtyard and roll out into the grounds," said Phin. "It is quite an animated scheme." He also created a 12-metre (39 ft) chaise longue, undulating in a series of mini hills and covered in natural turf.

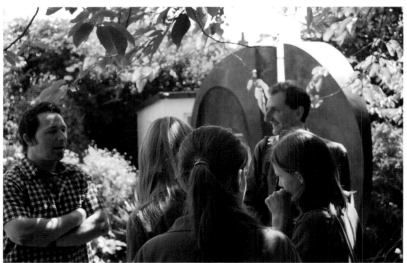

Head teacher Robin Kneebone admitted to an early scepticism that gradually changed into support: "I was startled at first. It's not the sort of thing you see in St Just or, indeed, in any school. My first reaction to the whole project was one of great surprise. The more I thought about it, the more I saw their enthusiasm for this colourful modernization of a grey, tired building." Jeremy learned "that it's hard to do this sort of thing. I feel proud of this. It's something new for the school. We've never had anything like this before. I like the way it's turned out." One of the parents said, after watching the client team present the ideas: "It's more than I could have imagined. I think it's amazing. I think it will enhance the school massively, and perk up the children's spirits."

Above: The existing courtyard at Cape Cornwall, St Just; the client team visit the Barbara Hepworth Museum and Sculpture Garden in St Ives; the client team presenting the final concept to teachers, governors and parents. *Opposite:* Model; side elevation and plan featuring the "sunglasses"; the undulating grass bench and the water feature.

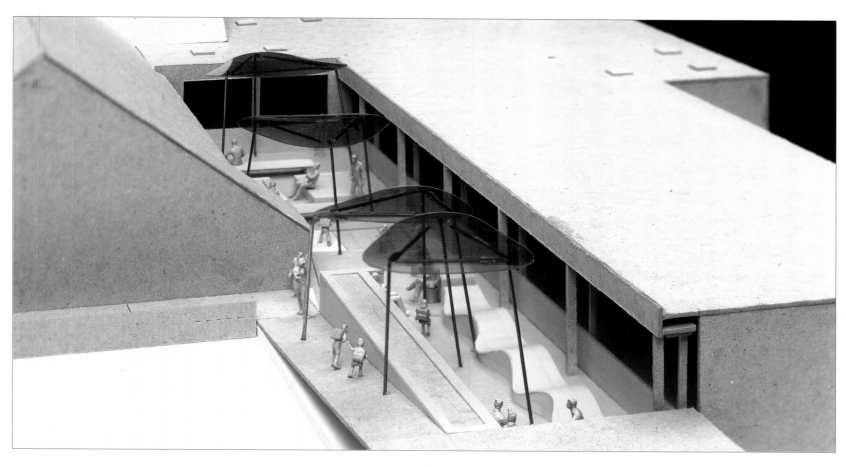

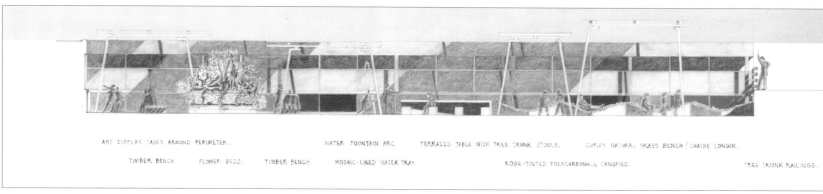

ART DISPLAY CASES AROUND PERIMETER. WATER FOUNTAIN ARC. TERRAZZO TABLE WITH TREE TRUNK STOOLS. CURVY NATURAL GRASS BENCH /CHAISE LONGUE.

TIMBER BENCH. FLOWER BEDS. TIMBER BENCH. MOSAIC-LINED WATER TRAY. ROSE-TINTED POLYCARBONATE CANOPIES. TREE TRUNK RAILINGS.

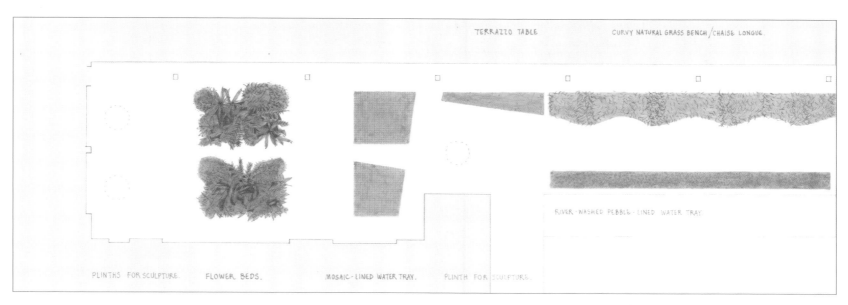

TERRAZZO TABLE CURVY NATURAL GRASS BENCH /CHAISE LONGUE.

RIVER-WASHED PEBBLE-LINED WATER TRAY.

PLINTHS FOR SCULPTURE. FLOWER BEDS. MOSAIC-LINED WATER TRAY. PLINTH FOR SCULPTURE.

"If this was completed and I was walking through this space, I would feel really happy that I'd actually had a part in making and designing this actual garden." Client, 12

The brief from pupils at Lode Heath School in Solihull asked for a project on their quad: "The vast majority of students don't like the quad, possibly because they are banned from it." The twelve- to fifteen-year-old client team wanted to convert the grass area into a contemplative space. There was nowhere else "big enough for large assembly or performance". They wanted seating, shelter, refreshments, music, lighting, plants and somewhere to display art: ninety-five per cent of pupils thought a water feature would be "great". But most importantly they wanted quiet, the brief stating: "We were prompted by the word 'tranquillity' in our brainstorming session. It came from the school's lack of facilities in break time, when we felt the school was crowded but did not offer a peaceful space for those that don't want to play football or go to the few lunch-time activities on offer."

We joined the client team with Future Systems, who took the pupils to their London offices and the new Lord's Cricket Ground Media Centre, which they had designed. Architect Amanda Levete believes the trip had a dramatic effect: "We opened their eyes to new possibilities, and we showed them how to think laterally. They didn't lose their pragmatism. For example, they raised the problem of how we were going to get a digger into the quad."

Future Systems' concept proposes digging up the quad's grass and creating a sunken amphitheatre, with semi-circular tiered grass banks looking down on a stage of pink AstroTurf, with trees providing a tranquil backdrop. The client team insisted they wanted to include water in the scheme, so the new space has a sprinkler system that sends high jets of water across the area during lesson time in hot weather, creating a water feature that can be viewed from the classroom.

"It's been tremendous for the client team," said lead teacher Tom Brosnahan. " A real eye-opener. They're only 12 and 13, but it didn't fly over their heads. They were enthused from the beginning. All the inspiration will stay with them for ever."

"I learned the way that the smallest thing can matter in a large design, even though you might not think it's important."
Client, 12

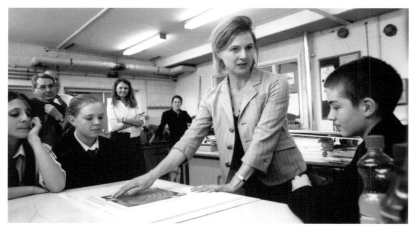

Above from top: The existing 'quad' at Lode Heath, Solihull; the client team carrying out research; Amanda Levete in conversation with her clients; Amanda presenting her final concept. *Opposite:* The final concept shows the quad transformed into a sunken amphitheatre, stage and relaxation area with a sprinkler system.

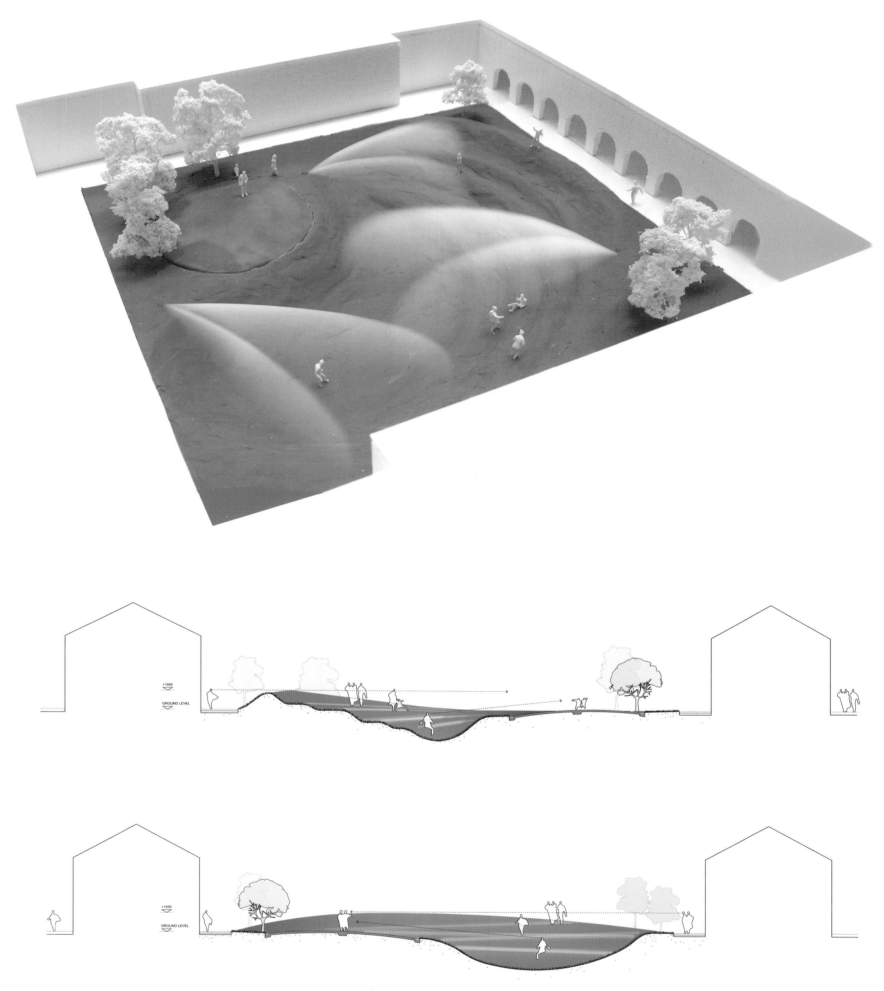

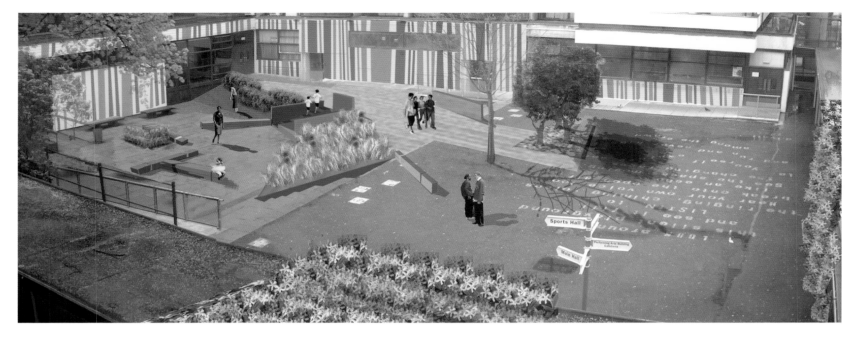

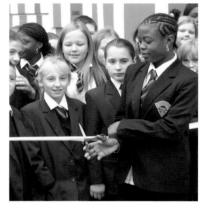
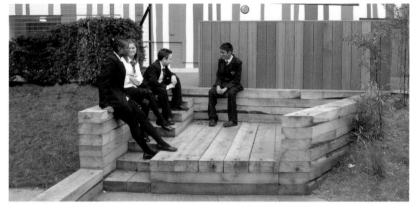

The problem with our space is that there is too much concrete, which makes it dangerous," said Chris, 13, a client at Islington Green School in North London. "There are a load of steps and there are too many benches that are awkward to get round. It is dull, boring and uninviting." The pupils at Islington Green wanted to develop a busy thoroughfare "to improve morale in the school by creating an outdoor social space". We joined them with Julian Lewis, Judith Lösing and Grant Shepard of East Architects, and landscape gardener Anne MacCaig of The Nature Room. The designers took the team on a visit to Laban, the centre for contemporary dance, in Deptford, south-east London, to show them the landscape. They also visited Culpepper Community Garden in Islington, near their school, which many had not seen before. "Plants can affect your behaviour," said Anne. A team member said: "I feel so peaceful in this garden."

Anne proposed a variety of robust plants that would flower during term time. "There's no point in flowers that come out in late July or August – the pupils aren't there!" she said. East designed a bridge made from decking that spanned the dangerous steps and made it safer and easier to cross from one side of the courtyard to the other.

East's concept includes a wooden parapet on the bridge that links to a wooden seating area via narrow steps. Railway sleepers provide seating, and the exterior classroom walls are painted with green and brown tree trunks. "We've created a number of 'rooms' that have a different feel to them," says Anne. "So, if you're feeling like a quiet chat, you go and sit in an area that is conducive to that; if you're feeling more lively, you can go somewhere else. The planting is designed to complement that." The plants are selected for spring and autumn foliage and year-round colour, so that pupils can see the changing seasons from their classroom windows.

Head teacher Trevor-Averre Beeson granted permission for the scheme to go ahead at the end of the summer term 2004. The project was implemented by the following September. Trevor said: "It's good that the pupils' voice has been listened to. Their ideas have been taken on board and therefore they will see it as being something much more theirs."

"When we came back from the holidays, I was amazed when I saw all this, and all our names painted on the wall: we are very proud of it." Client, 15

The City School in Sheffield is a thriving school in a socially challenged area. Built largely of concrete during the 1960s, it too boasts an unloved, drab courtyard. The client team, aged 12 to 15, wanted to introduce colour, shelter and seating; three of the most common requests by pupils asking for outdoor social spaces.

We joined them with Brian Vermeulen, Simon Tucker and Franz Brunnert from Cottrell & Vermeulen Architects, who have experience in designing unique, modern schools. They went with the client team to the riverside developments and the South Bank and Bankside areas in London, where they looked at innovative structures and spaces, including the courtyard at Somerset House, the National Theatre lobby area, Tate Modern, and City Hall near Tower Bridge. The visit was followed by a model-making workshop led by the designers, aimed at helping the pupils understand the existing space and enabling them to suggest possibilities for its transformation. This was a key moment, said Simon: "The workshop helped the pupils explore and articulate what they wanted: a covered garden with a range of features, including planting and hard surfaces."

The final concept includes a colourful canopy of translucent polycarbonate panels, which lift the grey space beneath. Some of the panels can be used for solar power; others for rainwater collection. Spaces between the panels allow in fresh air and rainwater for the plants and trees below. The contoured landscape design creates a safe space to sit, eat and relax. It incorporates a wide range of textures and bright colours, made from recycled products, and hardy planting, to provide informal social areas at the heart of the school. Seating is offered in the form of long, curved benches and an amphitheatre area. The architects also propose extensive planting and a water cascade.

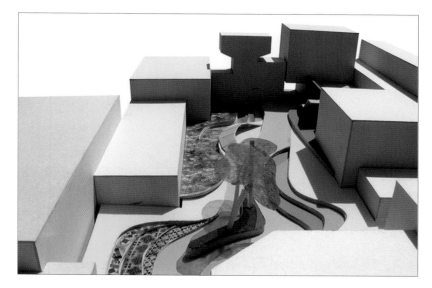

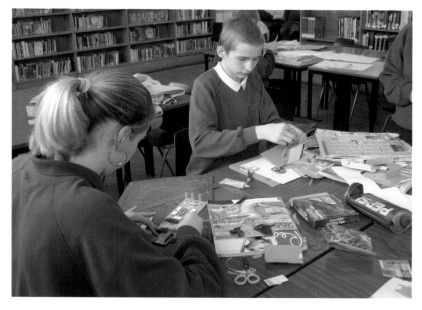

Opposite, anti-clockwise from top: Concept for the new outdoor social area at Islington Green, London; building work in progress; the opening ceremony; the client team enjoying their new space. *Above from top:* Existing courtyard at The City School, Sheffield; model of final design; workshops in progress; the client team at City Hall in London; lunch at Tate Modern.

heads in the clouds.

At The Ramsgate School in Kent, designers Dinah Casson and George Zigrand from Casson Mann generated concepts for a social space for a group of special young teenage girls known as The Sisters, who needed a place to learn and feel secure (see p. 41). The designers created a series of rooms in their refuge, which they called the Power House, full of imagination and colour.

The concept proposes a flexible room for performance, quiet relaxation and social gatherings. One particular idea, called 'Heads in the Clouds', is a suspended egg-shaped room into which you put your head; this fantasy environment is illuminated and decorated with clouds and skyscapes. Heads in the Clouds is a social space where you can chat without using body language. "You'd put your head into it and you'd feel like you were in a different world."

Teacher Annie Hamlaoui was impressed: "The girls have learned a new set of skills. They now go round the school complaining about colours that don't work, and noises that are distracting."

The client team were so engaged with the process that one Sister declared the joinedupdesignforschools project was the main reason she came to school.

"Before I met the girls I was worried we wouldn't understand each other. I was wrong. They astonished us with their ideas; they kicked off the ideas for this project." George Zigrand, designer

At Bishopsgarth School on Tyneside they have plenty of outside space, but it is bleak and dull. The client team, made up of a broad selection of pupils aged between 11 and 15 years, wanted to improve the appearance and atmosphere of the school grounds, taking into account pupils and visitors with mobility difficulties. "There is nowhere for pupils to sit outside at break and lunch times," said Steven, 13. "Some pupils play football, but the remainder end up walking around chatting and waiting for the bell to go." Chris, 12, was concerned with aesthetics: "The back of the school doesn't look good. There is a lot of litter, not much variety in colour and lots of mud."

In their brief the client team warned designers: "It is important that the materials used are robust and not easily damaged." The client team also conducted a survey, which showed that seats and litter bins were top priority, and that pupils wanted planting areas, picnic tables, artwork, bird feeders and bird boxes.

We joined the school with Les Baker and Scott Farlow of Reckless Orchard, with whom they analysed how the space was used by the pupils. They drew diagrams, took photos and recorded observations. "This was a fantastic opportunity for us to look at a real landscape with real issues, and work with the user group of that landscape to create something exciting and responsive," said Scott. "It was inspiring to work with a group of young people who were engaging, interactive, enthusiastic and full of fantastic ideas of their own." The designers took the client team to the Earth Centre in Doncaster, where they were able to think about planting, materials, seating, ecology and the kind of atmosphere they'd like to create. "The visits put loads of ideas into my head," said Steven.

The final concept is a dramatic eco-friendly representation of a river valley, complete with contoured hills, extensive planting and a shimmering 'sky river' of stainless steel that meanders (in three dimensions) through the space. The steel pays homage to the industrial history of the area. Beneath the steel river, on the ground, is a ribbon of blue paving, providing ramps for disabled access. The contours offer multiple opportunities for socializing. The design has gone down well with the client team: "I liked the raised seating for all the people," said Chris. "I liked the idea of having the steel river; it's a piece of artwork."

Above: Concept drawing for 'Heads in the Clouds' at The Ramsgate School, Kent. *Opposite:* Model of new outdoor space for Bishopsgarth School, Tyneside; the designers from Reckless Orchard and their client team. *Bottom left:* The existing space.

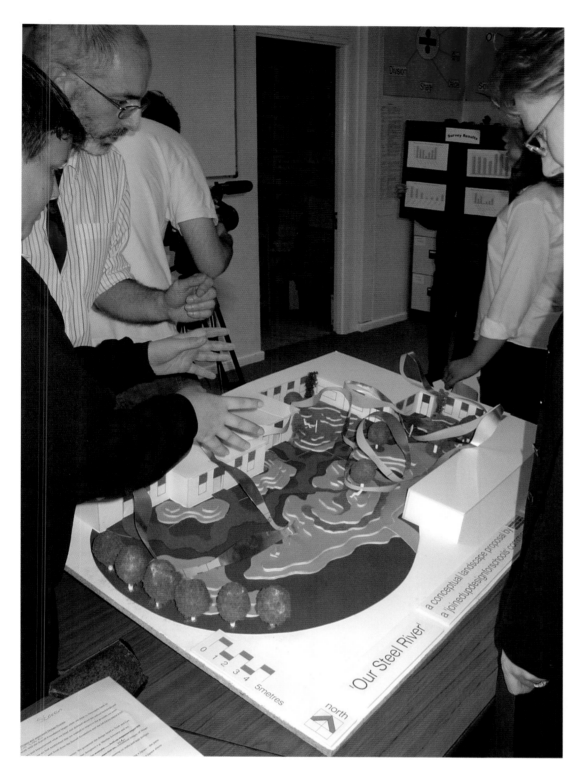

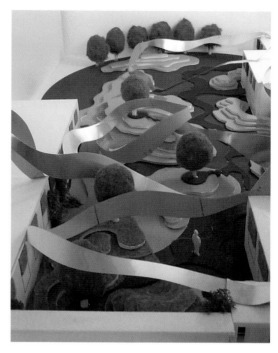

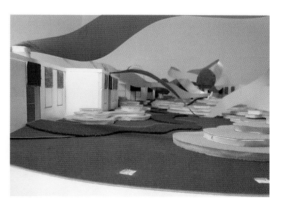

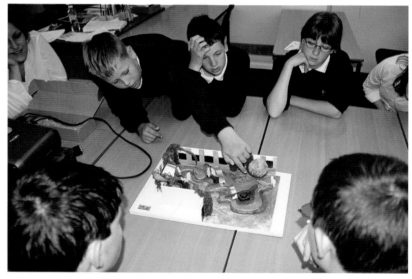

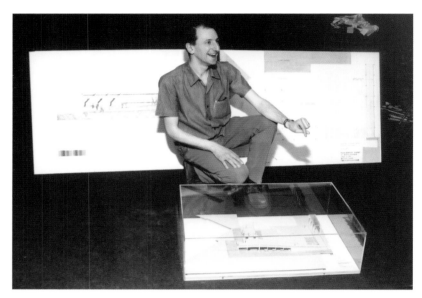

"I felt I had a big part in it. I felt really proud of it."
Client, 12

"Our school has very little greenery, as there are no grassy areas or plant features in the playground," said a pupil at Fairfield High School in Bristol, which is over a hundred years old and has limited outdoor social space. In addition to solving the lack of greenery, shelter and seating, this project had to consider the school's future plans to move to new premises.

We joined the Fairfield client team with architect Phin Manasseh, whom they asked to provide a solution that could be moved to the new school. The pupils complained about the lack of colour: "It's a very dull playground; we need a mural in there. Colour is not as important as seating and shelter, but it's more important than plants, gallery, sustainability and games apparatus."

They wanted to "create more space and use it", they wanted the new playground to take account of the school's identity – "it should look like it belongs to Fairfield" – and they wanted practical seating. They weren't keen on wooden seats: "wood gets damaged too easily", declared the brief.

To inspire his clients, Phin took them on a trip to the Centre for Alternative Technology (CAT) in Machynlleth, west Wales, where the team spent two days and nights in workshops and lectures learning about environmental materials, which prompted them to drop their objections to wooden seating. Phin Manasseh was impressed: "I was taken with the way they could grasp all sorts of complex ideas. They were very sharp on ideas and practicalities." The clients were equally impressed by both Phin and the process: "Phin looked at the brief and brought up some designs he'd chosen," said Charlotte, 12. "And we looked at them and then he went away and changed them a bit more. I felt I had a big part in it."

Phin's concept is for a double-decker wooden structure with a roof for shelter. It features a long ramp for wheelchair users, the underside of which provides further shelter and wall space for a covered art gallery. The concept provides plenty of seating and an area for open-air performances and classes. The structure is designed to be dismantled and reconstructed when the school moves. Lead teacher Nick Aslett was excited by the process: "What was extraordinary was that, as the ideas developed, more ideas developed from them. What an incredibly creative process! The kids recognized that if you let your mind go a bit, you can't half come up with some smart ideas."

This page from top: Existing playground at Fairfield High School, Bristol; designer Phin Manasseh presenting his model; Phin with his client team. *Opposite:* Concept drawings for a new structure at Fairfield.

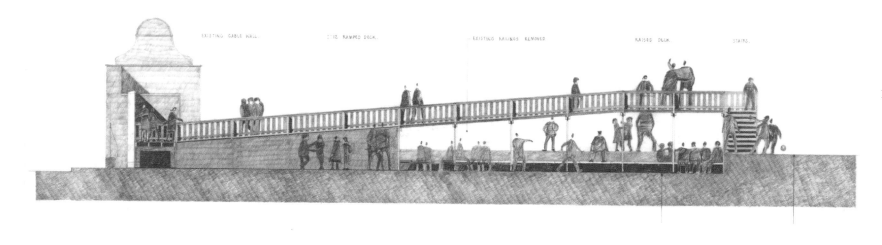

EXISTING GABLE WALL. 1:12 RAMPED DECK. EXISTING RAILINGS REMOVED RAISED DECK STAIRS.

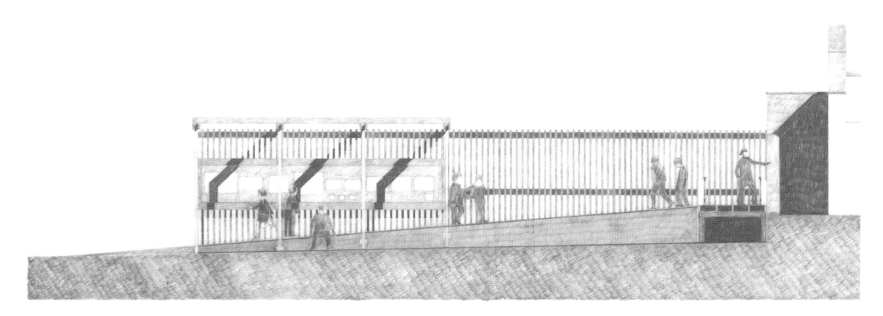

COVERED OUTDOOR GALLERY 1:12 RAMPED DECK. EXISTING BUILDING.

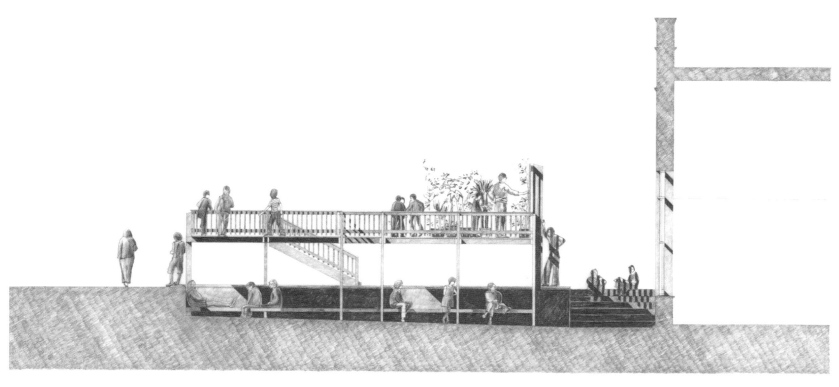

SHELTERED SEATING. ACCESS STAIR TO RAISED DECK. TIMBER SCREEN FOR PLANTS. EXISTING STEPS EXISTING CLASSROOM BUILDING

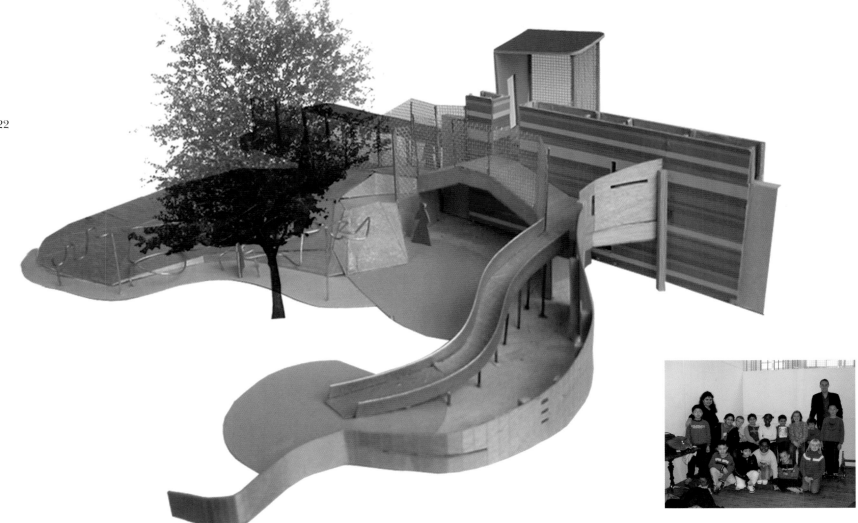

Play structures can be a wonderful way of creating vibrant, colourful social spaces for primary-school children. At Grafton Primary School in Holloway, North London, the pupils wanted a "safe but exciting play structure that can be enjoyed by all members of the school". The client team, fifteen pupils from Years Four to Six (aged 8 to 11), wanted to "change the play-structure", explained Sam, 8, "because the one we've got is broken and run down and if too many people go on it at once it might break".

Their brief was packed with ideas for making the new one as exciting as possible: "We should have two sets of monkey bars so one person can go one way and another person can go another," wrote one pupil. "And we should have different heights because some people don't like to go too high," advised another. Another warned of overcrowding: "Everyone will want to go on it at once so it needs to be big. And what about some shelter on the inside? Then we could use it when it rains."

We joined them with designers Liz Adams and Graeme Sutherland from Adams & Sutherland who devised a series of visits on the themes of 'Ground', 'Water', 'Sky' and 'Play'. For Ground, they visited Millbank Millennium Pier, where they spent time sliding down wooden ramps. Sam explained: "They weren't really slides; they were just to make the pier look interesting." For Water, the team caught the boat to Canary Wharf Tube Station and the Dockland's floating bridge, where they discussed moving structures. For Sky, they walked along the Royal Victoria Dock Footbridge, the height of which gives a sense of perceived danger whilst actually being very safe. For Play, they went to the Evergreen Adventure Playground in Hackney, where the pupils played on structures designed by Adams & Sutherland. "It's hard to design a play structure," said Liz, "you need excitement and safety. The children have huge expectations. They really got us thinking about the place they needed. A lot of playgrounds are about equipment in a blank space. They didn't want that." The visits inspired the children: "We learned how big or small a play-structure can be; we learned patterns that we could have on a play structure," said Aaliyah, 9.

The final concept from Adams & Sutherland is a colourful, multi-levelled structure. It centres round a tree sculpture offering shelter and yet transparency, the pupils feeling it was important that teachers could see what they were up to. "It is a special place for them," said Head teacher Nitsa Sergides. "It is not a game; they want it to be a place of their own, put together with a vision in mind as well as thought for all the children who will be using it, not just themselves."

Traditionally, playgrounds are, as their name implies, on the ground. This is not the case at Hampden Gurney Primary School in Westminster, where the school sold their playground to create a unique school building. Designed by BDP, the egg-shaped glass tower features crescent-shaped cantilevered balconies that serve as playdecks, 25 metres (82 ft) long by about 12 metres (39 ft) deep. The playdecks were chosen by the client team as the subject for their challenge. "The playdecks are at the moment just for running around," said Wael, 11. "We want them to be more fun."

Their brief to Conran & Partners was to transform the playdecks into inspirational spaces. "The playdecks are designed to take about two classes," said Sebastian Conran. "The problem is they are empty, the ceilings are low, and it's noisy." Sebastian, Mark Hales and Sandra Cunbacub worked with the client team to analyse "what they used them for, what they wanted to use them for, and what they could use them for. We bounced play ideas around between us and came up with fourteen ideas for new activities for the space."

The final concept includes coloured AstroTurf banking to create areas to sit and chat. The structure forms a loop that provides a central 'amphitheatre', which can be used as a performance space or a small chat room. The structural pillars are turned into 'activity pillars' for group games, complete with message boards and graffiti walls. The soft furnishing absorbs the noise and a specially designed audio system, using a sound cone, allows the pupils to play their own music without disturbing their neighbours. Mirror panels on the ceiling reflect the colour beneath.

"Sebastian was really cool," said Catherine, 11. "I like design stuff, and I thought it was really creative what Conran did. They really wanted to hear what we thought, like any other customers they had. They came up with some cool seat ideas: pod seating, which you can organize how you want."

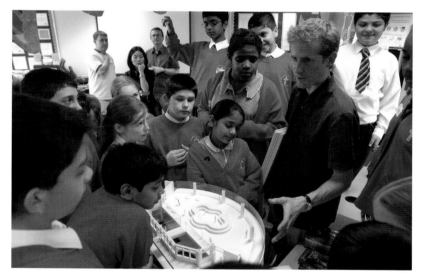

"I thought it was really creative what Conran did. They really wanted to hear what we thought, like any other customers they had." Client, 11

Opposite: Adams & Sutherland's concept for a new play structure at Grafton Primary School in London; the client team. *Above:* Sebastian Conran and Mark Hales present the final concept for the playdecks to their clients from Hampden Gurney Primary School, London. *Overleaf:* Conran's proposal, showing movable tiered seating.

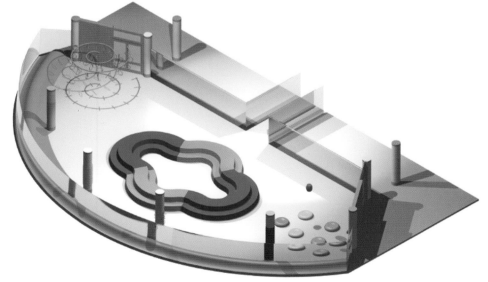

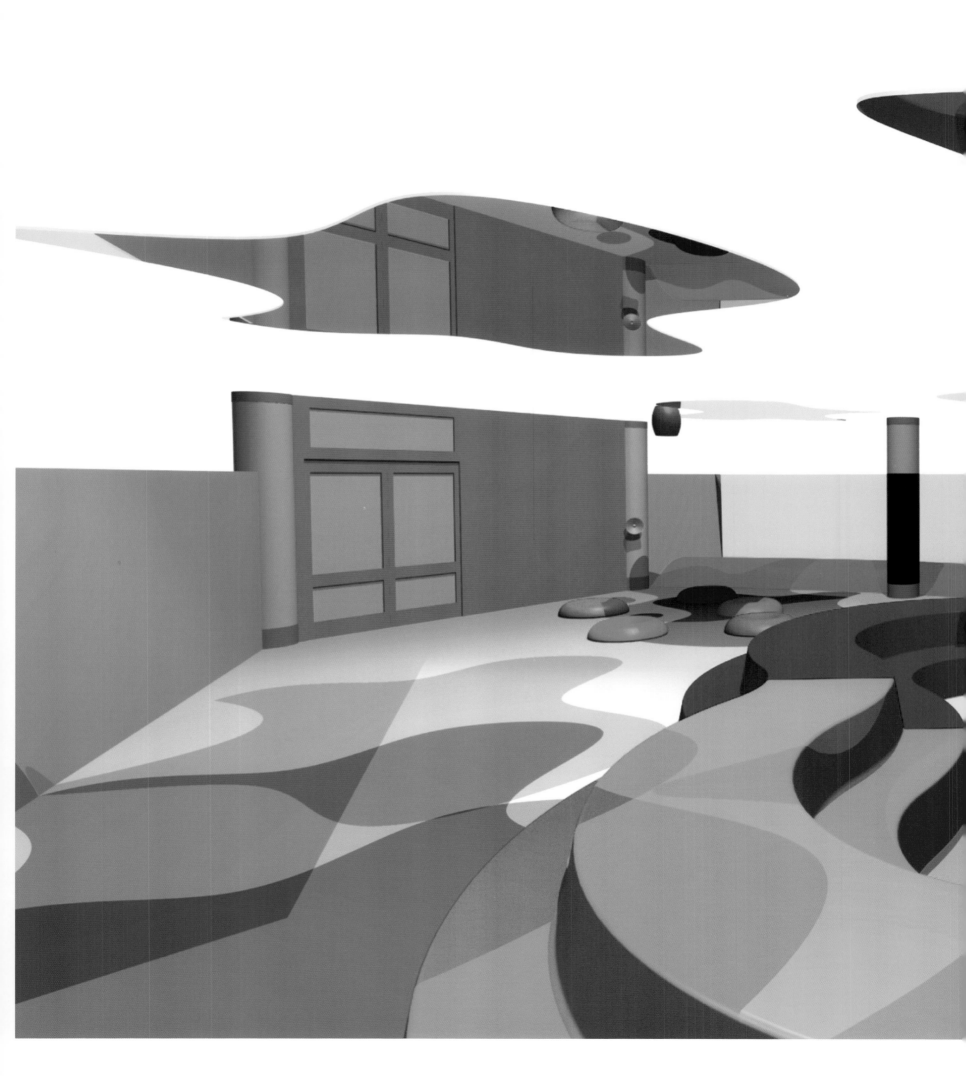

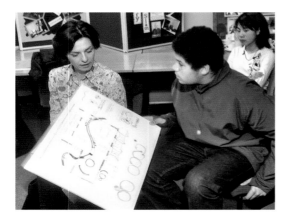

"It's absolutely wonderful. The designs are so far in advance of your general school structures you almost feel that, if only the children were more involved in designing schools, you would end up with more attractive schools." Murray Aikman, Deputy head

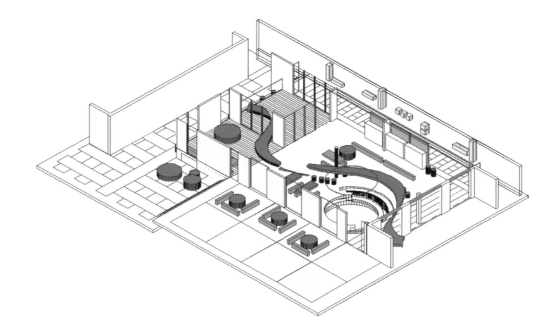

Above: The existing playground at Whitefield Fishponds Community School, Bristol; Ferhan Azman's concepts for providing shelter and seating; Ferhan discussing the design with the client team. *Opposite:* Designer Richard Seymour with his client team from Langdon School, London. *Overleaf:* Illustrations of Richard's concept.

"The school didn't have a physical heart," said Ferhan Azman from Azman Associates Architects, speaking about her first visit to Whitefield Fishponds Community School in Bristol. "There was this huge brick wall, and a huge gate. We couldn't find the way in!" The Whitefield Fishponds client team wanted to find a way of creating a sheltered playground in the middle of the school. They particularly wanted somewhere to sit down under shelter during break; the children had nowhere to go in the rain except under the stairs or into a crammed brick walkway with a concrete roof. One pupil complained: "the problem is that when we do find somewhere to gather, we are moved."

In their brief the client team wrote that a successful design in the playground would "make pupils more enthusiastic about school because we would feel we own our little social space". They wanted Ferhan to give them "their own special place to go and feel like we can get away from the rest of the school". They also wanted help to "give people outside a good impression".

Ferhan said: "Their ideas were impressive, so I wrote them down in front of them. They directed me in things to watch out for in my design work, like vandalism and litter. I'm pretty talkative, but soon I couldn't get a word in edgeways!" They told her that the entire client team was "very set that the mood or atmosphere of the shelter should be very different to the rest of the school: a bright, cheerful, comfy, warm, safe place." They also said they found curves more "relaxing" and the materials should be anything but concrete.

The concept is called 'The Hub', a bright and colourful central meeting area in the outside space between some of the main buildings, landscaped in the sinuous shape of a three-dimensional, moulded plastic, red 'snake'. The form rises into the roofed area, drops low to form sofas and tables, winds round a sunken amphitheatre, into a quiet area and up to a courtyard. Glass display cases line the walls so student artwork can be presented to the school and public. What was a dull playground is set to become the vibrant heart of the school.

The project's lead teacher, Matt Dowse, thinks that, if the scheme were implemented, "the benefits would be immeasurable. It would change the way kids interact. It would produce a better atmosphere in the playground and in the school." Head teacher Theresa Thorne was bowled over: "I was thrilled to see them describe it with a sense of ownership. Something special has emerged from the process. Even if it stops here, it's been an achievement, a huge learning experience."

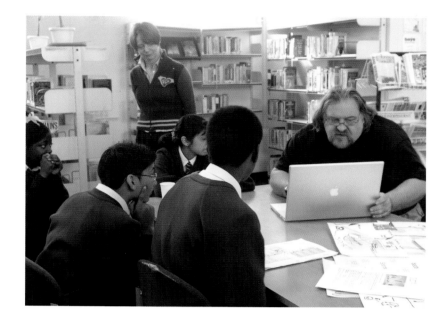

The brief from pupils at Langdon School in East London stated they wanted a social space that would "unite the school and increase a sense of pride". The client team, aged between 12 and 14 years, all studied D&T, and we joined them with Richard Seymour from Seymourpowell, who co-presented Channel 4's Designs on Your … series.

The designers and the team identified an area they could make into a communal garden, which would serve both the pupils and the onsite community centre. They visited Shakespeare's Globe in London, where Richard encouraged them to think about the relationship between time, space and amphitheatres.

The final concept is driven by Richard's desire to involve the whole school in building the community social space. It is a performance stage in the form of a massive sundial, set in tiered grass seating. When the gnomon (stationary arm on the sundial) indicates noon on Midsummer's Day, it signals it is time for a communal ceremony: the burial of a time capsule under the school in front of pupils new and old. The concrete base of the sundial is to be filled with personal items buried there by each of the pupil population.

"The thing I like about the design is that it includes everyone," said Amy, 14, one of the clients. "I've got something to look forward to in life, because I know in twenty years' time, when my kids are old enough to understand, I can always bring them back here and say, 'I helped, I was a part of this'."

"I think it's a really good idea to match the designers with the schools," said Head teacher Vanessa Wiseman. "That way the design is not imposed; it flows out of what the school is doing. There will be more ownership. It will be a part of the community's experience for many years to come."

A natural amphitheatre is
formed from stepped grass
terraces, supported by
walls formed from
old railway sleepers
The environment
is safe for
partially-
sighted
student

Area lit with spots
inside school

With luck, it will
not be necessary to lift
the original concrete
paving, but the grass
berms must be well
drained into custom
culverts —

Performances will be
visible from inside the
school as well – and inside
lighting permits use at
night also —

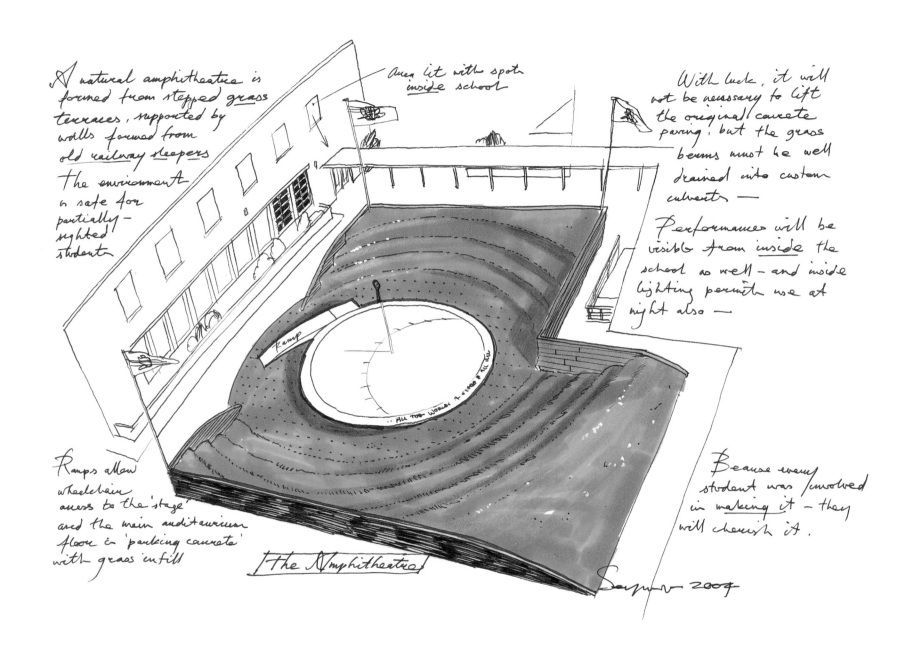

Ramps allow
wheelchair
access to the 'stage'
and the main auditorium
floor is 'parking concrete'
with grass infill

The Amphitheatre

Because every
student was involved
in making it – they
will cherish it.

Seymour 2009

At the centre of the concept is the 'stage' —
It is a 6 metre diameter disc, cast in concrete at the school. Cast into the surface are 2000 small objects, one from every student —
A stainless-steel mast is mounted in the centre of the stage, which acts as the gnomon of a sundial, showing the time by the sun — it is locked in position and can be removed when required. The 'stage' can be used for all forms of performing arts (theatre, dance, etc) as well as co-ordinated athletics from beam exercise to rollerblading.

The stage also makes an ideal outdoor classroom for use in the summer months. Being cast concrete, it is also resistant to 'adverse environmental factors'.

At noon on Midsummer's Day every year, the shadow from the gnomon shrinks to a dot — the signal for the school to bury a Time Capsule under the floor of the Main School — this continues every year for 15 years. On the 15th year, the first capsule is exhumed and a new one put in its place. Ex-students of that era are invited back to watch — the contents form the focus for a history project —
The ritual continues

TIME PLAYS MANY PARTS · ALL THE WORLD'S STAGE · AND ALL THE MEN AND WOMEN PROJECT PLAYERS · PLAY MANY PARTS AND THEIR ENTRANCES AND THEIR EXITS

2004

"The thing I like about the design is that it includes everyone. I've got something to look forward to in life, because I know in twenty years' time, when my kids are old enought to understand, I can always bring them back here and say, 'I helped, I was a part of this'." Client, 14

Pupils at Withywood Community College, Bristol, wanted to create "an outdoor, sheltered activity area; a multi-functional structure in which students could express themselves creatively and learn".

We joined them with Alsop Architects. Adrian Fowler of Alsop visited the British Airways London Eye and Will Alsop's Peckham Library with his clients. The pupils found the experience mind-opening and came back full of enthusiasm. "When we started we were just talking about four walls and a room," said Jodie, 13, "but it totally changed."

The sculptural form of the proposed shelter rises from the main fabric of the school building. The wooden structure has a roof made of decorated powder-coated aluminium. The shelter covers pond-like hollows called 'sitting pits', before melding into a larger form that contains two capsules, the lower level being a café area and the upper level an Internet/media room. "It's a counterpoint to the poverty-stricken boredom of the buildings around it," said Will Alsop. "This is a picnic spot and an Internet café that, in our dreams, should be open to the community."

Teacher Vicky Guppy saw the project as an inspiration to pupils: "This area is a bit run-down; the kids don't have a lot of ambition. To have something that different and that inspiring would be brilliant for the area and the school." Charmaine, 15, found it changed the way she thought: "It's made me think more about the way you build things – they don't have to be square!" Brett, 14, summed up the appeal of the new shelter: "I like it because it's funky and different. It would be a fun place to be."

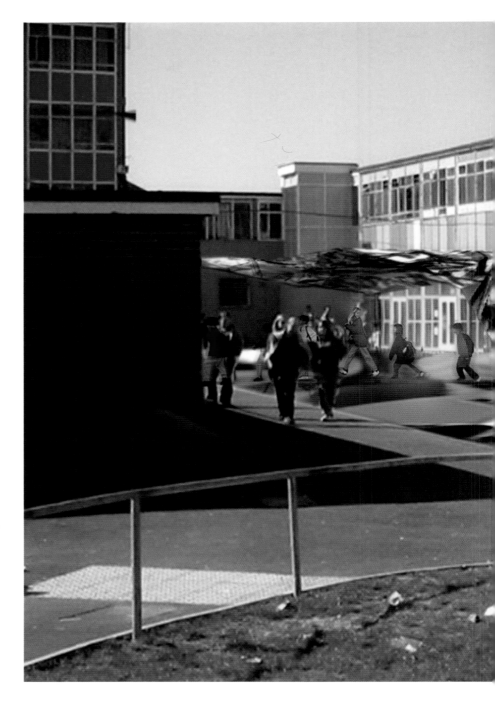

"It's a counterpoint to the poverty-stricken boredom of the buildings around it. This is a picnic spot and an Internet café that, in our dreams, should be open to the community."
Will Alsop, designer

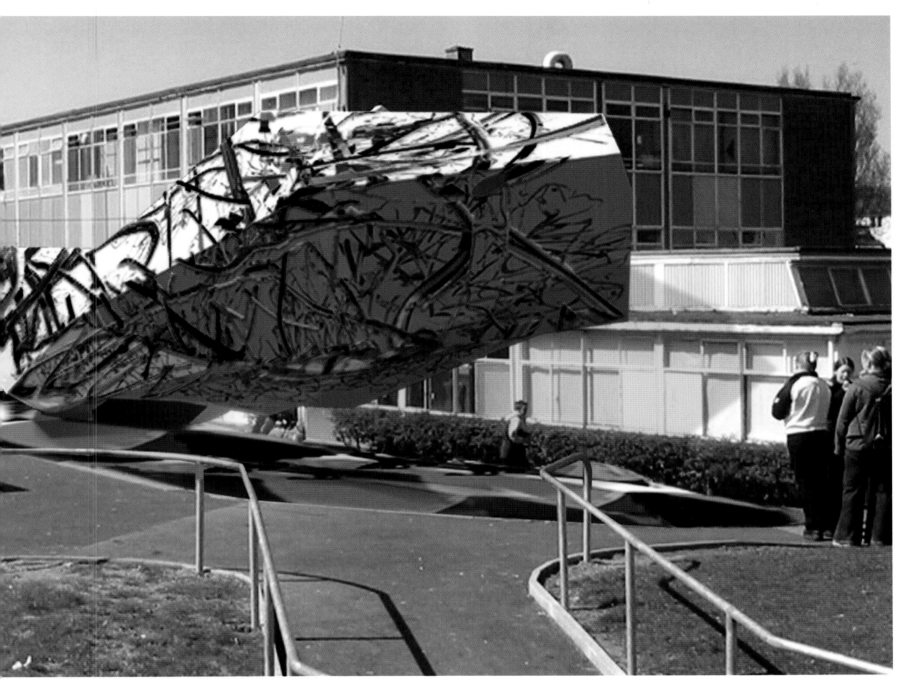

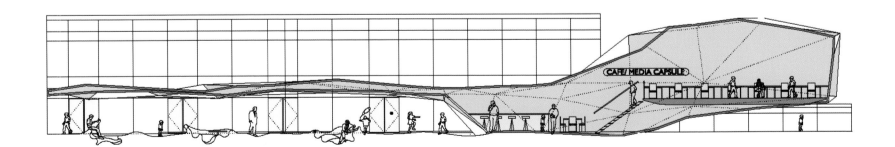

CAFE/ MEDIA CAPSULE

Will Alsop's concept for a dramatic playground shelter and Internet café and the current school exterior at Withywood Community College, Bristol.

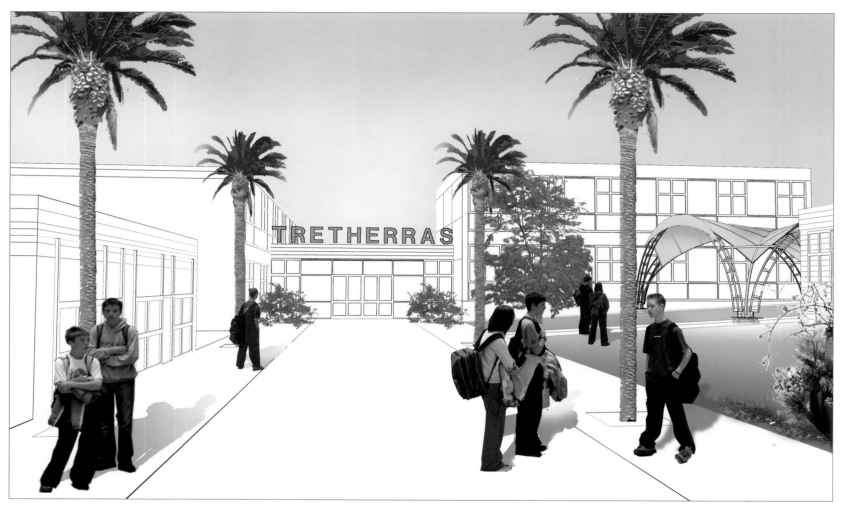

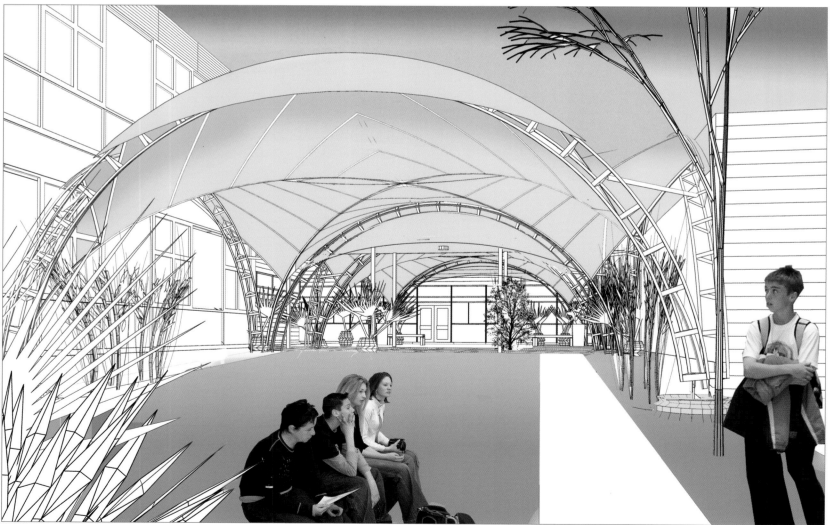

Marks Barfield Architects are famous for creating an iconic new addition to the capital's cityscape, the British Airways London Eye; it has been one of the most popular venues for client teams to visit. We joined Marks Barfield with Newquay Tretherras School and Treviglas Community College, both in Newquay, Cornwall.

Newquay Tretherras is a specialist technology school with a strong arts focus. The client team of thirteen pupils from Year Nine (aged 13 to 14) were chosen from a group of high academic achievers. They wanted to create "an outdoor social and learning space and make a nice environment in an area of 'dead space' near the entrance to the school". Their brief asked for "a bit of shelter outside. When we go out it's often very windy and rainy. There's nothing to do but get wet." They have tables outside but they "are covered in mouldy foods and chewing gum". They said they wanted to improve the entrance so as to "give a better impression to anyone visiting the school". They wanted "cosy seating" arranged in a circle so "you can chat to your mates", but stressed it should be "a little bit private so you can do your own thing". They wanted colour and ornaments; perhaps even some patterned stonework on the ground.

Architects Julia Barfield and Lucy Annan, from Marks Barfield, took the client team to London to look at how the courtyards at the British Museum, the Imagination building, Tate Modern and their own studios had been transformed by covering them with transparent and translucent roofs. Drawing inspiration from Cornwall's sun-and-surf youth culture, the client team and the architects explored different types of tensile structures for the courtyard. The conversation was rewarding for both sides and resulted in a cost-effective concept that fully answered the brief.

The concept design is for two prefabricated, tented, tensile domes fitted neatly into the available space, providing shelter without heavy shadow. A row of palm trees with a Hollywood-style school sign give the entranceway a Californian boulevard feel. The two domes create a flexible, sheltered inspiring space for socializing, learning, exhibitions and performances, revitalizing the entrance to the school. The client team loves the idea.

"We're hoping to carry on the Hollywood theme," said François, 14, "by putting our handprints in concrete to leave our own personal mark."

Opposite: Marks Barfield's concepts for a new entrance and covered outdoor social and learning space for Newquay Tretherras School, Cornwall. *Overleaf:* The woven wooden canopy designed by Marks Barfield for Treviglas Community College, Cornwall, as a courtyard shelter for dining, recreation and performances.

Nearby, in Treviglas Community College, limited social space leads to overcrowding and all the attendant behavioural issues that congestion brings. The client team of fourteen pupils from Year Ten (aged 14 to 15) wanted to solve this overcrowding by creating an outside social space in an unused courtyard. If they can do that, said the client team in its brief, "behaviour problems will decrease as there won't be so much pushing and shoving". They also argued that "people will begin eating healthier food because there will be space for them to sit down. Everyone at lunch times will be more relaxed and calm." They said they wanted the space to be "futuristic, funky, trendy and calming".

Marks Barfield again showed the client team inspirational courtyards, such as Norman Foster's Great Court at the British Museum and Ron Herron's conversion of the Imagination building, and worked with the pupils to find a solution to their own space.

The final concept is breathtaking: a trellis-like canopy, woven from strips of plywood, that form a 'wave' over wooden supporting struts. Covered in a waterproof membrane, ETFE, it spans most of the courtyard linking the three entrances, providing protection and partial screening for daytime diners. The design is modular and could be adapted for other areas in the school.

"Working with Julia and Lucy has given me the confidence to actually suggest ideas," said Amy, 15. "It gives you an insight into what, when you leave school, you've got to expect being an adult and how they've got to work and how you've got to organize yourself." And teacher Louise Hawthorn responded: "The thing that struck me was that it was probably one of the first times that young people had been asked their opinions about the world in which they live."

"It has been a wonderful experience. They've learned so much, and they've grown as they've gone along. The school was built in the 1960s and it demonstrates all the quirks and foibles of 1960s architecture. It's a very tired and jaded building. If this design were implemented, it would be a focal point that the children would recognize as their own success, and is therefore extremely important to them. It would be the very heart of our school, at our centre. And that would be very inspiring."
Helen Mathieson, Head teacher

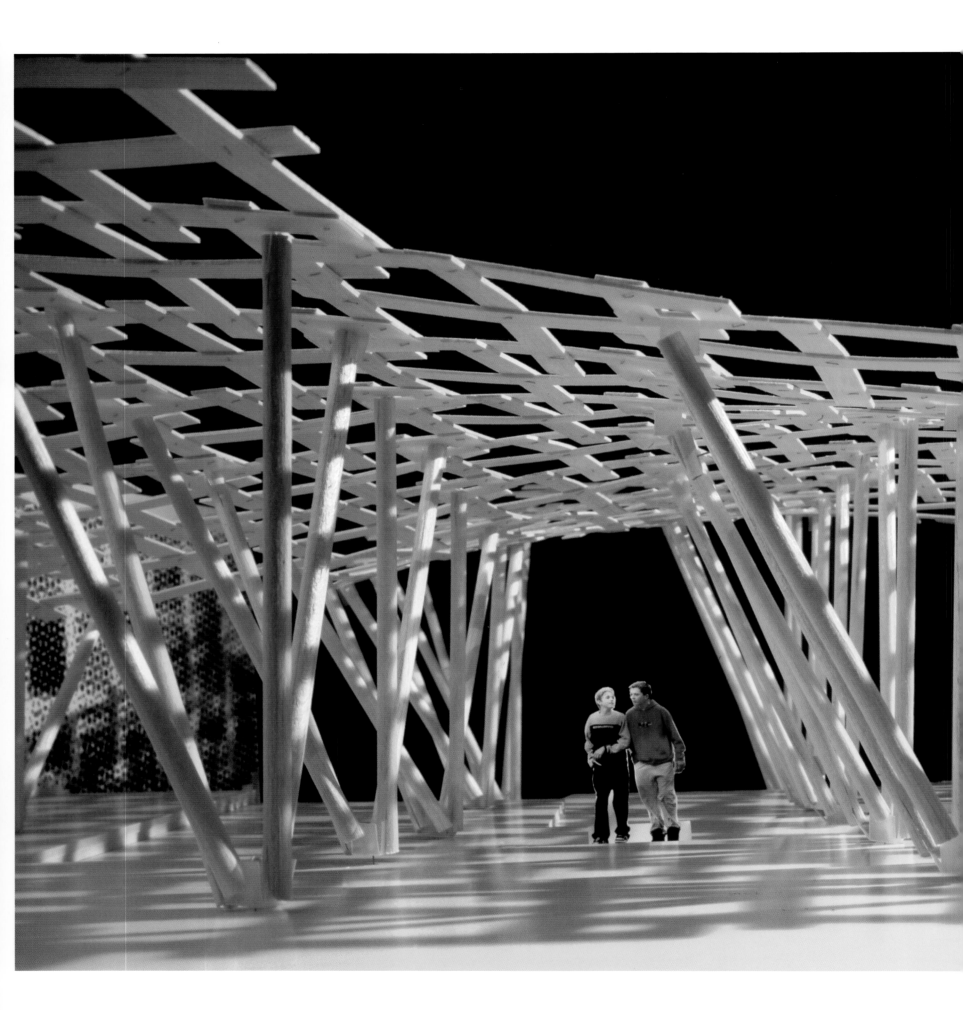

Storage

"There isn't any space to move because there are jackets and bags on the floor." Client, 7

Pupils need somewhere safe and suitable to store possessions; books, coats and personal items need to be accessible but secure. Limited space in classrooms and corridors and pupil numbers higher than originally planned for school buildings make it essential to resolve this issue in an imaginative and practical way.

"Better Lockers" is the simple title to the brief written by the client team at Plumstead Manor School in Greenwich, south-east London. With 1200 pupils in the school, not everyone has their own storage; sometimes two or three pupils have to share. "Lockers get damaged, doors get broken," said one client. "They're too small to share and they need to be graffiti-proof", and, "They look ugly. We need a way to personalize them without damaging them."

The client team conducted a survey and set up a suggestion box, feeding the responses into the presentation of their brief, an imaginative performance that demonstrated the stress felt by graffiti, vandalism, insufficient space and lost keys. The pupils were also concerned about the environment, in response to which architects Priestman Goode organized a visit to Delleve Plastics in Stratford-upon-Avon to look at the production process of water pipes made from recycled waste materials. This helped inform one of the final concept designs, which proposes making lockers out of the pipes. As well as tackling environmental issues, this concept helps reduce production costs. As Paul Priestman explains: "If you use an existing product it means you don't have to tool up for it."

The concept presents numerous space-saving designs including a portable locker in the form of a bag, which can be attached to the walls. The client team were most impressed, however, with an L-shaped locker featuring combination locks that solve the problem of lost keys. A carefully designed interior provides space to hang coats, store PE kits, and secure books and equipment. In response to the pupils' concern about production costs, Priestman Goode propose creating a template for the L-shaped design so that pupils can build the lockers themselves in D&T classes at the beginning of their school life.

"Creatively it's been excellent," said lead teacher Kathy Smith. Unfortunately everything we do these days seems to be constrained by one thing or another. But it is great for the students involved. They are all talking about it."

Above from top: Existing lockers at Plumstead Manor, London; the client team presenting their brief through a performance; Paul Priestman presenting his concepts. *Opposite:* One of Paul's concepts, which proposes making lockers out of recycled water pipes.

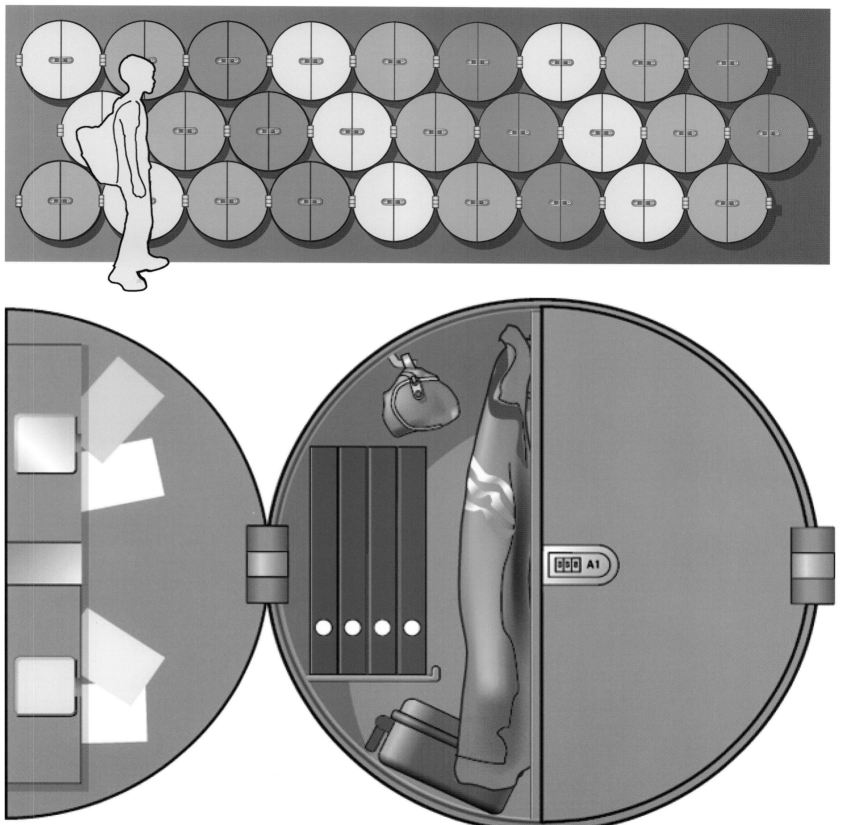

"It taught me about working in a team and learning to listen to other people. It made me feel like I was helping my school." Client, 14

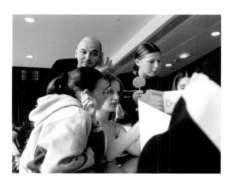

There are no lockers at all at Wentworth High School in Manchester; pupils carry their bags with them everywhere they go in school. When designers Rosario Hurtado and Roberto Feo, from El Ultimo Grito asked them to describe their challenge, they picked up their bags, PE kit, coats and scarves, and dropped them on the tables. "That's our problem!" they said.

The corridors at Wentworth High are too narrow to accommodate standard locker designs. So, working closely with the client team, El Ultimo Grito created a prototype that could be used in restricted spaces in schools across the UK.

The new locker concept is shallower than standard equivalents, which has been achieved by placing the lockers on a diagonal. To save further space, the locker door opens only partially, but allows full access because the interior storage box is attached to the door and comes out as it is opened. Netting and shelving keep coats neatly separated from school equipment, and combination locks replace keys.

Client team-member, Caroline, 14, summed up another problem that the team was keen to tackle, pointing out that the school was "all boring and drab. It should be more colourful". Designer Rosario agreed: "When you walk around the school it's quite dark and it doesn't express the creativity that the pupils have, which is a shame because they have a really strong art department." As well as being functional, the concept presents a solution to the problem of an uninspiring environment. The addition of a transparent sleeve on the doors of the lockers provides a display area for artwork, making it easy to personalize or create a display over a group of lockers.

Wentworth High's Head of Expressive Arts, Ken Simm, was impressed. "This project gave them leg-room to express themselves, to go beyond what they normally do day to day. They've put a lot of themselves into something that is going to happen. They've been saying throughout the whole process that they'll be able to come back in ten years and say: 'We did that, we did all that.' I think that's fantastic."

"The problem in our cloakrooms," said Lauren, 10, from Ranelagh Primary School in Stratford, East London, "is that the coats always fall off and somebody might walk on them, and fall over and hurt themselves". Her colleague Courtney agreed: "There's too much crowdedness in the cloakroom because in the morning we all go to hang our coats. When we get mud on our shoes, and we step on other people's jackets, we get mud on their coats."

We joined Ranelagh with architects Piers Smerin and Amalia Skoufoglou from Eldridge Smerin. Lack of space was not the problem; the problem was organizing that space efficiently. As the conversation developed between the pupils and Eldridge Smerin it became clear there was a second storage problem. The pupils do PE in their main hall, but have nowhere to store PE equipment, or anywhere suitably private to get changed.

The architects took the client team to Tate Modern. "It was really good," said Teresa, 9, "we collected a lot of ideas to help us with the lockers, because we could use the colours we saw there, and ideas of shape and size."

Eldridge Smerin's concept proposes opening up the locker rooms by removing existing partitioning racks and putting in an innovative and colourful locker system, with a specific layout to help dictate the flow of pupils around the space. "I think they're good because when someone opens the door, it's not in your way," said Lauren, 10. "It's so spacious that you can just walk in, open your locker, and just go out. It's nice and calm."

The concept is flexible enough to cater for pupils of all ages. Younger pupils can use storage space at a lower level with blocks of lockers, which are overseen by a teacher. Older pupils are given more control and responsibility with their own locker in taller hexagonal blocks. With the addition of seating, the room is transformed into an organized and relaxing space.

To solve the equipment storage problem, Eldridge Smerin propose a protective screen that sits on castors at the end of the hall, which is easy to pull away from the wall so that pupils can get changed behind it. There are hooks for clothes and racks for shoes. A dividing wall separates the girls from the boys, and the unit's low height affords privacy as well as provision for discreet monitoring by staff.

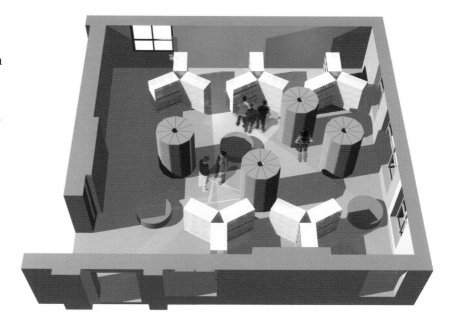

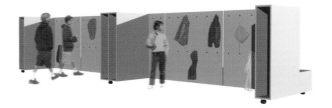

"It's so spacious that you can just walk in, open your locker, and just go out. It's nice and calm." Client, 10

Opposite: El Ultimo Grito's concept for Wentworth High School, Manchester, proposes lockers on a diagonal and a transparent sleeve to display artwork. *Above:* Eldridge Smerin's concept for Ranelagh Primary School, London, proposes a locker system with a layout that dictates the flow of pupils around the space, as well as a movable protective screen.

At Brecknock Primary School in Camden, north-east London, a large, busy, multi-cultural primary, the young client team from Year Five (aged 9 to 10) wanted "somewhere for us to put our things". One pupil said: "Our bags have to go in a little green box which is too small and our coats have to be on the back of our chairs, which really makes it hard for us to work." Their brief was full of inventive proposals: "How about having chairs with cushioned seats that have a fabric locker on the back for your bag and coat; it could have your name on it," proposed Amy, 10. Emma, also 10, suggested having a "clothes hanger with a bag and zip instead of a locker". We joined them with designer William Warren: "The school is vast but has narrow corridors so storage is going to have to be in the classroom," he told us. "This will also solve problems of security." Central to his design idea is the promotion of a sense of pride and personal ownership.

William worked with the client team to explore how the lockers could be personalized. He took them to their nearest residential street to look at front doors and then asked them to draw the ones they liked. When they looked at their work they discovered that, whilst the basic shape and structure of the doors were the same, there were a number of ways in which the doors had been individualised through colours, windows and letter boxes. William also used a visit to the Imperial War Museum, to look at medals and insignia to introduce the concepts of pride, ownership, responsibility and respect. These ideas were further reinforced through a badge-making workshop, which resulted in a design concept for brass plaques to display proudly on the front of the lockers. "They've got their names in them," explained William, "and what they want to do when they grow up. They did a lot of the drawing for the plaques; it was as if I had a graphic design team working with me."

The team worked out the size requirement by testing their belongings in cardboard boxes of various sizes; they wanted the lockers to be as small as possible but as big as necessary. Once they had the right box size, they set about the task of personalizing them. They decided to give each locker a different front door based on the front doors they had drawn earlier. This way, "every locker in the school would be different," explained William, "each having a different door style or colour. It's like giving everyone a little home and giving everyone respect. They even have a letter box so they can send messages to each other." To further personalize their locker, pupils will be able to choose the handles, door numbers and name plates.

The Foundation had asked William to explore possible links with manufacturers. He met with a number of firms and received positive feedback from Helmsman, a forward-thinking UK manufacturer, which agreed to prototype the designs. "I wanted to keep the locker price down, and the manufacturer could see this could become part of their range for junior schools. It's only a little more expensive than normal lockers because the box is standard; it's just the doors that change." Brecknock School took delivery of its new lockers in December 2004.

"It's been absolutely priceless working with the kids. Nobody knows more than they do about their school environment and how they use it, so they are the perfect client." William Warren, designer

"All the staff now want one too. They're beautiful. You just look at them and you want to put something in them!" Sandra Duffy, teacher

Above: William Warren with his clients at Brecknock Primary School, London. *Opposite top:* Drawings by the client team of front doors. *Opposite below and overleaf:* The client team with their new lockers.

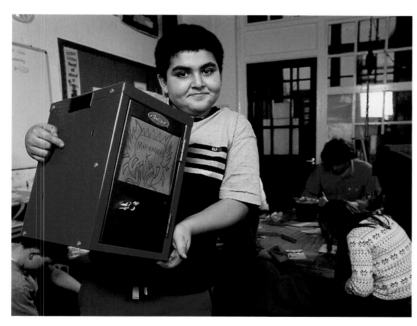
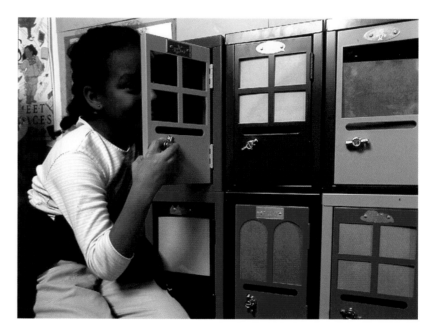

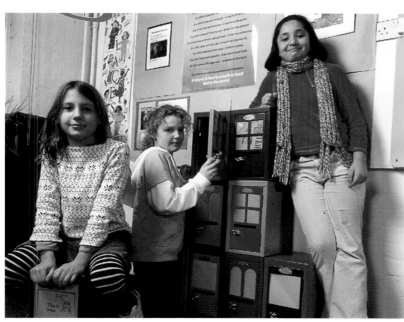

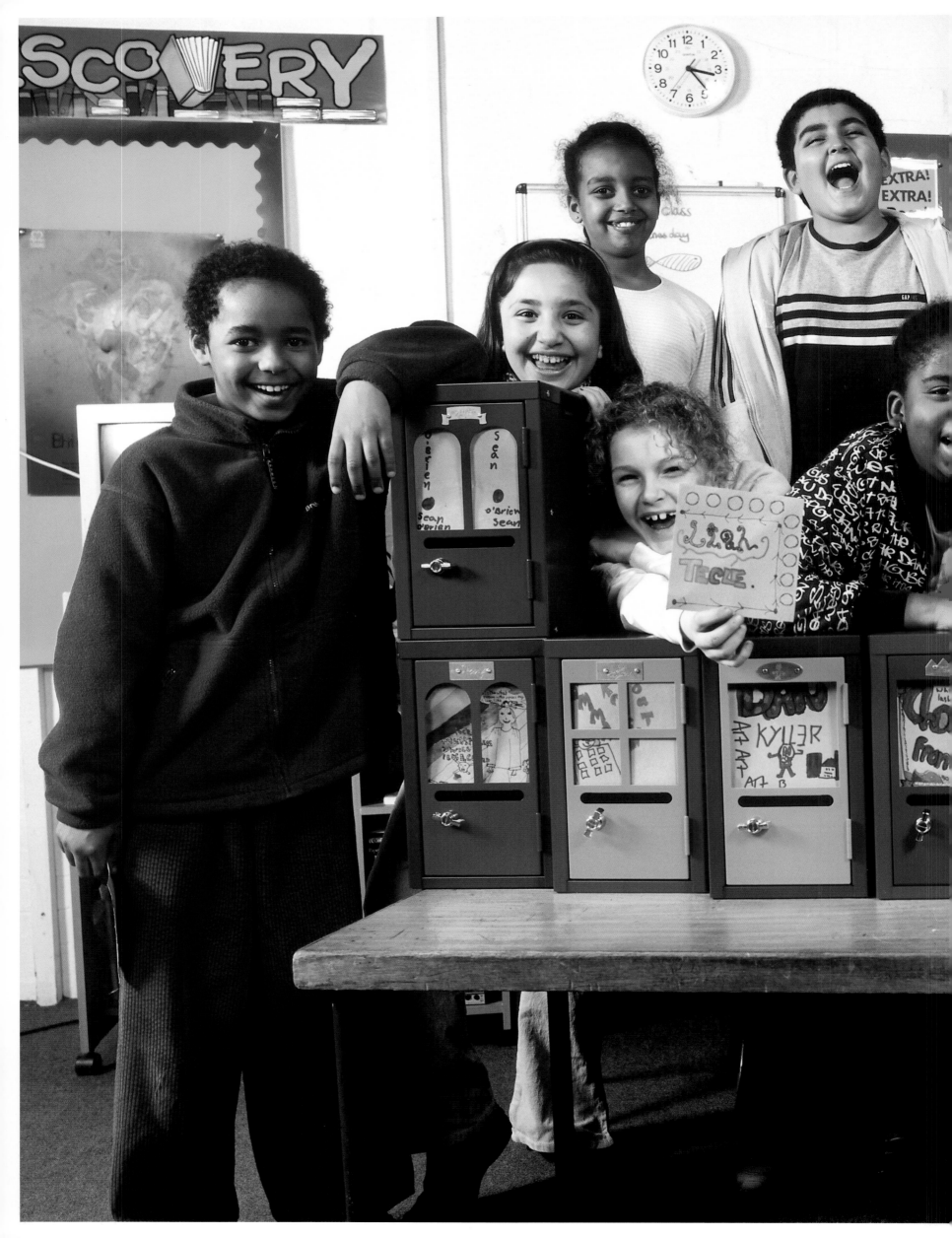

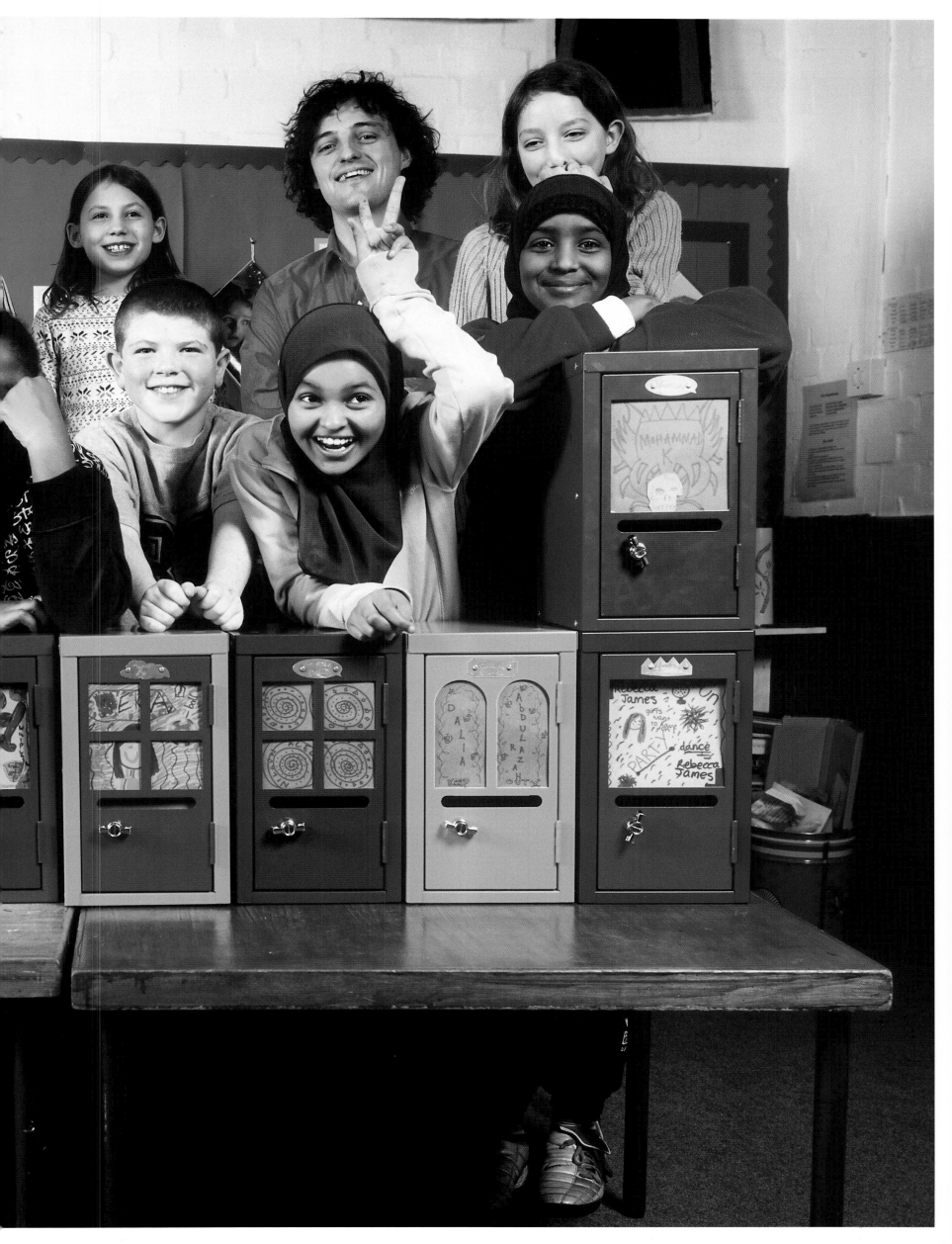

Toilets

"They disgrace the school. They're really messy and they smell a lot." Client, 10

144 School toilets were identified as a major problem in all the challenge workshops, and they drew some of the strongest criticisms from the pupils. But in the end only two schools briefed their consultants to redesign their toilets; most client teams didn't want to "waste the opportunity" that joinedupdesignforschools provided on "the bogs".

Their concerns were commonly shared: they typically found their toilets unhygienic, full of dirt traps and often dingy. "They're minging," said one pupil, holding her nose. Cleaners reported they were difficult to maintain. One told us that she worked hard before each break time to get the toilets clean and stocked with paper, but by the end of break there was mess everywhere, all the toilets were blocked and, somehow, all the toilet paper had been used. A lot of children didn't like using them because they were taken over by 'gangs', who said, in their turn, that they went there "because we've got nowhere else to go". Some pupils complained they were bullied in the toilets. And some said they never use the school toilets; they waited until they got home.

"Make the school toilets cleaner and safer," said the brief from pupils at Barlow Roman Catholic High School in Manchester. They made a video, including interviews with pupils, staff and cleaners, which explained that the toilets were built in three separate blocks, making them difficult to supervise. The result, they said, is bad behaviour by small groups of pupils. The client team said the toilets are too small and there are some major plumbing problems. The cubicle locks get vandalized and so do the hand-driers, so the pupils use toilet paper to dry their hands. This often ends up blocking the basins, which also get blocked when people are rinsing off mud from their sports boots. The maintenance staff complained the toilets were very hard to keep clean. The brief reported problems with graffiti and with secret smoking. The school put in smoke alarms, but the pupils put plastic bags on the sensors. Some pupils said they didn't go in because they found the gangs of older pupils too intimidating.

We joined the Barlow client team with architects Kevin Gill and Ben Barton from JudgeGill to develop a solution to vandalism and anti-social behaviour. Jade, 13, thought JudgeGill were great. Speaking about a workshop with the designers she said: "They listened to

us and took our ideas in and made something of them. We had two big pieces of paper: one for the girls' toilets, and another for the boys' toilets. We filled both papers with ideas. It was exciting to see our ideas getting used." Ben Barton said the respect was mutual. "They learned to ask better and better questions. They really contributed to the design."

The team researched the Internet and magazines to create mood boards for the girls' and boys' toilets, describing preferred colours and textures in each. Ben took them into Manchester to show them precedents and examples of toilets in various bars where they had solved similar problems. He said: "The key was showing them different ideas, different ways of solving the problems that would inspire them. Bright colours, and attractive glass features."

Frank, 13, said he learned a lot from the visits: "The trips were good, though we spent a lot of time looking at toilets. We got an idea for a trough sink instead of a series of separate sinks." Out of this conversation came the decision to create one large, light, bright, attractive, new toilet block to be used by the whole school, including the teachers.

JudgeGill's concept locates the new block centrally in a disused, muddy courtyard near an existing toilet block. The exterior is surrounded by attractive timber decking walkways. The wall of the hand-washing area is entirely glass, which makes it easy to monitor and allows the pupils to look out on to a mosaic mural made by the pupils themselves. Down the centre of this new space is a line of toilets, male on one side and female on the other. The floor is made from a seamless grey resin,

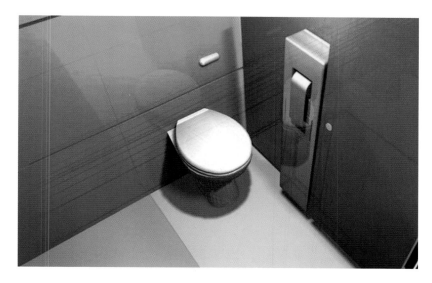

which makes cleaning easier. Cubicles are roller-painted MDF to make it easier to repaint. Plumbing is protected by removable panels. The washbasins consist of a single stone trough, while non-contact taps reduce the risk of germs. In order to prevent mud from blocking basins, there is a separate trough for washing boots. "

Pupils did this," said Laura, 12, "It's not like a teacher came up with the design. So I think they're less likely to vandalize them." The proposed toilet block is now set to be the most attractive building in the school. "I probably will remember this in later life," says Frank, 13. "If the new toilets don't get vandalized, it will have been an achievement. I'll feel pretty chuffed."

Head teacher Anne Marie Proudfoot was very impressed: "It's an extremely creative process, the ideal way to work and well worth the effort."

"The trips were good, though we spent a lot of time looking at toilets." Client, 13

Above and overleaf: JudgeGill's design for a new toilet block for use by pupils and staff at Barlow Roman Catholic High School, Manchester, features transparent walls to help staff monitor behaviour, but has privacy within the cubicles.

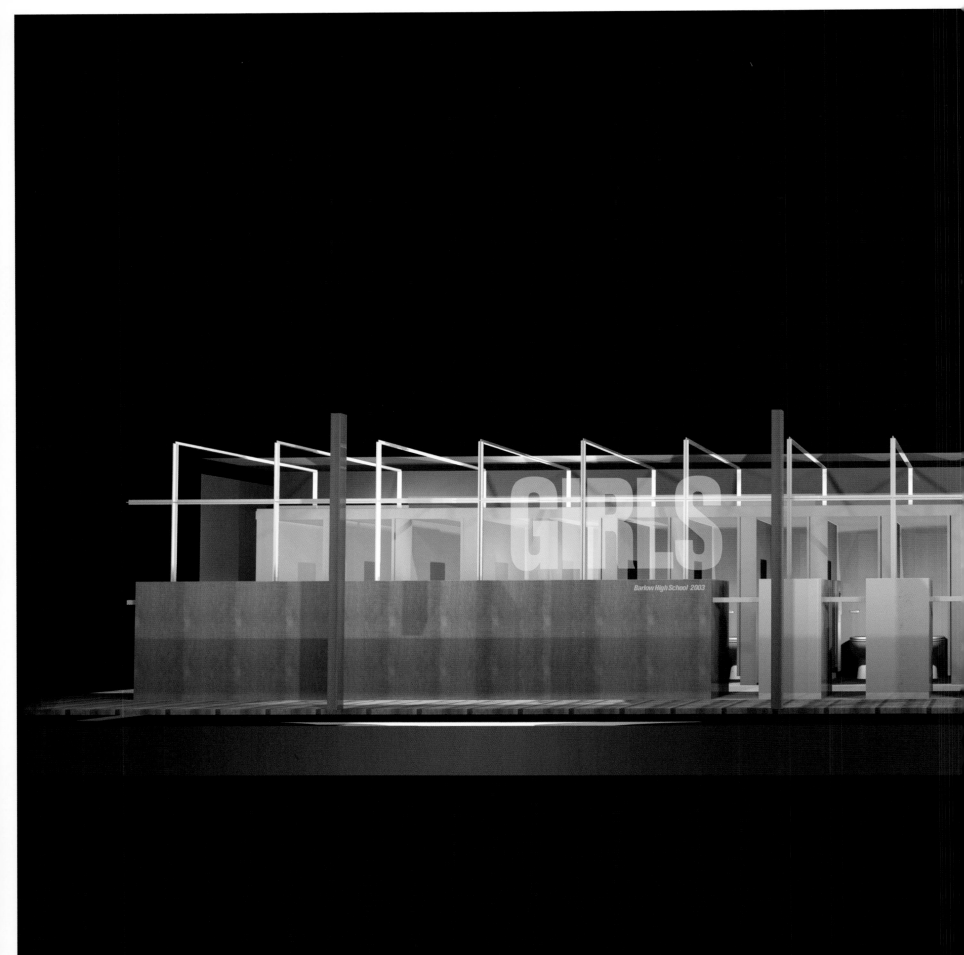

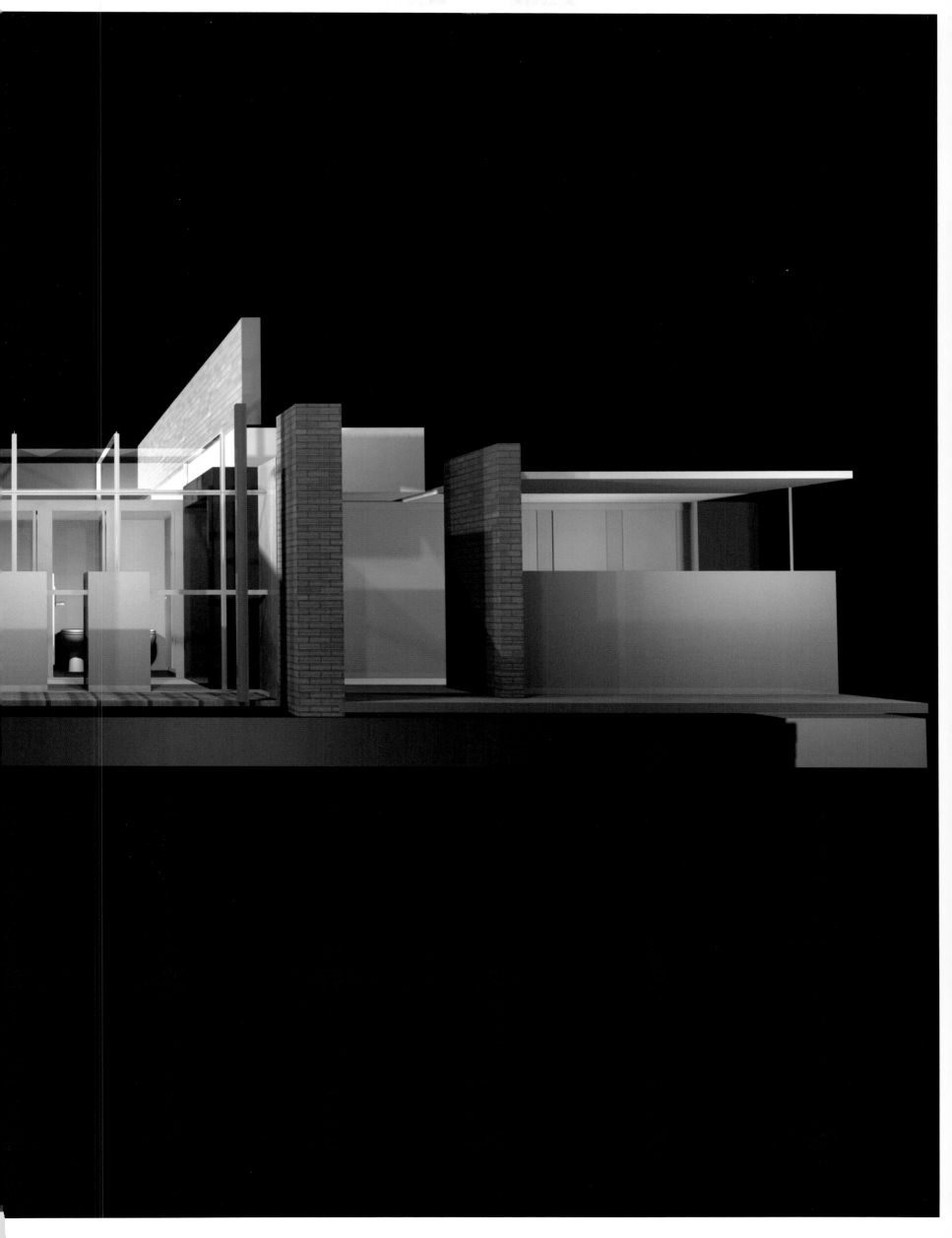

Issues facing primary schools are slightly different. At Deptford Park Primary School in south-east London, the pupils weren't concerned about bullying, smoking and supervision, but they *were* concerned about hygiene.

"It's all ugly and there are tissues stuck up on the walls," said JJ, 10. Aissata, also 10, agreed: "They disgrace the school. They're really messy and they smell a lot."

We joined the client team with architect Mike Davies from the Richard Rogers Partnership, who took them on a series of visits to inspire their thinking. They were impressed by the rubber-lined loos in the architects' headquarters and the touch-free taps, hand-dryer and light switches. They also visited one of the partner's houses, where they learned about modern spaces. At The River Café in Hammersmith, they saw how a tight space could be designed to feel open, clean and colourful.

Back at the Richard Rogers Partnership, they had a model-making session with the architects and began a lengthy debate on which colours and materials they should use in the Deptford toilets (see p. 40).

Mike Davies asked them to imagine the best place in the world they would like to be, rather than in the toilets at Deptford. Gbolahan, 10, said: "I want to be on a Caribbean beach, with dolphins leaping in the bay." And that became the theme of their design, "so that when you are in the toilet," explained Gbolahan, "you look at the dolphins and you just feel relaxed. Like you're on holiday!"

The concept features wavy tops to the cubicles, beach colours on the walls and floors ("we want the floor to be like sand") and dolphins on the walls. The Richard Rogers concept even had TV screens buried in the mirrors for displaying school information. Mike expressed concern about the whole issue of toilets in schools: "This problem is endemic: they're smelly, they're horrible, they're cold, they're wet. Basic sanitary processes can be very unpleasant, and sometimes the toilets are the one place not policed by the staff, so you get a bit of bullying, intimidation or people mucking about. There's quite often bad vibes for the children."

It is time for a change.

Above: Mike Davies discussing designs and colours with his client team; a perspective drawing of the new design for Deptford Park Primary School, London.
Opposite: Concepts for the Caribbean-themed toilets, featuring hygienic hands-free basins and toilet flushes.

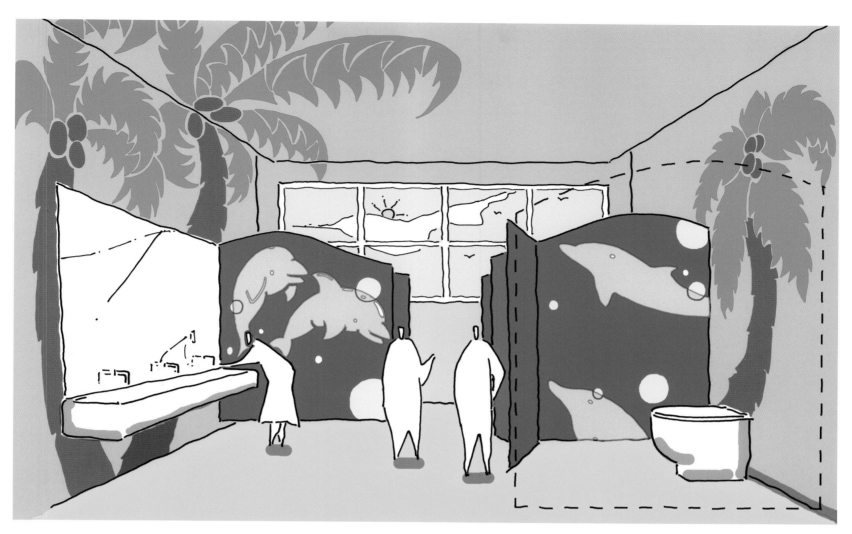

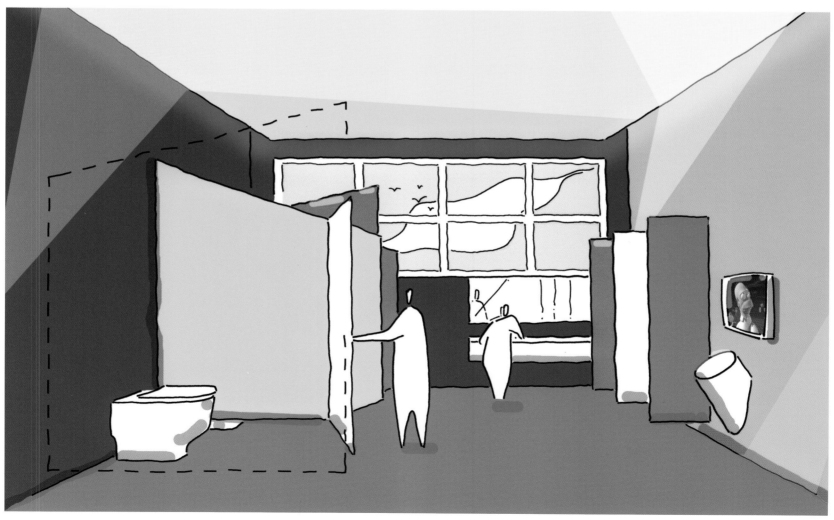

Uniforms

"We want a uniform so that people will take pride in our school." Client team brief

The joinedupdesignforschools programme revealed that most pupils wanted to feel proud of their school and thought that modernizing their uniform would improve their self-respect. Many conducted whole school surveys, which showed that ties and blazers were unpopular, that they preferred more relaxed, relevant styles and lighter, more breathable fabrics. What they wear matters, not always because they want to stand out, but often because they want to fit in. Self-image and their place in the community is important to them.

It was clear that pupils look to the present and the future for clothing ideas. For them, school uniforms are stuck in the past. "It's dull, uncomfortable, ill-fitting, itchy and uninteresting," summarized one of the pupils we spoke to. "The cut of our uniform means it usually doesn't fit right; it's uncomfortable," said one girl. "It's rubbish," said another. "We want colour, funk, a modern design, comfort and style," announced one of the briefs to the designers.

Pupils personalize their existing uniforms by un-tucking their school shirts and wearing their ties loose and short. They are not rejecting uniform; the vast majority of the pupils agreed that uniforms instil a sense of pride and belonging, but they think that school authorities know too little about youth culture and clothing design, and are not the best-qualified people to say how they should look, though one school surveyed the staff room and found that seventy-five per cent of teachers agreed there was no need to tuck in shirts.

One client team announced in its brief: "It will make us happy to wear something that we have helped to design because then it becomes ours." If they had a hand in the design, they said, they would be far more likely to "wear it properly". Some pupils complained about how revealing their PE kit is, and how the uniform presented challenges to people of different religions.

One brief asked that the uniform include provision for Asian heritage students: "a 'duppatta' head covering, and [instead of a skirt] a salwar kameez or trouser suit." In short, they want a uniform that is not *uniform* because it allows them be individual. They want an affordable range of clothing rather than a prescriptive one-style-suits-all formula.

"We want something exciting and fun to wear, something more twenty-first century!" said pupils at Aldercar Community School, Langley Mill, Nottinghamshire. They presented a brief to Paul Smith and his Head of Design, Sue Copeland, that included mood boards made up of photographs cut from fashion magazines, and another extensive survey. The twelve- to fifteen-year-old client team told them they wanted to change their current black uniform because it was "too hot in summer". For the same reason they wanted to ditch the school tie. But they still wanted something smart. Paul warned against their desire for clothes that reflected the fashion of the moment, saying: "I like your idea of pedal-pushers but they could be out of fashion in a couple of years, and you'll find yourselves wishing you'd never asked for them." Sue showed them that there was no need for a revolution; that small changes and little details can make all the difference.

Over several months of meetings and visits, Sue and Paul generated a design. After consulting with pupils throughout the school, the client team rejected proposals for light-coloured trousers on the grounds that they could get dirty too easily. They agreed to the subsequent idea of choosing their own black trousers to match, ease of maintenance taking precedence over warmth in summer.

Opposite: The new uniform for Aldercar Community School, Nottinghamshire, designed by Paul Smith, replaces the school tie with grosgrain trim on the shirts.

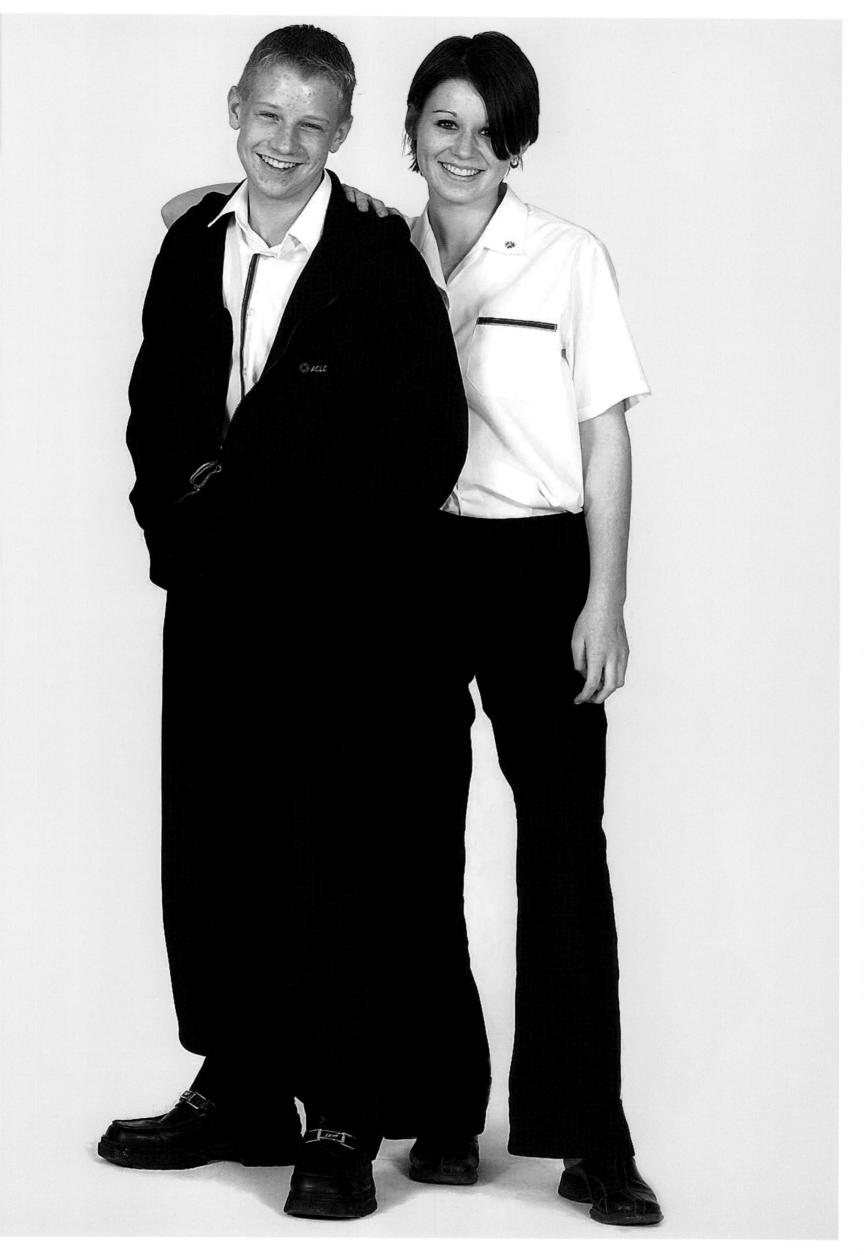

The pupils are now wearing the new uniform. "Three cheers to Sir Paul – may there be more like it," said *The Times*'s fashion writer, Emily Davies, in a highly positive review (10 July 2004). The uniform, which has also been shown on the BBC's *Blue Peter*, features long- and short-sleeved comfortable cotton shirts, embroidered with the school symbol and trimmed with grosgrain tape in the school colours. This pioneering idea allows the pupils to remain smart without the necessity for the tie.

The pupils are delighted: "Brilliant. I love it. These are dead good. I'd wear this out of school on the weekends!"

Tony Cooper, Head teacher, said: "This has really raised aspirations and expectations; it shows the pupils the potential they have, and what life after school is all about. It gives them a real goal; [Paul Smith is] a real role model. The whole school realized that if the client team was successful, the whole school would benefit. You should have seen their faces on the day when we were able to say: 'We're going to have this uniform.'"

" I was very excited to be involved. At my first meeting the situation was a bit strange to us all, but we soon hit it off and got some great results." Paul Smith, designer

"We want a uniform so that people will take pride in our school. It should boost morale," said the pupils of Ivy Bank Business & Enterprise College in Burnley, Lancashire, arguing that it was hard to have high morale if you were embarrassed by what you were wearing. Ivy Bank pupils were concerned about itchy materials and low-quality fabrics that ran in the wash. "We want a uniform that's high quality, bright and exciting, completely new," said their brief, which also reported that ninety-five per cent of the children they'd surveyed said they wanted to scrap the tie and the blazer, and that fleeces and hoodies were preferred. They wanted a uniform that "reflects our status as a business and enterprise college, that is modern, individual, colourful, interesting, durable, comfortable, smart and stands out."

We joined them with Ally Capellino, who arrived on the project fresh from redesigning the Girl Guides' uniform. The client team told Ally they wanted a collection of clothing that offered them choice. Working closely with the team, Ally developed a relaxed and stylish range of clothing using plain and patterned greens to reflect the name of the school so that, through colour, Ivy Bank pupils could be identified on the street. As Ally said, "This works as a uniform when you see more than two pupils standing together." Lead teacher, Gill Broom, could see the positive effect that the project had on them: "It's broadened their horizons, lifted their confidence, improved their self-esteem and raised their aspirations."

At Beechwood Secondary School in Slough, Berkshire, the client team wanted to feel proud of what they wore on the sports field, especially when competing with other schools. "We always look terrible when we go out to play against other teams," said Billy, 12. "If we have a good-looking kit it will help us feel like a better team," added Jade, 12.

At the presentation of their brief, they told designer Natasha Wright: "Our challenge to you is to design a PE uniform that is suitable for a progressive school, will boost morale, develop a sense of pride, and instil confidence to face the enemy on the field." They went on to explain: "No one wears the correct kit. Why? We're well behaved and eager to learn. But we're just not inspired." They followed this with a picture of a girl not looking her best in the school PE kit, and asked: "Would you want to wear this?" It was impossible to say yes. They listed their requirements: "We want colour, vibrancy, style, durability, air flow, reversible gear, loose fit." They had studied different types of materials that were "breathable and soft on the skin". And they wanted it to be easy to wash.

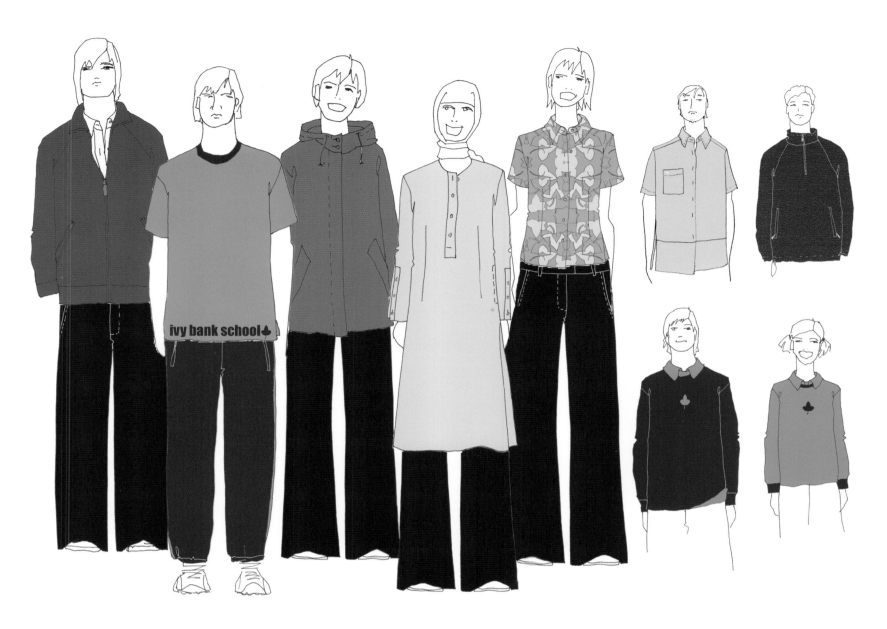

At a workshop with the pupils, Natasha started to generate ideas for a cost-effective, durable and timeless sports kit that also managed to answer the pupils' concerns about being 'cool'. The client team's thinking was influenced by major sports brands that have become fashionable, comfortable street wear.

Natasha took them to the Alternative Fashion Week in Spitalfields, East London, where she was showing her own fashion collection. They found the experience inspiring, not least because their exclusive seats, taken by some early arrivals, were dramatically cleared for them, making them feel like pop stars.

Natasha worked closely with Kris Barber of the London Apparel Resource Centre, and generated a final concept that is a complete sports uniform including a royal blue and yellow kit-bag featuring a simple graphic.

Opposite: Aldercar's new uniform. *Above:* Ally Capellino's concept for a collection at Ivy Bank, Burnley. *Right and overleaf:* Natasha Wright's prototype PE uniform for Beechwood Secondary School, Slough.

Whole School Plan

"Please design a new school for us."
Client team brief

In all of the Common Issues described up to this point, we followed our rule that it should be the pupils, and not the schools, that chose what they wanted to change about their school. But we broke that rule after we were approached directly by a head teacher who wanted help designing a primary school from scratch. We agreed to include him in the programme because he wanted his pupils to be consulted throughout the design process. We also thought that such a project might contribute to the thinking behind most, if not all, of the common issues raised by pupils across the UK.

Castleview Primary School is a high-achieving, multi-cultural school in Slough, near Windsor Castle. The Head teacher, Italo Cafolla, explained his situation: "It started with an approach from a developer who wanted to build on land that we owned. In our current school we are incredibly cramped, 450 children crammed into a 1960s building. I saw an opportunity to construct a school for the twenty-first century using money earned from the sale of the land to the developer. And then the Sorrell Foundation came on the scene; I saw it as a unique chance to do something outside the education sphere in which children were placed at the centre."

Italo asked the sixty children in Year Five (aged 10 to 11) to apply to be part of the twelve-strong client team via mind-map, PowerPoint or letter. They had to say why they wanted to be part of the project and what they would bring to the party. Their applications were considered by a group of pupils and teachers, who chose a mixture of boys and girls. The team began by preparing a brief.

They focused at first on the problems they were familiar with. "The school we've got is a bit cramped and small," said Arron, 11, "and the toilets are not very nice and are too far away. We use the hall for everything: PE, dining and assemblies. We want to have a hall for sports and another for assembly, and a separate hall for eating." Jasmina, also 11, agreed: "There are too many corridors, all taking up lots of space we could use to make bigger classrooms. And sometimes the toilets start to smell." Another important issue was the view. They felt the name of their school was "a bit like a lie" because they didn't really have a view of Windsor Castle.

We joined them with Building Design Partnership (BDP), which had produced an award-winning design for Hampden Gurney Primary School in Westminster (see p. 123). To help them develop the brief further, architect Keith Papa took them to see Hampden Gurney and the British Museum, to look at the welcoming, open effect created by the good use of light and space. The client team also went to the Design Museum, where they were inspired by the *History of Modern Design in the Home* exhibition, and to BDP's own offices, where he treated them as he would adult clients by seating them in the boardroom and offering them drinks and food.

He showed them the plans for the BDP offices (a converted brewery) before taking them on a tour. His intention was to help them relate architectural drawings to physical space. As they walked through the building, he explained how a modern architectural practice worked. It was during these visits that Keith Papa's conversation with his client team really began to develop. Italo watched it grow: "We were very lucky with Keith; he's incredibly gifted and treated the children as equals. He encouraged them to express their views and decide what they would reject and take forward." Keith Papa responded by saying: "The thing I was most amazed by was that there was no need to talk down to them. I didn't need to change my language. I spoke to them like any other client."

Keith worked with his client team to create mood boards (collages of pictures, colours and patterns) to illustrate how they wanted different parts of the school to feel. "We put different pictures on the board to show the feelings, and we put on colourful things and wrote captions to say why we liked it," said Jasmina. "They really wanted to use the exterior space," said Keith. "They wanted outside inside." He was pleasantly surprised by their practicality. "At our first workshop we didn't have a debate about a flash playground as I expected," he said.

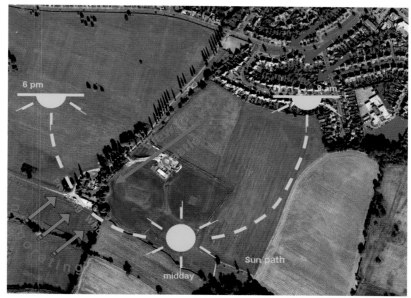

Opposite: Members of the client team from Castleview, near Slough. *Above:* Elements of BDP's design concept for the new school.

"Instead, we talked about parking. They're very concerned about it, because the streets around them are narrow and residential." So they started to plan the structure using pieces of paper to represent different elements – the hall, a classroom, a toilet block, and so on.

The pupils studied traffic flow, light, heating and colour. They learned to judge what would work and what would not, and why. They thought about the number of floors, whether the classrooms could be more flexible, and how to solve the problems associated with corridors. Gradually a shape for the school began to emerge. "Keith said that if the school was in a kind of shape it would work better," said Jasmina. They noticed that the shape of the school resembled a face "like a friendly alien."

Keith presented his first response on PowerPoint and as a 3D model. Italo was moved by what happened next: "A lovely thing happened then, because this was really when the client thing took off. They told him quite clearly what they liked and didn't like. To say they criticized him is the wrong word. But they gave him instant feedback on the bits of his designs which they felt didn't fit in with what they thought was appropriate. They understood the issues about pupil movement and really questioned his solutions. They said things like: 'Why's the car park there? What's the point of this? Why do you have to walk *through* the school to get to this point? And we didn't want that there, we wanted it *here*!' The level of conversation and the quality of those queries about the design were I think of a higher order."

At a later stage Keith gave the client team the standard specification for a primary school; that it must have so many classrooms of such a size, and should have two floors only. He represented the various elements with cut-out paper, and worked with the team to find arrangements that were the most practical and the most fun. They chose one with three floors, the top floor enjoying a clear view of Windsor Castle. "In the end," said Keith, "the pupils decided on a set of classroom spaces that opened out into resource spaces and then into other spaces, like the dining area, and finally into the landscape itself. That would give teachers a great opportunity to get children working together in spaces outside the classrooms. It also just opens the whole school out."

The classrooms, arranged in a semi-circle around the central atrium, can be both discrete and shared.

"The classrooms have movable walls," said Kimdeep, 11. "That's very exciting. It means you can join two classes together; you just move the walls out so you can work with another class in an open-plan class. You see, the walls have got wheels underneath."

The final concept shows the school arranged in layers, with each year group self-contained in its own area but joined with the next year group. The views across the Greenbelt land towards the castle are considered as part of the school's dynamic, and integral to the design. "The children have been in control of the project in many ways," said Italo. "They've learned negotiation and articulation. The children had to make a presentation to the governors on what the school was about and also to their own peers. And they had to handle a Q&A session. They had to be clear about what they wanted to everyone in and beyond the project, and they learned how to give way to other people; all of those higher order PHSE [Personal, Health and Social Education] social skills. That was clear from the start. They assumed roles and responsibilities. There was lots of giving and taking and meaningful social interaction. This is something that doesn't normally happen for children. And they were given such a sense of ownership and responsibility."

Young Jasmina commented that the programme had brought her other benefits: "I've learned to be confident in front of people and learned how to think in different ways for the better." Arron was also delighted by the new skills he had acquired: "I learned to design, how to draw pictures and put them into making a building. And talking in front of people; before I used to shrivel up and get really embarrassed and say: 'No! I don't want to do this.' Now I've done a lot of it."

"It's a great way to design a school," says Italo. "The advantages are obvious; in the past schools have been designed by an architect or local authority to a spec off the shelf. It's all about money limitation. This one wasn't like that. I think if the voices of the pupils and the teachers were clearly expressed in the way school are built, you'd have a lot less problems in school."

Castleview is currently waiting for the developer to secure planning permission.

"It's a great way to design a school".
Italo Cafolla, Head teacher

First floor plan

Second floor plan

Ground floor plan

Castleview Primary School. *Above:* illustrated plan; exploded diagram; ground, first and second floor plan. *Opposite:* Illustrations of the proposed school interior.

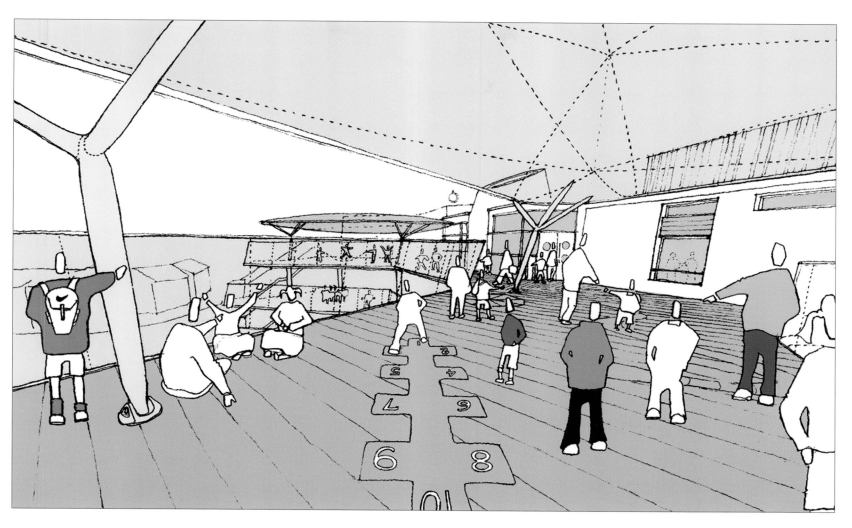

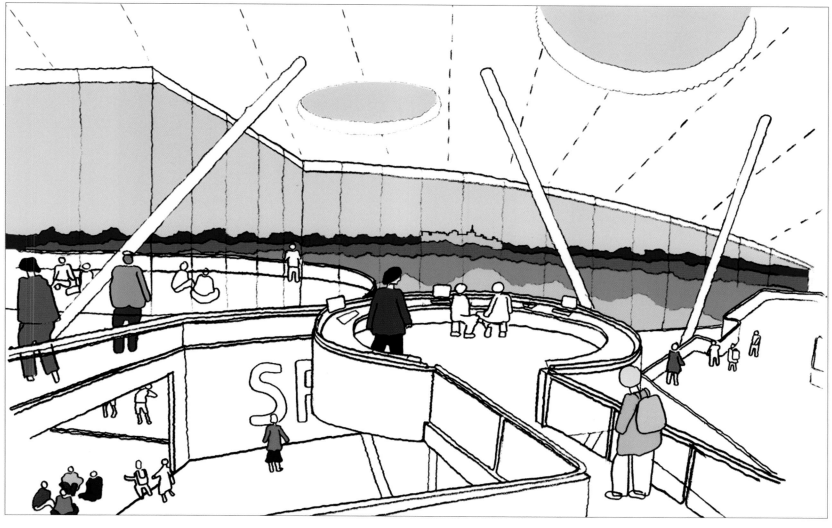

Life Skills

"Now at university, I've got no problems when I'm asked to present; I've cracked that." Gemma Dowse, former client

Life skills have always been at the heart of joinedup-designforschools. This is because time and again we've seen the impact that creative thinking has had on individual lives. We've also seen how the creative process inherently contains opportunities for people to learn and develop the sort of highly transferable skills that can help them succeed not just in design, but in life in general. It seems that the design process, by its very nature, is particularly good at teaching life skills. So what are life skills? We see them as falling into three broad categories: personal, social and thinking.

Personal skills include personal awareness, open-mindedness, organization, motivation and responsibility. *Social skills* include communication, collaboration, teamwork, citizenship and negotiation. And *thinking skills* include creativity, problem-solving, practicality, spatial awareness, financial awareness, aesthetic judgement, observation and evaluation. Add all these up and they make a powerful portfolio of *working skills*. People who begin to master these skills gain a very important extra 'skill', one that is perhaps the most important of all the life skills. They gain self-belief, which has been a central aim of the joinedupdesignforschools programme from its inception.

"Every young person should be able to develop his/her full potential, and become equipped with the knowledge, skills and attributes needed for adult life," said Mike Tomlinson in the DfES report, *14–19 Curriculum and Qualifications Reform, 2004*. In response, the CBI demanded that, by 2010: "The vast majority of young people should leave full-time education and training with the skills and qualities necessary for adult life and work." As their Director-General, Digby Jones, said: "You have nothing to fear if you skill yourself."

Life skills are becoming recognized as vitally important, not only in Britain but around the world. UNICEF, for example, is currently promoting Life Skills-Based Education (LSBE) "as a means to empower young people in challenging situations".

Jessica Milner, a client team-member at Monkseaton Community High School in 2001, is now at university. She wrote to us recently to say how she was "immensely proud" to have been involved in the programme: "To be sixteen years old and have a host of interesting, intelligent and creative professionals asking you for

your opinions, and actually being genuinely interested in hearing them, is so refreshing. I think this is one of the great, and brave, ideas behind the initiative: to *not* be told when to speak but to be allowed to freely offer frank, honest criticisms and to feel comfortable to voice ideas, are not privileges usually synonymous with schoolchildren. It gave me confidence to speak up with my ideas and challenge others." She went on to say how she was taught to think 'outside the box': "This is something that has stuck with me ever since and will no doubt aid me in my career."

The pupils in the joinedupdesignforschools programme discovered life skills through an interaction with professional designers which took place over two school terms. It worked because the designers had 'rules of engagement' that we outlined in our briefings to them. The main rule was simply this: the pupils are the clients. Therefore, treat them like clients, with respect, and listen to what they have to say because they know their experience of school better than anyone. This approach nurtured a mature dialogue and put both parties on an equal footing.

In the case of personal skills, the pupils developed personal awareness by recognizing and developing their position within the client team and the school. They also learned from the designers how to put themselves in other people's shoes. The concepts had to work for everyone in the school. They also learned open-mindedness and organization from their mentors, the designers, because they had to for the sake of the project.

Above: Gemma Dowse and Jessica Milner from Monkseaton Community High School, leading the joinedupdesignforschools presentation at the Smith Institute seminar at Number 11 Downing Street in 2001.

In terms of social skills, the pupils improved their communication because the designers were good communicators and good listeners; they showed their respect for the pupils' opinions. So the pupils began to talk on equal terms with the professionals and were improving their communication skills all the time. Their communication skills were honed still more as they developed presentations and stood up in front of the school, the teachers, the governors and the parents to present their designer's concepts. They learned collaboration and teamwork because they experienced how their consultants worked in a team, and because they realized they couldn't achieve common consensus and progress without it. So they necessarily learnt how to negotiate and compromise. Citizenship emerged naturally because so many of the projects had to take into account the opinions of, and impact upon, the wider community. Indeed, for the first time, many pupils began to understand how the school was actually organized and how it functioned as a community dedicated to their education.

Similarly, reasoning, problem-solving and thinking skills improved as they learned creative thought processes from the designers and saw how to solve problems in a practical way. Many of the projects were aiming to meet low budgets, and the client teams had many discussions about how to keep costs down, learning to question and sometimes to reject ideas because they simply were not affordable. They learned to analyse and evaluate the consultant's work by comparing it with their original brief and checking it against a range of criteria (such as the wishes of the wider pupil body), including their own developing aesthetic sense, which itself was informed by their conversation with the designer, visits to relevant locations and their own research. If they didn't like a proposal, they made it very clear to the designer, because they understood that otherwise they risked getting something they did not want.

The more their comments hit the mark and progressed the project, the more approval they received from both designers and their own client team. The more they saw their ideas informing the developing concept, the more self-confident they became. The more self-confident they became, the more liberated they felt, and the more they could contribute.

Other factors came into play. It often proved to be the case that the lead teachers would work immensely hard to help the pupils, and often their relationships improved. Some teachers compared it to an ideal work experience opportunity in which, instead of being assigned to the photocopier or the filing cabinet, pupils actually saw how a profession worked and could make a real contribution to a project. The pupils also felt honoured to be in an ambassadorial role, representing the school in an important project. Some of the client teams were of mixed ages, and older pupils found themselves listening to the opinions of younger pupils, and vice versa. This fed the atmosphere of open-mindedness and freedom from censure. And when their presentations received congratulations and applause from governors, parents and teachers, once again they felt honoured and important. Crucially, they felt their work could contribute to the future of their schools and leave a legacy of their time there.

They also acquired new knowledge: how to understand architectural plans (so much easier when dealing with a space they were interested in), how to consider the impact of materials, heating, lighting, colour, air quality and ergonomic design. How queuing and traffic flow can be improved and how to plan spaces. They developed an understanding of the importance of their school's reputation in the community, and the way in which good communications (internal and external) could make a difference. Many client team-members expressed a new pride in their school.

Of course, not all the pupils learned all the life skills listed here, and some gained more than others. But the programme touched all of them and some said it changed their lives.

Almost always the clients took such ownership of the project that they felt they had created the design. Jody, 14, from The City School, Sheffield, said that, if their project was implemented, "I'd feel proud of myself that I'd done something, that I'd made changes in my school. I'd tell all my friends: 'Oh, I made this happen; I did that.'" Jack, 7, from Hythe Community School, Kent, was equally proud: "We learned to make things. My favourite was the bucket lights; they looked cool. When I walk into this reception area after it's built, I think I'll feel famous!" The reception area was designed by Ben Kelly; the bucket lights by Michael Marriott but, as far as Jack is concerned, he did it.

Opposite: Pupils from Park View Academy, London, rehearse before presenting to their Head teacher, governors and parents; members of the client team at Dunraven School, London, after receiving their Certificates of Achievement.

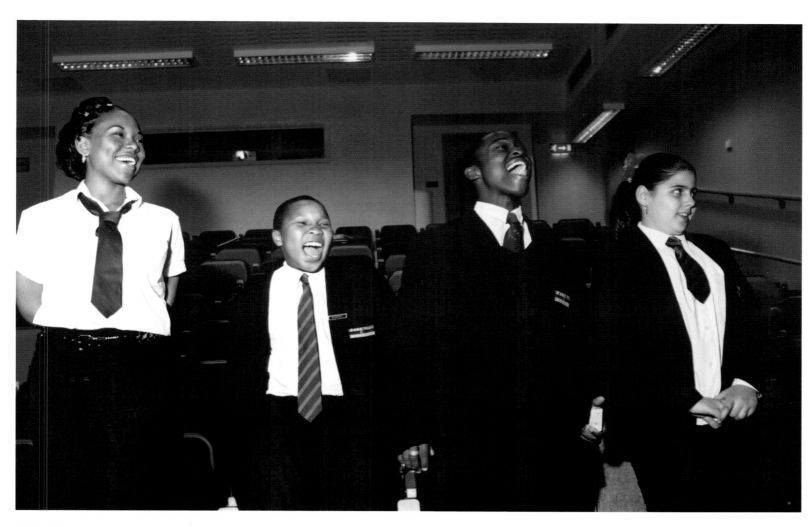

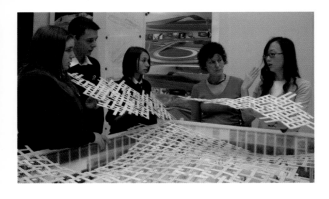

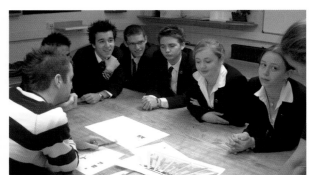
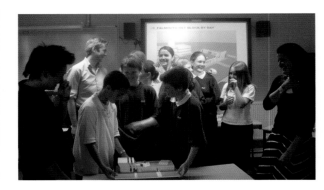

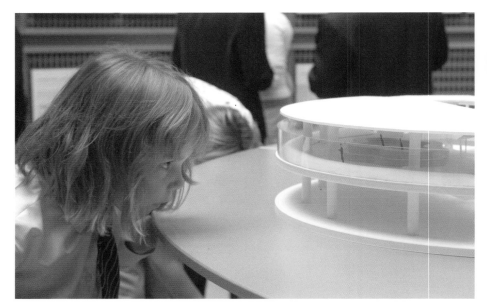
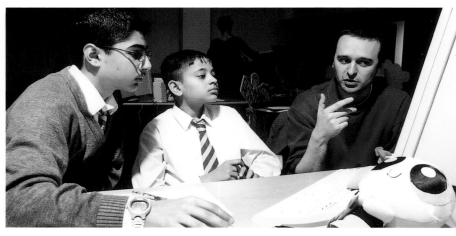

LIFE SKILLS

For yourself, for work, for life

Creativity

Problem-solving

Communication

Teamwork

Reasoning

Organization

Open-mindedness

Personal awareness

Negotiation

Practicality

Financial awareness

Evaluation

Observation

Responsibility

Motivation

Spatial awareness

Aesthetic judgement

Conversation

Collaboration

Citizenship

For self-belief

166

"They've learned new social skills, team-working, listening, thinking, answering questions, plus digital skills, how to do a presentation, how to look at images. And how to make a short film, complete with story-boarding and editing, which enhanced literacy. But self-esteem was the big issue. That really improved!" Kathi Chamberlain, teacher

"I think the pupils have got a lot out of the project. The sense of empowerment has been so important. We've trusted them to come up with something strategic for the school. We are always looking for ways to motivate young people, the keys to the door that can unlock potential. This has created lots of opportunity to learn and develop. I think that's marvellous. The children have benefited immensely." Paul Grant, Head teacher

"They've been highly motivated. They'll be able to transfer those skills into teamwork in the classroom. They've learned to work in a team, to recognize that different people have different ideas. They've learned listening skills, communication skills and problem-solving. And they've learned to step back and evaluate before going on. They've learned how to think of things differently and creatively. Those are the sort of life skills that will make them very employable in the future. They've also had a detailed look into the world of design and the thought-processes involved. But more important is the range of personal skills they've been able to develop." Simon Taylor, Head teacher

"They learned all sorts of communication skills, self-esteem skills, giving them confidence which I'm sure they will transfer to other areas of the curriculum. It's been wonderful for them and, whatever happens, they've got ownership of it in the school community; they've really, really felt it's a very important role they've had." Anne Canning, Head teacher

"The pupils have gained a great deal of confidence. Some were quite shy and reluctant to speak to adults they didn't know. They've done presentations in front of big groups of people. It's also helped them to listen more carefully. The whole

communication process has improved. They didn't have much notion of how something goes from ideas to practice. They do now! They've become more mature by being treated in a more mature way. They've had their minds expanded – and they now think about things in a different way. I think that's really beneficial for them." Karen Slack, teacher

"It offers the students a coherence to their learning. They're learning leadership skills, communications skills … And they are learning to learn, they are learning to find things out for themselves, as well as learning about architecture and design. It's not that they don't learn these things in school; it's just that with a project like joinedupdesignforschools they deepen their understanding, and learn to transfer the knowledge from one curriculum area to another. They learn the meat while doing many different things." Les Hall, Assistant Head

"The academic benefits could result in better exam results. This group were probably going to be academically successful in the long run. But what they didn't have was a belief in themselves so that they could take and make a success in a career at large. They've now had their whole horizons widened. This project has enabled that to happen. We have now a confident team, confident in their presentation and in their aspirations of the future. They clearly now see themselves people of worth who can go to go out there to do something in the world. I think everyone on the project, to a person, has been influenced in this way. It's just wonderful." Sara Davey, Head teacher

"The students changed so much during this project. They've become really confident. Some of them have really developed social skills and teamwork skills, some have started to become enthusiastic about the school environment. They've learned to listen better. And our independent, high-fliers have learned to take other people's views into account. They are learning delegation skills. And seeing the shy students doing presentations has been great." Dawn Penberthy, teacher

"They looked at the use of space, colour, texture, form and function. They learned transferable skills about managing time and working to deadlines. They developed communication and presentation skills. They learned how to make a layout look good, which is useful for GCSE. Crucially, they learned how to talk about their work. It raised their confidence and raised their self-esteem. The self-esteem issue cannot be underestimated. The school is situated in an area of social deprivation with high levels of unemployment. Some pupils on the estate live with awful deprivation. So the major, major thing about this programme was it raised their aspirations. We went to the Laban centre and it just blew their minds. One girl saw people her age doing dance and she decided she wanted to start dance lessons. It was like she suddenly saw a way ahead. It was a hugely aspirational motivator – showing that school can actually lead somewhere. I think they learned so well because this was so personal and they cared about it. It was their hall and they wanted to have ownership of the changes. And being called a 'client team' from day one gave them a special sense of stature in the school. They felt special, like ambassadors for the school." Rachel Quesnel, teacher

"They've learned to speak their minds, to have opinions, to be involved, not to stand back. These are key skills." Norma Haines, teacher

"What's really good about it is it's a real project. It's also cross-curricular in the very best sense. It's actually like real work. They've chosen a particular design brief, they've been acting as the client to professionals, engaging in sorts of dialogues and processes, consulting with our staff, governors, students. The skills that they've used in this are phenomenal: partially design skills, interpersonal skills, communication skills. They found out about how financing impacts upon decision-making. Like a real project, you have to be aware of all the various constraints, politics, finances. I think what they've got out of this experience is tremendous and it makes me think we should be doing far more of that sort of thing in the classroom and in the schools." Bob Guthrie, Principal

"I've learned self-respect. I now know that I'm important because I've helped out with such an important task. I am part of a team." Client, 15

"It made me feel more confident about getting a job. On the visit I saw so many different places – it made me feel confident to go elsewhere. It made me feel that there was a point to the whole school experience." Client, 15

"We learned how to improve things – we wouldn't have learned that in school. We learned to work with each other and to work with professionals. And I've learned to give ideas more time – rather than just relying on first impressions." Client, 14

"I'm really confident now at doing presentations. It's really different because you're putting your point of view across and getting what you want. It's a different way of learning, because you're not just sitting there and getting stuff out of books. You're actually sitting there and giving your ideas. They come back with their idea of your ideas and you say if you don't like it – you don't just sit there and listen to a teacher! It makes me feel a lot better. It made me feel excited – like I can't wait!" Client, 12

"William [the designer] taught me to believe in myself drawing. I never used to – I used to get irritated. Now I just believe in myself and I can draw – just like that!" Client, 9

"The things I learned most with SPY was to look at things more in depth, and see how things have meaning and why they have been put there. I now have a better way of looking at things." Client, 14

"It was a real change working with people who know their stuff. It's one thing to talk about these things in D&T, but it's not the same as doing it, as we have done. And you learned about costs as well." Client, 14

"I've learned that there are no boundaries; you can go as far as you want to go and you just have to have an open mind, so that you are willing to allow this to be actually true." Client, 15

"You're in control. The teacher doesn't set the work; you set the work. You're not in control much at school. But in this you were. I've learned skills that would be useful in a job interview because you have to tell adults you've never met all about yourself. My confidence has grown because I've learned what to talk to people about. I've learned to do presentations." Client, 15

"Teamwork is the best skill I've learned. I've learned to work in a team properly. And it's a great experience to work with professional people. Six months ago I would never have stood up and done a presentation! I feel a lot more confident now about talking to people and in front of people. The whole project has been brilliant. It will be a life-long memory. It's been brilliant and it will stay with me forever." Client, 15

"It's really opened my eyes because I've discovered how the outside world works. It's given us experience of what's what with everything. I've definitely become easier to work with. I was quite independent, but I now know that teamwork can get you somewhere. I've learned how to relate with adults better. I've definitely become more ambitious in what I want out of my life. Before this I was just going with the flow." Client, 14

"I'll be feeling very proud of my involvement. It will be like: 'Wow, look what I've helped with, look what I've done.' It's raised my morale and it's raised the morale of the rest of the team." Client, 14

"I've got more team-working skills now, and I know a bit more about finance and funding. It was good for self-confidence." Client, 15

"We became much better at putting our views forward. I know I did. I think that will really help in job interviews. I understood the importance and value of my own ideas." Client, 13

"It taught me about working in a team and learning to listen to other people. It made me feel like I was helping my school." Client, 14

"From this experience I've learned to say my own opinions and express what I feel truthfully." Client, 16

"Working with the designers has given me confidence to suggest ideas and, if people don't agree with them, getting feedback. I've realized: 'Well, perhaps that wasn't such a good idea,' and I've been able to think it through in my own head. It gives you an insight into what, when you leave school, to expect being an adult, how you've got to work, and how you've got to organize yourself. In life, if there's something you don't agree with, you've got to speak your mind because if you don't you'll never get what you want." Client, 15

"For me it was all about confidence. Talking to people. Before I'd be shy even to talk to grown-ups. Now I can chat away to them." Client, 15

"To be 16 years old and have a host of interesting, intelligent and creative professionals asking you for your opinions, and actually being genuinely interested in hearing them, is so refreshing. I think this is one of the great (and brave!) ideas behind the initiative. Not to be told when to speak, to be allowed to offer frank, honest criticisms and to feel comfortable to voice ideas, are not privileges usually synonymous with schoolchildren. It gave me confidence to speak up and challenge others. It introduced us to the concept of 'thinking outside the box', which has stuck with me ever since and will no doubt aide me in my career. Now I aim high and strive to achieve high." Jessica Milner, former client. 20

"I can honestly say that the joinedup-designforschools programme totally changed my life. When we spoke at Downing Street I was really nervous; everyone was so professional it was nerve-wracking. But then, a speaker from Demos got up to talk after us and he said: 'I don't want to speak after those two girls!,' which made me really proud and realize what I was capable of. Now, at university, I've got no problems when I'm asked to speak. Other students are terrified but I just feel, 'Oh, I've cracked that.' Gemma Dowse, former client, 20

Education & Design

"Designers should go into other schools because others should have the same fun as us." Client, 11

In the biggest investment in secondary education for more than fifty years, the UK government has initiated multi-billion pound plans to rebuild or renew every state secondary school in England over a fifteen-year timetable.

Fifty years ago, the UK design industry existed largely as a collection of highly skilled individuals and small partnerships. Today it has become a world leader in terms of quality, size and breadth of design disciplines. It is a mature industry with a critical mass of medium- to large-sized businesses, as well as a host of highly talented individuals.

However, the majority of the work carried out by the design industry is for the private sector in which, according to the Design Council's *Design in Britain 2004–2005* report, "the UK's most successful businesses rate design as the second most important factor for success, with only marketing judged to be more significant".

One of the aims of joinedupdesignforschools was to explore how the expertise of UK designers could also benefit schools. Over fifty design consultancies have worked on the programme, bringing skills from design disciplines such as architecture, product, new media, communication, fashion and clothing, reputation and identity, interior, landscape and graphics. Around 150 individuals from design practices have been involved, most of whom had never worked for a school before. Their contribution to the joinedupdesignforschools programme demonstrates the benefits of properly engaging the UK's design industry with schools, to make a difference to the lives of pupils and staff and create a better learning environment for the future.

At this crucial time of investment, expectation and hope, it is absolutely vital that this once-in-a-lifetime opportunity is seized, not just to build, but to *design* great schools; not just to house, but to *inspire* the young people who grow up in them.

"Most of us went to dodgy, ugly schools, and it fires you up to think: 'What if schools were brilliant? What if schools were inspiring? What if schools were what they are not? What if they weren't rubbish?'" Thomas Heatherwick, designer

"If people demand better quality of their environment, not just as clients but as users as well, then the quality of the whole environment will improve. And where better to start than at school and in their own school." Julia Barfield, designer

"Linking design with education makes you go back to absolute truths because kids smell a lie a mile off; it's like the joke that's not funny – adults laugh at it, kids won't. So, to get anywhere in this collaboration, it has to be absolutely honest. It's a truthful process; in terms of design, it's a first."
Simon Waterfall, designer

"Linking design and education has transformed our expectations of what is possible. This has done something for everyone in the school." Dr Paul Kelley, Head teacher

"People want education to function against best practice in the market, and yet they give us buildings that are sub-standard."
John Howells, Head teacher

"Our relationship with the architects was immediate. The school is left with the basis for the development of our grounds that is so much more exciting than we ever dreamed."
Kathryn Kyle, Head teacher

"There are many school buildings that, while functioning well, are not interesting places for children or adults to be. We need to develop new ideas for school design that are exciting and really work. To deliver the best and most effective education, school buildings need to be designed so that they stimulate children's imaginations and reflect advances in technology."
Mukund Patel, DfES

Overleaf: Examples of work carried out by designers who have worked on the joinedupdesignforschools programme.

Marks Barfield, BA London Eye
Fat, Blue House, London
Fletcher Priest, London Planetarium
Future Systems, Lord's Cricket Ground Media Centre
Warren + Clerkin, Creative Workbench

Graphic Thought Facility, Digitopolis Exhibition
Eldridge Smerin, Selfridges Birmingham, Level 2
Terry Farrell & Partners, The Deep Submarium
Graven Images, Room At The Top, Bathgate
Paul Smith, Spring/Summer 2005 Collection

Airside, Platform For Art website
Phin Manasseh, House, Mildway Grove, London
El Ultimo Grito, Lavazza Coffee Corner, Italy
Adams & Sutherland, EvergreenPlayAssociation
Wolff Olins, Tate Modern Brand Identity

Alsop Architects, Peckham Library
Urban Salon Architects, Skyscape, Greenwich
East, Brader Perryman Office, London
SPY, Savoy Opera, London
Frost Design London, Zembla Magazine

 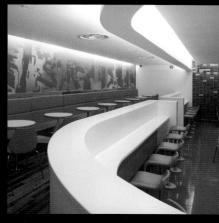

 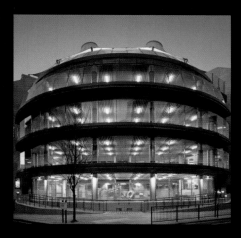

 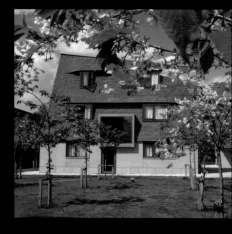

 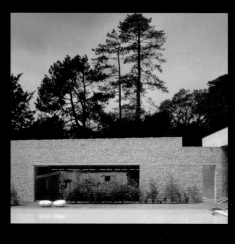 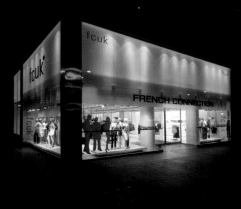

Wells Mackereth, Cafeteria
Richard Rogers Partnership, Lloyds Building, London
Ben Kelly Design, The Basement, London
Poke, Abba to Zappa website
Love Creative, Youth Justice Reports 2004

Seymourpowell, Aquaspeed iron for Tefal
Playerthree, Scooter Ace on-line game
Bisset Adams, Base youth centre, Tooting, London
Azman Associates Architects, Alexander McQueen Store
De Matos Storey Ryan, Spa, Cowley Manor, Glos.

Priestman Goode, Pendolino Highspeed Train, Virgin
Thomas Heatherwick, B of the Bang, Manchester
BDP, Hampden Gurney School, London
Digit, Digital Aquarium, Design Museum Tank
Din Associates, French Connection Store, London

Elmwood Design, Football Association Brand Identity
SHH Architects, McDonald's flagship, London
Conran & Partners, by Toaster for Sainsbury's
Cottrell & Vermeulen, Churchill College, Cambridge
ArthurSteenAdamson, St Kea Brand Identity

The Gallery

The joinedupdesignforschools programme has been an extraordinary collaboration between institutions, businesses and individuals. Schools have worked with design businesses. Pupils, teachers and head teachers have worked with architects; product designers; communication and new media experts; fashion, graphic and landscape designers; and specialists in reputation and identity. All these projects have provided the new knowledge which is described earlier in this book in Common Issues (p. 33) and Life Skills (p. 161) but, of course, each project has its own story and is special in its own way.

In this section, we record each project (in alphabetical order) with a brief description of the concept created by the designers in response to the challenge set by their clients. When viewed as a collection, they provide an inspiring snapshot of what can be achieved by collaboration.

A2 Arts College, London + Fletcher Priest

Two schools (Thomas Tallis and Kidbrooke Schools) worked together to improve youth relations in the area's community. Fletcher Priest created the concept for a versatile community arts space that is safe and engaging for both schools and the local community.

JOINEDUPDESIGNFORSCHOOLS
INVOLVED AROUND:

100 schools in projects and workshops

700 pupils in client teams

10,000 pupils indirectly involved

54 design businesses

150 individual designers

100 head teachers

175 teachers

170 visits by client teams

Abbeydale Grange School, Sheffield + Wolff Olins

The client team wanted the students to feel more pride in the school and to enhance its reputation within the wider community. Wolff Olins created a colourful identity, which reflects the inclusive nature of the school.

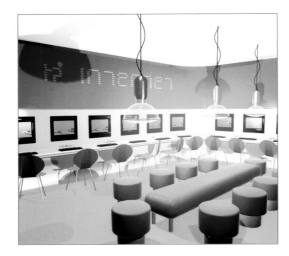

Acland Burghley School, London + SHH Architects

Fewer than half the pupils at Acland Burghley made use of their dining facilities. SHH Architects proposed a dynamic, multi-purpose dining experience that includes an Internet café and an outdoor social and learning space.

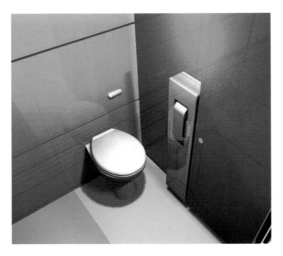

Barlow Roman Catholic High School, Manchester + Judge Gill

Barlow faced a problem common to many schools in Britain – poor toilet facilities. Judge Gill proposed bright, spacious facilities for both pupils and staff, offering a solution to the problems of vandalism and smoking.

Beechwood Secondary School, Slough + Natasha Wright

The client team wanted to address practical issues of sportswear while also looking to enhance school pride and provide a sense of identity. Natasha Wright generated a final concept for a durable, contemporary sports kit.

Aldercar Community School, Nottinghamshire + Paul Smith

The client team's brief was for a contemporary uniform that was comfortable during summer and winter. It had to be cost-effective and capable of lasting through changing fashion trends. Paul Smith met the challenge and the pupils are now wearing the new uniform.

Beacon Community Junior School, Falmouth + Kevin McCloud

The client team explored ways in which colour could alter the atmosphere of their learning spaces. The resulting design by Kevin McCloud is a bright, colourful, multi-purpose space that can be used for indoor sports, as a dining hall and to display artwork.

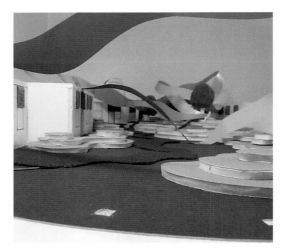

Bishopsgarth School, Stockton-on-Tees + Reckless Orchard

The client team wanted a more dynamic outside environment that was accessible for pupils with mobility difficulties. Reckless Orchard produced a concept that considers waste recycling and includes a sculptural reference to the region's steel-industry heritage.

Brecknock Primary School, London + William Warren

The client team wanted to improve storage for their belongings. William Warren created a colourful concept based on the individuality of front doors, with unique decorative panels and letter boxes. Working with manufacturers Helmsman, the pupils are now using their new lockers.

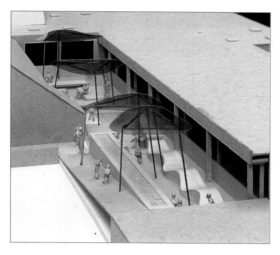

Cape Cornwall Comprehensive, Penzance + Phin Manasseh

The client team wanted a sheltered outdoor social space to go to during breaks and lunch. Phin Manasseh developed a concept that includes seating, a water feature, and a display area in which the pupils could curate their own art exhibitions.

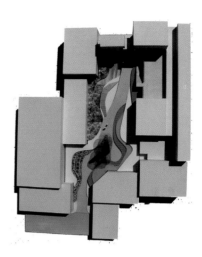

The City School, Sheffield, + Cottrell & Vermeulen

The City School client team wanted a sheltered area for a busy, open-air courtyard. Cottrell & Vermeulen developed a concept that provides flexibility, comfort and shelter, with a concern for the environment.

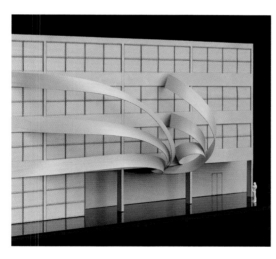

Camden School for Girls, London + Thomas Heatherwick

In common with many schools, Camden Girls recognized the importance of having a bright, welcoming and comfortable entrance area. Thomas Heatherwick's concept provides a dramatic, sculptural façade and redevelops the reception area to improve the use of space.

Castleview Primary School, Slough + BDP

A visionary process enabling teachers, governors, parents and designers to learn what pupils want in their new school building. The final concept by BDP provides a masterplan that highlights everything a modern primary school might need.

Clapton Girls' Technology College, London + Bisset Adams

Overcrowding during lunch time and lack of social space makes interaction difficult for pupils at Clapton Girls'. Bisset Adams created the concept for a contemporary building extension that incorporates a new dining area, a social/learning space and a roof garden.

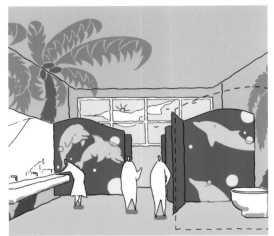

Deptford Park Primary School, London + Richard Rogers Partnership

The Deptford Park client team wanted to address the quality of the school's toilet facilities. Mike Davies of the Richard Rogers Partnership developed a concept with a Caribbean theme that's colourful, safe, hygienic and easy to clean.

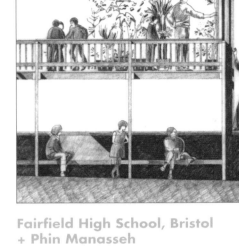

Fairfield High School, Bristol + Phin Manasseh

The client team wanted to enliven a bare tarmac playground to encourage creativity, learning and fun. Phin Manasseh proposed a multi-functional structure with improved seating, greenery and colour. The solution is transportable so that it could move with them to a new school site.

Finham Park School, Coventry + Playerthree

The client team identified an issue with school communications. It wanted a system that would allow pupils, teachers and parents to communicate efficiently. Playerthree developed a communication tool that also serves as an educational web-based game to supplement curriculum development.

Dunraven School, London + Frost Design London

This secondary school had lots going on for both pupils and the local community. Frost Design London created a concept for a magazine to help them communicate the school's individuality and celebrate its achievements.

Falmouth School, Falmouth + Urban Salon

The D&T classroom was cold, crowded, uncomfortable and noisy. Urban Salon solved practical problems and produced an exciting, sustainable and contemporary design studio concept, with a testing laboratory, library, flexible modular furniture and roof-top terrace.

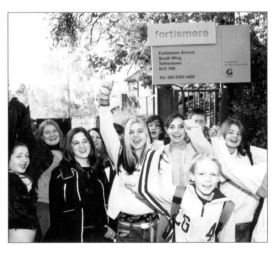

Fortismere School, London + Interbrand

The client team wanted a unifying identity that would give the pupils a better sense of community. Interbrand designed welcome packs, stationery, signs and a poster campaign that highlights student aspirations for the future. The new identity was implemented in 2003 and has been effective in unifying the school's separate wings.

Grafton Primary School, London + Adams & Sutherland

The client team wanted an outdoor space for creative work and play. Adams & Sutherland designed a concept for an exciting but safe play structure that tackles issues of supervision and provides quiet areas, shelter and adventure.

Hartcliffe Engineering Community College, Bristol + Alsop Architects

The client team identified the need for an inspiring social and work space for final-year pupils. Alsop Architects focused on retaining students at sixth-form level by proposing, a personalized learning environment where they can study and escape from the pressure of exams.

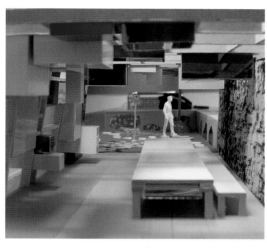

Hinde House School, Sheffield + Walters & Cohen/The Nature Room

The pupils at Hinde House School wanted to study science in an exciting, interactive way. Walters & Cohen worked with landscape designers The Nature Room to design an outdoor classroom and gardens for both educational and recreational needs.

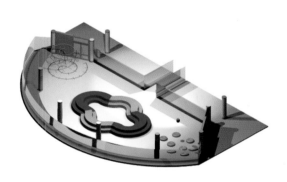

Hampden Gurney Primary, London + Conran & Partners

Hampden Gurney is a newly built, ultra-modern school. Conran & Partners' concept inspired fun and learning on their play decks by providing a space for performance and debate as well as play.

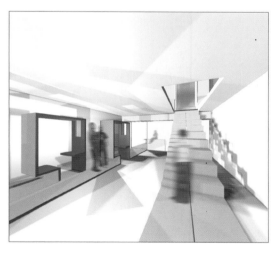

Heart of England School, Coventry + Eldridge Smerin

The pupils wanted a flexible sixth-form space that incorporated study and social areas. Eldridge Smerin developed a concept for a space that helps them deal with academic pressures by developing new ways of working and learning.

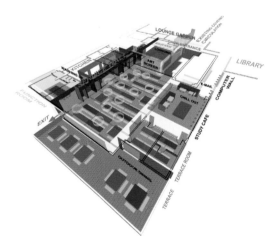

Hockerill Anglo-European College, Herts. + De Matos Storey Ryan

The client team at Hockerill wanted to modernize the refectory and solve the problem of pupil circulation at lunch times. Inspired by contemporary London restaurants, De Matos Storey Ryan solved this by designing a light, spacious and modern dining room.

Holte School, Birmingham + Trickett & Webb

Out of school hours, Holte serves as a leisure centre for community events. The pupils felt the school needed a stronger identity. Trickett & Webb designed alternatives for new logos that celebrate the school's achievements and promote its diversity and energy.

Hugh Myddelton Primary School, London + ArthurSteenAdamson

The young client team looked at the history of the school's name. Marksteen Adamson created a new school identity that welcomes visitors and enhances school pride. The scheme was implemented in 2003.

Islington Green School, London + East Architects/The Nature Room

The Islington Green client team wanted to improve the school grounds. East Architects worked with The Nature Room to transform a dull courtyard and provide secluded seating areas, planting, a wall painting and a pedestrian bridge that doubles as a performance stage. The concept was implemented in 2004.

Hookergate Comprehensive School, Tyne & Wear + Elmwood Design

The pupils wanted to improve the school's reputation. Elmwood Design developed a bright, strong identity for use on signs, stationery and school publications. They planned a community promotion campaign to explain changes in the school and to increase school pride.

Hythe Community School, Kent + Ben Kelly Design

Hythe Community School is a vibrant infants' school and Early Excellence Centre. Ben Kelly created a welcoming and safe reception area that incorporates an art gallery to show pupils' work. The project was implemented in 2003.

Ivy Bank Business & Enterprise College, Burnley + Ally Capellino

The pupils wanted a unique uniform which allowed individuality whilst reflecting the school's new Business & Enterprise College status. Ally Capellino created a concept for a personalized uniform collection that reflects the pupils' individuality.

Ivy Bank Business & Enterprise College, Burnley + JudgeGill

Ivy Bank was one of the first schools to be granted Business & Enterprise Specialist School status. As part of the bid, it developed an innovative idea for running a learning environment based around a retail space. JudgeGill's stylish, contemporary design incorporates the new school identity. The project was implemented in 2004.

Kingsmeadow Community Comprehensive, Gateshead + SPY

The client team wanted to consider reputation; they wanted to convey the inspiring, forward-thinking nature of their school. SPY developed designs for the school badge, stationery, school signs, the website, and the colour scheme for the buildings, the school bus and uniform ties. Implementation of this project began in 2004.

Leasowes Community College, Dudley + Din Associates

Din Associates created a path-finding concept that provides a unique identity and enhances the school's presence within the community complex, giving them a new space for their reception, library and café.

Kaskenmoor School, Oldham + Terry Farrell & Partners

To support the school's bid for Performing Arts Specialist School status, Terry Farrell & Partners' concept for the school hall is to create a bright, colourful, contemporary space and studios for performances and presentations.

Langdon School, London + Seymourpowell

The Langdon client team wanted to tackle issues of respect and pride in the school environment. Seymourpowell proposed an innovative solution for creating an outdoor social space with a time-capsule element. The objective is for every Langdon pupil to participate in the making of the new space.

Lode Heath School, Solihull + Future Systems

Future Systems created a concept for a performing arts facility in an outdoor quad area. The resulting concept for a social space and amphitheatre provides opportunities for relaxation and curriculum activities.

Monkseaton Community High School, Tyne & Wear + Fletcher Priest

Fletcher Priest Architects designed the 'classroom of the future'. The concept provides a unique, cost-effective solution to expand and modernize existing learning spaces, giving much-needed daylight and fresh air.

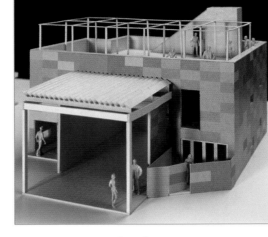

Mounts Bay School, Penzance + Phin Manasseh

Phin Manasseh was asked to help the client team create a sheltered, multi-use structure that could be managed and run by the pupils. Entitled 'The Creativity Barn', the concept is a building that allows pupils to have an alternative social and independent study area with facilities for group work, ICT and performances.

North Manchester High School for Boys + Love Creative

The pupils at North Manchester wanted to improve internal communication so that everyone knew what was going on. Love Creative proposed a pupil-facing website that is engaging and informative, and reflects the pupils' sense of fun, using a secure chat-room format that represents the school's curriculum.

Mount St Mary's Catholic High School, Leeds + Elmwood Design

The client team wanted to tell outsiders what it had achieved and what it was doing for the wider community. Elmwood's concept was a web design that gives information about the school from the pupil's perspective, animated with cartoon drawings based on the pupils themselves.

Newquay Tretherras School, Newquay + Marks Barfield

The client team wanted to revitalize the school entrance and create a sheltered outdoor area by utilizing 'dead space'. Marks Barfield developed a concept for a welcoming Hollywood-style palm-tree walk, with a dome-structured canopy that provides sheltered space to socialize, exhibit work and present plays and concerts.

Park View Academy, London + Poke

Although the school had excellent IT facilities, the client team felt they needed a system to make communication easier, so that everyone knew what was going on. Simon Waterfall from Poke designed a revolutionary, interactive tool that improves pupil-to-pupil and teacher-to-pupil communication.

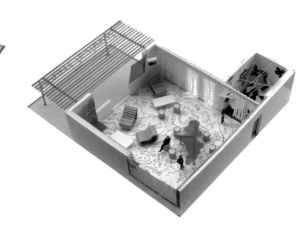

Plumstead Manor School, London + Priestman Goode

Plumstead Manor had a limited number of lockers for its 1200 pupils. As a result they shared lockers that were easily broken, broken into, had limited storage and took up large areas of corridor space. Priestman Goode proposed a unique, secure, space-saving solution.

Quarry Brae Primary School, Glasgow + Graven Images

The client team at Quarry Brae told their designers that their classrooms needed more space and versatility. The Victorian classrooms had high ceilings but limited floor area. Graven Images proposed a 'tree-house' construction that utilizes redundant classroom space to provide a quiet reading area with IT facilities.

The Ramsgate School, Kent + Wells Mackereth

The Ramsgate School is being rebuilt: the client team wanted a pleasant last year in the existing space. Sally Mackereth designed three colourful, contemporary interiors that respond to the pupil's need for a relaxing place to socialise and that could be created with off-the-shelf products.

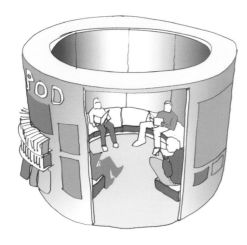

heads in the clouds.

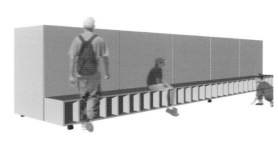

Porter Croft CE Primary School, Sheffield + Pringle Richards Sharratt

The pupils at Porter Croft wanted a cheerful, welcoming new entrance area. Pringle Richards Sharratt created a design for a bright, colourful space that includes a special reading zone and story-telling hub.

The Ramsgate School, Kent + Casson Mann

The client team at Ramsgate School was a group of girls, aged 13 to 15, known as 'The Sisters'. Casson Mann's concept looks at maximizing the potential of their Power House, an area that is a refuge from the pressures of home or school life, where they can explore different kinds of learning in a multi-sensory environment.

Ranelagh Primary School, London + Eldridge Smerin

The Ranelagh client team wanted to find a more efficient storage solution for the school. Eldridge Smerin's concept combines privacy for changing during PE lessons with seating and storage units, as well as different lockers for older and younger pupils. The concept helps solve the problem of pupil flow in a busy school.

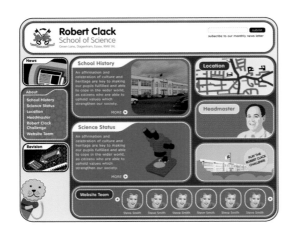

Robert Clack School of Science, Dagenham + Airside

As pupils in a fast-improving school, the client team at Robert Clack felt it was time their achievements were made known throughout the community. The concept design by Airside provides an accessible website for a broad audience, combining educational and informative elements, in a vibrant representation of the school.

St George's Catholic School, London + Ben Kelly Design

The client team wanted to make dining enjoyable and spend less time queuing outside. Ben Kelly's concept transforms the school hall to provide more space, daylight and colour. It changes the flow to speed up queuing and includes designs for unique, lightweight tables and seating that folds against the walls.

Summerhill School, near Dudley + Graphic Thought Facility

Summerhill School has moved to a new building. Graphic Thought Facility developed a navigational system and signs that reflects the school's character and its new foreign language specialist status. The project was implemented in 2004.

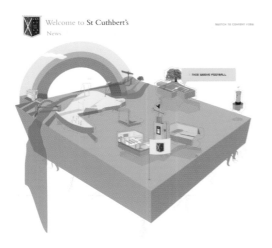

St Cuthbert's Catholic High School, Newcastle + Digit

St Cuthbert's client team wanted to find a way of promoting the school to the wider community. Interactive web designers Digit conceived a website that communicates effectively with a variety of audiences through a log-in system.

Speedwell Technology College, Bristol + Fat

The client team addressed the need for a modern approach to the design and function of art rooms in schools. Fat designed a free-standing art gallery and outdoor shelter, which concentrates on the storage and display of art, while tackling the internal environment and practical requirements.

Sussex Road Primary School, Tonbridge + East Architects

The client team at Sussex Road wanted to find a way to improve the space and atmosphere of their busy entrance area, which is used by pupils, teachers, office staff, parents and visitors. East Architects proposed an exciting and contemporary 'Box of Tricks' as a dynamic addition to the school.

Swanlea School, London + Deepend

The client team wanted to find better ways to communicate. Deepend created an online, interactive game to encourage learning and to help visitors understand the school. 'Skoolrush' uses the plan of the school to help new pupils navigate their way around by solving curriculum-based questions. The game was implemented in 2001.

Wentworth High School, Manchester + El Ultimo Grito

The pupils at Wentworth High School carry their heavy bags with them during school hours. El Ultimo Grito devised a new storage facility and addressed the need for wheelchair access. The concept involves a locker display gallery as a solution for limited storage space in narrow school corridors.

William Patten School, London + Theis & Khan

While starting with the idea of making use of a neglected building by turning it into a sports factory, the result of this project was a total rethink of the school grounds. The final design by architects Theis & Khan involves pathways, a sports pitch, a roof garden, a pond and a new multi-purpose building for creative activities.

Treviglas Community College, Newquay + Marks Barfield Architects

Lack of space during lunch time led to overcrowding, long queues and some behavioural issues. Marks Barfield Architects came up with an exciting, woven wooden structure for covering a large, unused courtyard next to the dining area. The concept provides sheltered space with landscaped seating for eating and relaxing, and a stage for special events.

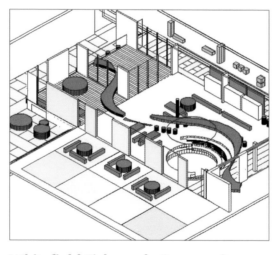

Whitefield Fishponds Community School, Bristol + Azman Associates

The client team developed ideas for a creative, multi-purpose, outdoor space for performance, art exhibitions, activities and socializing. The project tackles a problem common to many schools: internal overcrowding at break times. Azman Associates Architects' concept provides a focal hub to the school with lively, bright and flexible areas.

Withywood Community College, Bristol + Alsop Architects

Withywood wanted to create an outdoor sheltered activity area, a multi-functional space in which students could express themselves creatively, and learn. Alsop Architects proposed developing under-utilized external areas to address overcrowding and to provide a stimulating outdoor facility.

We would like to thank all the schools, pupils, staff, head teachers, design businesses and individual designers who have taken part in joinedupdesign forschools. Special thanks for their work on this book: writer Nick Skeens; designers Fay Cuthbertson, Pete Howe, Andrew Collier and Scott McGuffie; design adviser Marksteen Adamson; project manager Philippa Richards and copy editor Mary Scott. For their work on the joinedupdesignforschools films our thanks to: director Iseabal MacIver; editor Lawrence Barraclough; camera directors Henry Richards and Oliver Ralfe; interviewer Nick Skeens. For the pilot programme film production: TV6 and 4Learning. For their work on the joinedupdesignforschools exhibition at the Victoria & Albert Museum: exhibition designers Eldridge Smerin; exhibition graphics Fay Cuthbertson; exhibition builders TWG. Thanks to all at the V&A, especially Gwyn Miles, David Anderson, Damien Whitmore, Kara Wescombe, Helen Downing, Michael Casarteli and Clare Cotton. We would like to thank the Department for Education and Skills: David Hopkins, Mukund Patel, Shaw Warnock, Mike Gibbons and Anne Diack. Special thanks to: Kris Barber, Etienne Bol, Lida Cardozo-Kindersley, David Carroll, Alistair Creamer, Fritz Curzon, Giselle Domschke, Vince Frost, Bridget Gaskell, Antony Gormley, Peter Hamilton, Jane Leslie, Alan Livingston, Estelle Morris, Lord Puttnam of Queensgate and Peter Skerrett. We would like to thank the directors and staff of over 100 venues visited by the client teams and those who hosted workshops: Airside, AK Engineering, Alternative Fashion Week, Antony Gormley Studio, ARAM Showrooms, Arup Bristol, At-Bristol Explore Exhibition Halls, Baltic, Bar 38, Barbara Hepworth Museum and Sculpture Garden, Base Tooting, Bisley Office Furniture, Bloomberg, Borough Market, British Airways London Eye, British Library, British Museum, Business Design Partnership, Camden Arts Centre, Canary Wharf Tube Station, Candid Arts Trust, Cartoon Network, Centre for Alternative Technology, Channel 4, City Hall, Construction Resources, Creative Partnerships, Culpepper Community Garden, Delleve Plastic Ltd, Demos, Design Museum, Docklands floating bridge, Dulwich Picture Gallery, Earth Centre, Ed's Diner, Evergreen Adventure Playground, Explore Exhibitions, Falmouth College of Arts, Terry Farrell & Partners, Geffrye Museum, The Green Building, Hampden Gurney School, Harrison Learning Centre, Thomas Heatherwick Studio, Imagination, Imperial War Museum, Laban, Life Centre, Lisson Gallery, London Aquarium, London Zoo, Lord's Cricket Ground Media Centre, Phin Manasseh's Private Residence, Market Place, Marks Barfield Architects, Mash, McDonald's Oxford Street, Millbank Millennium Pier, Millennium Bridge, Millennium Dome, National Maritime Museum Cornwall, National Museum of Photography Film & Television, National Theatre, National Theatre Studios, Natural History Museum, Newlyn Art Gallery, Niketown, One Central Street, Oxo Tower, Peckham Library, Pringle Richards Sharratt Architects, Purdy Hicks Gallery, The River Café, Royal Festival Hall, Royal Victoria Dock Footbridge, Sadler's Wells, Sanderson Hotel, Science Museum, Selfridges, Birmingham, Selfridges Manchester, Seymourpowell, Shakespeare's Globe, Sheffield Hallam University, Sketch Gallery, Paul Smith shops, Smiths of Smithfields, the Smith Institute, Somerset House, Sony Stardotstar, R K Stanley, Talacre Community Sports Centre, Tate Modern, Tate St Ives, Tate to Tate Boat, Thames Water, Theis & Khan Architects, Think Tank Millennium Centre, Tower 42, Urbis Centre, Vitra, Wagamama, Walters & Cohen, Westbourne House, White Cube, William Warren Studio, Wolff Olins, Woolworths Kids First, Yo! Sushi, John Young's Private Residence, and the Young Vic.

And we would like to say a very special thank you to all the members of the Sorrell Foundation team for their tremendous contribution to this book and the joinedupdesignforschools exhibition at the V&A, as well as for all their work and commitment to the joinedupdesignforschools programme: director Sharon Plant; project managers Sondre Ager-Wick, Sean Hurley, Helen Lowdell, Kati Price and Kumal Sond; administrators Jo Baker, Alan Milestone, and past members of the team David Goodlet, Sally King, Ian McDonald, Adriana Paice, Emma Wrafter and Shelagh Wright.

186 State-of-the-art school buildings can improve educational standards and have a positive effect on everyone who uses them. That is why the Government launched an ambitious five-year strategy for children and learners, backed by a record level of investment in school buildings and Information and Communications Technology (ICT), which will radically improve the quality of education provision for all children in this country and create high-quality resources for the whole community.

Investment in 2004–05 is £5.5 billion, rising to £6.3 billion by 2007–08, including Public Finance Initiative (PFI) credits and investment in ICT. This compares with under £700 million in 1996–97.

The increase in funding marks a leap forward in investment planning. It will enable strategic and radical changes to be made to the schools' estate. Around £2 billion a year will be spent on the Building Schools for the Future programme, with the aim of rebuilding or renewing all secondary schools over the next ten to fifteen years. Over the same period there will also be substantial investment in primary-school buildings.

This offers a rare opportunity to transform the educational built environment and must not be wasted. The legacy of the last major school-building programme is still with us and is still being paid for. The many over-glazed, poorly insulated and often porous buildings of the 1960s and 1970s generally have high running costs and, unless well maintained, do not provide the learning and working environments needed today. We must not make the same mistakes now.

There are also many school buildings that, while functioning well, are not interesting places for children or adults to be in. Do they contribute to raising educational achievement? The designs of offices, research centres, galleries and museums have changed enormously in the last twenty years, but most schools built during the last thirty years could have been designed sixty years ago. We need to move forward and develop new ideas for school design that are exciting and really work. To deliver the best and most effective education, exploiting all the possibilities of ICT, school buildings need to be designed so that they stimulate children's imaginations and reflect advances in technology. They need to provide high-quality environments that are conducive to learning, and that are functional without being boring. They must be able to cope with changes in a future that we cannot predict.

It is for this reason that we are trying out new ideas. We are looking at ways of designing inspirational buildings that can adapt to educational and technological changes. ICT can give schools the option of teaching children in a variety of ways, and can provide electronic links to other schools and facilities in this country and abroad. This will not happen if we design spaces in schools that do not facilitate various patterns of individual and group working. Flexibility is key, because whatever visions of education we design our buildings around now, we can be sure they will need to perform in a very different way in a few years' time.

The Department launched a number of design initiatives over the last few years, such as: **City Learning Centres** – eighty innovative projects, rich in ICT, aimed at raising standards in inner city secondary schools; **Classrooms of the Future** – twenty-six pilot projects, spread among twelve London Education Authorities (LEAs), testing out innovative designs for schools; **Teaching Environments of the Future** – the sequel to Classrooms of the Future, examining how design can help resolve school workforce issues. Eighteen LEAs are developing pathfinder projects; **Exemplar Designs** – eleven designs, five for primary, five for secondary and an aged five–eight all-through school from some of the best designers today, which explore ideas and concepts for the school in the twenty-first century and act as springboards for developing imaginative and sustainable school buildings, tailored to local needs and aspirations.

Information on these and other projects and DfES publications is on the Department's website: *www.teachernet.gov.uk/management/ resourcesfinanceandbuilding/schoolbuildings*



One of the keys to the development of successful school building designs is the involvement of pupils and teachers in schemes appropriate to local need. For this reason, the DfES supports the Sorrell Foundation's joinedupdesignforschools programme, which has devised ways of working with pupils as the clients of leading architects and designers.

In addition, the DfES Innovation Unit supported a series of workshops held at the Victoria and Albert Museum during the joinedupdesignforschools exhibition, which showcased the exciting work that came out of this project and explored issues raised by pupils. The DfES Innovation Unit acts as a catalyst for change in the school system, by bridging policy and practice to create an arena in which all parties can develop innovative responses to those learning challenges that face the education sector. The issues that arise when creating state-of-the-art school buildings are many and varied, but the perspectives of teachers and pupils are a crucial part of the mix if the potential of this radical investment in the school building programme is to be fully realized.

Keep in touch with the Innovation Unit via our website: *www.standards.dfes.gov.uk/innovation-unit* and join our lively online neighbourhood. We look forward to welcoming you.

innovation
department for
education and skills
creating opportunity, releasing potential, achieving excellence

Architecture Foundation
www.architecturefoundation.org.uk

CABE (Commission for Architecture and the Built Environment)
www.cabe.org.uk

Crafts Council
www.craftscouncil.org.uk

Creative Futures
cadise (Consortium of Arts & Design Institutions in Southern England)
www.creativefutures.cadise.ac.uk

Creative Partnerships
www.creative-partnerships.com

CUBE (Centre for the Understanding of the Built Environment)
www.cube.org.uk

D&AD (British Design and Art Direction)
www.dandad.org

dba (Design Business Association)
www.dba.org.uk

Design Council
www.design-council.org

DEMOS
www.demos.co.uk

Design Museum
www.designmuseum.org

Institute of Structural Engineers
www.istructe.org.uk

The Institution of Engineering Designers
www.ied.org.uk

ISTD (International Society of Typographic Designers)
www.istd.org.uk

LI (The Landscape Institute)
www.l-i.org.uk

The London Design Festival
www.londondesignfestival.com

RIBA (Royal Institute of British Architects)
www.architecture.com

Royal Academy of Engineering
www.raeng.org.uk

RSA (Royal Society for the encouragement of Arts, Manufactures and Commerce)
www.rsa.org.uk

School Works
www.school-works.org

The Urban Design Group
www.udg.org.uk

V&A National Art Library
www.vam.ac.uk

Adams & Sutherland: Adams & Sutherland is an innovative young architectural practice set up in 1997. They undertake a diverse range of work for public and private clients, to which they bring a clear and sensitive design approach and a commitment to engaging creatively with users.
www.adams-sutherland.co.uk

188

Airside: Airside is a London-based design group, started in 1999. They work in every possible medium – at the moment they're working on knitting, screenprinting, badgemaking, pop promos, posters, websites, brand identities, events, T-shirts and animations for mobile phones. They are ideas-led. They believe that all design is experiential design, and focus on elegant and efficient interfaces, whatever the medium. They believe in communities and create them through their work by inspiring and empowering people.
www.airside.co.uk

Ally Capellino: A design company producing a range of designer handbags and accessories, which are sold worldwide, mainly in Japan, Italy and the UK.
www.allycapellino.co.uk

Alsop Architects: Will Alsop is one of the most prominent of UK architects. His practice is an international operation, but one guided by the principle that architecture is both vehicle and symbol of social change and renewal. Will follows a parallel path as an artist, feeling that it is a discipline inseparable from architecture. He has held many academic posts, and actively promotes the artistic contribution to built environments.
www.alsoparchitects.com

ArthurSteenAdamson: Established in 2003, ASA is a new and innovative branding agency. All their work is driven by inspiring people, shareholders or the public in general. Their clients include the BFI, BUPA, Film London, 3G, Lloyds and St Kea.
www.asawebsite.com

Azman Associates Architects: Established in 1993, the practice's completed projects include a RIBA award-winning concrete house, Alexander McQueen's flagship store and recent exhibitions for the Victoria and Albert Museum and the Barbican. Current projects include a new café chain and a feasibility study for a series of hotels in Copenhagen.
www.azmanassociates.com

BDP: BDP creates a wide variety of award-winning buildings and spaces, aspiring to create the very best user-centred and inspirational environments, including the first Stirling Prize shortlisted primary school.
www.bdp.co.uk

Ben Kelly Design: A multi-disciplinary interior design team, which has produced seminal work, influencing the design of interior spaces both in the UK and worldwide.
www.benkellydesign.co.uk

Bisset Adams: Founded in 1994, Bisset Adams is a design consultancy with core specialisms of architecture, interiors and brand identity, allowing them to take a holistic approach to design commissions.
www.bissetadams.co.uk

Casson Mann: An interior/exhibition design company, working for public and private clients on a variety of multi-disciplinary projects both national and international, including the British Galleries at the Victoria and Albert Museum and the Churchill Museum at the Imperial War Museum.
www.cassonmann.co.uk

Conran & Partners: Sebastian Conran has gained a reputation for simple, ingenious design and inventions, which have been awarded numerous design, marketing and innovation awards.
www.conranandpartners.com

Cottrell & Vermeulen: They respond to place, client vision, and the participation of the users. They bring invention and understanding to each project, translating the things they find into beautiful and effective architecture.
www.cv-arch.co.uk

De Matos Storey Ryan: Their objective is to create simple, well-detailed and affordable modern environments. They see architecture as an all-encompassing medium, incorporating landscape and all forms of design.
www.dmsr.co.uk

Deepend: Deepend was one of the world's leading digital agencies before it closed its doors in 2001. The Skoolrush project enjoys continued development in the hands of Playerthree.
www.playerthree.net

Digit: Interactive design agency Digit has become well known for its websites punctuated with humour and innovative playful installations. Current clients include Vodafone, Motorola, Habitat, the NHSU and Stella McCartney.
www.digitlondon.com

Din Associates: Award-winning design consultancy established in 1986. The practice has a reputation for innovative contemporary design, servicing clients such as the National Gallery and Selfridges. *www.din.co.uk*

East Architects: East is an internationally recognized, London-based architecture, landscape, and urban design practice. They concentrate on projects of public relevance and have a fresh, direct and collaborative approach.
www.east.uk.com

El Ultimo Grito: A creative studio specializing in design. They work across the different design disciplines, with a strong conceptual approach. Their projects range from graphics to interiors, passing through clothes, industrial products and packaging. Their clients include Magis, Griffin, Mathmos, Marks & Spencer, Nola and Lavazza.
www.elultimogrito.co.uk

Eldridge Smerin: Educational projects apart, projects range from the first house shortlisted for architecture's Stirling Prize, to one floor of Selfridges' new Birmingham store.
www.eldridgesmerin.com

Elmwood Design: Elmwood is one of the UK's leading, independent, multi-disciplinary branding and design consultancies, with offices in Leeds, London and Edinburgh. Their clients include the BBC, HBOS, B&Q, BT, ASDA, McVities, Whyte & Mackay and The British Council. Elmwood has won many awards, as the effectiveness of their work has been recognized by the judges of major competitions in the UK and the USA.
www.elmwood.co.uk

Fat: Fat produces architecture and urban design of the highest standard. Clients include the City of Rotterdam, Urban Splash, Kessels Kramer and Diesel.
www.fat.co.uk

Fletcher Priest: Fletcher Priest Architects undertake masterplanning, architecture and interior commissions across a portfolio of workplace, residential, research, retail and arts and leisure projects. Fletcher Priest Architects are based in London and Cologne.
www.fletcherpriest.com

Frost Design London: Established in 1994, Frost's innovative use of photographic images and striking typography has been applied to a diverse range of projects and won the company many accolades.
www.frostdesign.co.uk

Future Systems: Future Systems, led by principals Jan Kaplicky and Amanda Levete, is established as one of the UK's most innovative architectural practices, challenging traditional preconceptions of space.
www.future-systems.com

Graphic Thought Facility: Established in 1990, Graphic Thought Facility is a small graphic design studio, with particular experience in exhibition design and print production.
www.graphicthoughtfacility.com

Graven Images: Graven Images is an award-winning, cross-disciplinary design consultancy, specializing in graphic, interior and exhibition design for corporate businesses in the UK, Europe and worldwide.
www.graven.co.uk

Greyworld: Greyworld is a group of artists who create urban art through the mediums of installation, sculpture and multiples, with the aim of encouraging interaction with the audience.
www.greyworld.org

Interbrand: Marksteen Adamson, as Global Creative Director for Interbrand, created and led numerous high-profile international identity programmes, including PriceWaterhouseCoopers, Pharmacia & Upjohn and Welcome to Estonia.
www.interbrand.com

JudgeGill: JudgeGill was formed in 1993, with a focus on developing all areas of communication and collaboration. From this foundation they have evolved to create unique design solutions across all disciplines.
www.judgegill.co.uk

Kevin McCloud: Kevin McCloud is a writer and broadcaster, and one of Britain's foremost authorities on domestic architecture and design. He has written several books and is a regular contributor to magazines and newspapers and, among other things, presents the Grand Designs series for Channel 4.
office@mccloud.co.uk

Love Creative: Voted the best design company outside London by *Design Week*, Love Creative work in a number of disciplines: corporate identity, advertising and anything and everything else … .
www.lovecreative.com

Marks Barfield Architects: Marks Barfield Architects is an award-winning practice that is commercially aware yet ethically driven, and is dedicated to the creation and delivery of buildings and environments that are imaginative, sustainable and enjoyable to use. They integrate visionary design, high-quality engineering and communication, with a commitment to intelligence, innovation and integrity.
www.marksbarfield.com

Natasha Wright: Natasha Wright is a new innovative designer whose work travels two distinctive but intertwined paths. Her mastership of both glamorous high fashion and casual urban glamour have led to her appointment as design consultant at firms as diverse as FUBU New York and Raphael Lopez London.
www.natashawright.com

Paul Smith: Established in 1970, Paul Smith has earned a place at the forefront of British men's and women's fashion for his classic tailoring 'with a twist'.
www.paulsmith.co.uk

Phin Manasseh: This practice makes careful buildings through commitment to collaboration – a prerequisite for sustainability. Appropriate design allows unexpected qualities to emerge. Work includes residential, school, theatre, studios and industrial projects.
phin@manasseh.plus.com

Playerthree: Playerthree have been purveyors of fine games and interactive content for web, mobile and ITV since 2001.
www.playerthree.net

Poke: A barrel load of monkeys herding a flock of cats through the digital superhighway.
www.pokelondon.com

Priestman Goode: Priestman Goode specialize in product, transport and environment design. Clients include BAA, Lufthansa, Virgin Trains and more … .
www.priestmangoode.com

Pringle Richards Sharratt: This award-winning practice were established in 1996. They provide an individually focused and bespoke approach to design projects, from museums and galleries through to commercial and residential.
www.prsarchitects.com

Reckless Orchard: Reckless Orchard is a young landscape design practice that explores traditional landscape themes and reinterprets them, often in urban, community-orientated locations. Their designs aim to be both evocative and provocative.
www.recklessorchard.com

Richard Rogers Partnership: Richard Rogers Partnership is a leading international architectural practice, with 130 staff and offices in London, Barcelona, Madrid and Tokyo. Key projects include the Pompidou Centre, Paris, Lloyd's of London, Channel 4 TV, Terminal 5 Heathrow, Madrid Airport and the Millennium Dome at Greenwich. New commissions include Birmingham Library, the National Assembly for Wales, Cardiff, and law courts in Antwerp. Extensive masterplan experience includes schemes in the UK, Germany, Italy, Portugal, Mallorca, China and Singapore.
www.richardrogers.co.uk

Seymourpowell: Seymourpowell is one of Europe's most celebrated product design consultancies, creating innovative products for international markets on behalf of some of the most well-known brand names in the world.
www.seymourpowell.com

SHH Architects: SHH are architects and designers working in retail, leisure, offices, residential, exhibition and environmental graphics. Based in Hammersmith, West London, the practice was set up in 1992 by directors Spence, Harris and Hogan (SHH).
www.shh.co.uk

SPY Design: Dedicated to creative agitation, fun and inspiring minds, SPY are an innovative and free-thinking brand agency whose clients span both the private and public sector.
www.designspy.co.uk

Terry Farrell & Partners: Terry Farrell & Partners (TFP) is a London-based practice of architects, planners, masterplanners and urban designers, which has been established for forty years. TFP specialize in placemaking both in the UK and overseas. Key concerns of the practice are a commitment to sustainable regeneration projects, high-quality architecural design of buildings and the enhancement of the public realm.
www.terryfarrell.co.uk

The Nature Room: The Nature Room was founded by Anne MacCaig. She is a designer and photographer using nature as inspiration for interior and exterior environments.
www.thenatureroom.com

Theis & Khan: As well as the award-winning Jubilee Waterside Centre, projects include a wide range of public buildings, from art galleries to youth centres as well as private one-off houses, all undertaken with passion and commitment.
www.theisandkhan.com

Thomas Heatherwick: Thomas Heatherwick Studio was founded in 1994 to bring together architecture, design and sculpture. Projects include *B of the Bang*, the UK's tallest sculpture; a rolling bridge in Paddington; and a Buddhist temple in Japan.
www.thomasheatherwick.com

Trickett & Webb: Trickett & Webb was a design company which was in practice for thirty-three years. The company won many awards, including seven D&ADs, for their work on postage stamps, packaging and identity.

Urban Salon: Urban Salon is one of the most innovative architectural and design practices in the UK, with a portfolio covering architecture, interiors, exhibition design and research. Runners up in Young Architect of the Year in 2000, the studio specializes in complex projects that require unconventional, speedy and inventive solutions.
www.urbansalonarchitects.com

Walters & Cohen: Walters & Cohen was founded in 1994, and has built up a portfolio of completed work and competition wins in the sectors of education, leisure, housing and the arts.
www.waltersandcohen.com

Wells Mackereth: Sally Mackereth is an architect and partner at Wells Mackereth, which was established in 1995. Completed projects include Smiths of Smithfield, West Street bar restaurant and hotel, Triyoga, Scout gallery, Pringle of Scotland stores and Stone Island.
www.wellsmackereth.com

William Warren: William's designs in furniture and products require us to think a bit more about the things we use and own. He often develops projects alongside manufacturers.
www.williamwarren.co.uk

Wolff Olins: Ned Campbell and Charlotte Hopkinson are designers at Wolff Olins. The consultancy is recognized for its creativity and cut-through thinking, and has offices worldwide.
www.wolffolins.com

Index

Photographic credits

Our special thanks to Peter Hamilton, Fritz Curzon and members of the Sorrell Foundation team for the reportage photography, throughout this book

The author and publisher would like to thank the following photographers and copyright holders for the use of their material.

First published 2005 by Merrell Publishers Limited

Head office
81 Southwark Street
London SE1 0HX

New York office
49 West 24th Street, 8th floor
New York, NY 10010

www.merrellpublishers.com

Publisher: Hugh Merrell
Editorial Director: Julian Honer
US Director: Joan Brookbank
Sales and Marketing Manager: Kim Cope
Sales and Marketing Executive: Emily Sanders
Managing Editor: Anthea Snow
Editor: Sam Wythe
Design Manager: Nicola Bailey
Junior Designer: Paul Shinn
Production Manager: Michelle Draycott
Production Controller: Sadie Butler

British Library Cataloguing-in-Publication Data:
Sorrell, John
Joined up design for schools
1.Design 2.Design – Study and teaching – Great Britain
I.Title II.Sorrell, Frances
745.4

ISBN 1 85894 308 6

Design Team: Fay Cuthbertson, Pete Howe,
Andrew Collier and Scott McGuffie
Design Adviser: Marksteen Adamson
Project Manager: Philippa Richards
Edited by: Nick Skeens
Copyedited by: Mary Scott
Indexed by: Christine Shuttleworth
Printed and bound in Slovenia

MALL REBECCA AYRES CAROLINE BOOTH EMMA HALL EMMA RACHEL JONES RACHEL JONES
WILLIAMS KYLE DONE JACK GREEN DAVID HARMAN JOSH MORGAN JADE RUSSELL HANNAH HODGSON DOMINIC ROG
N AMY ELLIS JUSTINE AKERS-HART KIM BURKE CATHERINE BREISLIN DOMINIC MCDONNELL KERRIE MAGUIRE LAURA BRISCO
HIE KAUR EVIE PETRONI WINCY PANG PETER MOORES TOM O'NEIL MADDY SANDILANDS LUKE BIGGS NATHAN HOWE
D LEAH GLANVILLE STEPHANIE GOOCH JENNA HONEYWELL MICHAEL KNIGHTON SAN SAN LAU JONATHAN LAWRENCE
AS AMY BLOOMFIELD CHARMAINE DEFREITAS CRAIG CHALKER LOUIS SPENCER BRETT NELMES JODIE LIAS OLUBUMI BALOG
ELD LAURA HAINING DONNA RANKIN CHARLIE WILSON SCOTT ARLIDGE CHRIS HOPKIN JONATHAN NIZTOLOMSKI PHILIP
JENG LOTTIE ENGLAND JACK EVANS LEOR HERMAN HAYLEY KAVANAGH KERRY KNIGHT AMANDA LORING ALICE ST ROSE
OSBORNE DANIEL SCOTHERN ADEKUMBI ADEROUNMU TOPE AJALA GBOLAHAN BALOGUN AISSATA IBRAHIM JI CHANG-P
RY MARVIN RAMSON LOUIS ROMANUS ALICE GEORGETURNER DAVID PEACH KRYSTAL HAY WILLIAMS YAN WONG PAUL
PHER SCOTT PHILLIP TEE RACHAEL WHEATLEY LEAH BOYLE CARYS BRADLEY MEGAN COWLES JACOB DAVIES PETER LEVI RO
BATKINSHIP LUCY CORNELIUS ROHAN D'SOUZA ABDULLAH FAWAZ KATHERINE FOYLE KHAIYA HEWITSON EBONYMIN
HA AZIZ JOSEPH BATTISTE MAHBUBA BEGUM AKSA HUSSAIN ASAD KHAN RAISI MEADE AKHTAR MIAH CHANTIMA BRYA
RRO MINH TRAN LUCY WARRELL ELLIE HANKINS HAYLEY BROWN MARNIE BROWN JAKE BUSS LOUISE MILLS LIAM SHONIE
ABE JORDAN PAGE CLAIRE PRIOR AARON SMITH ABIGAIL SOLEY SAM TAYLOR HELEN CARNAFFEN RACHEL COX GEMMA
AH DIXON LIANNE DODGESON THOMAS GIBSON NICOLA JOHNSON RAYMOND LAVELLE FRANCINE MALPAS NICHOLAS
USAN KAYA EDWARD MENSAH NIKISHA PILE CHRISTINA RHODES ROXANNE COPELAND CHARLOTTE CURRAN SARAH DEA
WONG MARK ANDERSON JADE BLACKMOOR DANIELLE CURRAN CLAIRE KELLY ROBBIE LITTLE PAMELA TRAYNOR ANDREW
MY MEANY HAUWA MUKTARI SANDRA NUNES DANIELLE O'SHEA PEDRO QUEIROZ MICHELLE TANNOR KRIS WEAVILL CHES
ORRIS STEVEN MORTON ANNE-MARIE PAGE ALEX PLANT VICTORIA PLANT HELEN RETALLICK JAYNE ROPER LIAM ROSEBLADE
GUM HASANUL HOQUE IMRAN MAQBOOL MIZANUR RAHMAN INDER SINGH JOSHIM UDDIN FETEHA KAHN RUPA PUJA
ISSA KING HANNAH LAMBER TAMMY LEACH KIM LE MARE KELLY PALMER LAURA PRIOR GEMMA VINE SAM BROWN RICH
IGHAM BELLA SOUTHWORTH-SIMONS SHIKERA COLE ABI BENNETTS JAMES MALLINSON RHIANNON CLOSE ILONA TARN
OPHER PHILLIPS CHLOE JACKSON ANNA JAY BELLE TAYLOR KITT THORNTON GIDEON BERESFORD PIARA SHARPE REBECCA
TEGAN MCLEOD FREYA MUSTARD SOPHIE SCHORAH LAMORNA ROWE ZACH PODD DOMINIQUE PENDER REBECCA OR
ORD JACK LIDDICOAT EAVEN ARMSTRONG ROSE MERTON DAVID PRATT HOLLY HUDSON TAMSIN ASTLEY MATTHEW LATT
SAM CASCARINA MATTHEW WHORWOOD ALEX TOY MELISSA WILLIAMSON ABBY HADDRELL RORY TAYLOR HANNAH HE
ON CRAIG BARCLAY EMMA HARNS BRETT MACE LYNE WHITFIELD BEN WHITE SPENCER STAFFORD ORLANDO DIVER MAX
WARTH REBECCA JAMES AMY LANCASTER SEAN O'BRIAN THEA SLOTOVER MARGARET STALFORD LIAH TEDE MOHAMME
ONTAGUE MIKA ROSS SOUTHALL HELENA MESSITER-TOOZE CHLOE DUNBAR CARLY ROBINSON RHIANNON EVANS MIREI
ELA KONDELL JAKE SIMM PAPOUI BENJAMIN O'HARA AALIYAH MACKAY AJASA SAMUEL EATON BETUL AKSOY MEHMET A
XUE KAMSH CHAN KERRY SMITH LUCIA ADAMS JODY-ANN BROWN DALE LALL BETHAN ELLIS AYSUN YILMAZ TERESA TRIM
JE SMITH MICHAEL AGYEMAN SARAH NASH RIA DEAN KIRSTIE COSTIGAN CHRIS JOYCE EMMANUEL AYINDE CLAIRE MOO
TON ANNA LUNIN DAN BURLEY OMAR CHRISTIE JOHN HOWARTH MERYEM TOSUN ROSHAN IRISH ZUNED DAHANUWA
HUDSON CAROLINE REENLEES LINDSEY WILDE HELEN MAHON JOHN RHODES JAMIE DUNNE LAUREN DENNETT STEVEN
JONES NATASHA BUX LAURA SMITH SHAWNEE POOLE SEAN JACKSON EMMA WATSON JORDAN MITCHESON MATTO
ONG LAUREN DAULTON ASHLEY PEARCE DAVID MINTO KAYLEIGH CHAN WINNIE HUI BEN POOLEY ROBYN MANSFIELD
R LIGHTFOOT JOHN HUGHES LUCA DELTODESCO SIMON DRUMMOND DOUG DALY OLIVIA MADDEN CARMEN RICHARDS
Y AUCAM COLOMA SITHEE KOTECHA ROBYN STAINROD JOSH JARVIS DAMON HINCHLIFFE DAISY JUBB REDD KEMPTON
ANTON JADE KELLY AISHA YOURIS MERISSA GULLIFORD SABAH CHOHAN ARRON THIND HARAMRIT SANDHU AMANDEEP
LLA MOHAMED ATTAR NICKY BLAKE MORRIS LAM ANDREW DIAS ALIYA WILKINSON JACK COX GIULIO D'AMBROSIO CHA
PHRIES SARA WALTERS JAMIE MATTHEWS KRISTINA STEPHENS ZOE JORDAN GRACE WISE SARAH CLARK KIRSTY WOOD
THANY FENN ZEINAB ABDULLAH IMOGEN WARD LUCY ROBINSON STANLEY CARNELL JAVERIA NAWAZ DANIEL SMART RY
EST REANNE TAYLOR JIMMY MCDONALD SHERIDAN PIERPOINT JODIE RICHARDS THOMAS SQUIRES EMILY GALLAGHER KE
NAULD MPEKE MICHAEL EWENS MICHAEL BAILEY MEGAN CLOUGH KIMBERLEY DAWSON KEVIN JACKSON KIERAN BRAD
HRIS SIMPSON ASHLEIGH TAYLOR DAVID ANDERSON KEVIN BELL DARREN CUTLER DARYL JOHNSON FU HONG LI ANTHON
N DOMINIC ROGERS EMMA-LEE RILEY SIMON DUNCAN MEGAN CLOUGH KRUPA PATEL MICHAELA JOHNSON AIMEE
LAURA BRISCOE ALEX DALY-JOHNSON SIOBHAN BANAHAN EMMA CANNON LAURA EVANS JACK JOHNSON JADE THO
HAN HOWE MICHAELTHOMAS ROXANNE CATLYN SHERALYN COKE MELANIE DIXON-BAMFORTH RACHAEL FEAR CARLY
N LAWRENCE CONNIE NETHERCOT HANNAH PAYNE KURTIS POPE EMMA POTTER KAYLEIGH TOWNSEND KAYLEIGH WIL
BUMI BALOGUN CORRINA PRICE DAVID RITCHIE REUBEN ARMSTRONG ROMAIN MARADAN GEORGE COLWEY LANIE ROSE
MSKI PHILIP ASHTON LIZ CUFFLEY CARLEY SMITH HELEN BARCLAY AMY LIDSTONE LAURA LIDSTONE HASSA ABDULLA BIMPE
CE ST ROSE SAMANTHA SAUNDERS HELEN WHEELER ANTONIA ALLEN ALANA ASTON TERRI GADSBY ADAM GRICE KATIE
CHANG-PINGTIVE TAN VU LEANNA DAVIS COLLEEN FLASH JONATHAN GRANT ASHLEY LECKY APRIL LEE ALISON HUSSIN
G PAUL DAVIS LUCY DEVANE ANDREW FUNNEL KIMBERLEY JONES RICHARD MARLOW STACEY OSBORNE HARRY REDFOR
I ROSE MACFARLANE JACQUELINE MESSAM LILY POWER JUSTIN SEALS POLLY STOKER HANNAH WILLIAMS ANNA WORRA
MINGLE ANDREA MOON BHAVISHA PATEL RICKY CLARK ALICIA COHEN REBECCA FARLEY RACHEL FRANCIS ZOE GARLAN
BRYAN TANYA BURNS STEPHANIE CORNER HARRY EDWARDS VOJISLAV IGNJATOVIC GEORGE LABUTAN JOSHUA MONERY
E JACK SOMERVILLE WILLIAM WALKLING MAX DE WARDENER DAN BAGLEY JACK CROSS HOLLIE JONES EMILY GOODWI
DOWSE JESSICA MILNER SARAH MILNER ROSS BANKS AMY BATT EMMA BENTLEY CHRISTOPHER CAMPBELL SARAH BUTE
AS MCGUIRE MERYEM BOZKURT TUMAY BOZKURT CANDICE CURTIS ZEYNEP DAG CECILE DARKO HARRY DAVIES PAUL DUN
AN KERRI DOOLAN FURDUSSA HASSAN RACHEL LE BAS SIRRKA LOPES KYRSTELLE MAFINA TOBI SOREMENKUN MY HOA
WALLACE ROSELYN AKINJIOLA BABS AROGUNDADE ELIAS ASSOULI RICHARD AUSTIN STEPHANIE DELGADILLO NEIL JANG
ERYL WILLIAMS ALEX BUTLER DAVID FOWLER SIAN FOX JACK HEWES KATIE HILL LUCY HILL LINDSAY HODNETTE ANITA KIN
E ANDREW WALTON LIANNE WRIGHT AMINOOR ALI AKLASUR AHMED TAHMINA AMIN EAMANI BEGUM ALEYA BEGUMS
H LAKI BEGUM BECKY BOVINGTON GEMMA DOWD ADRIANNE DUBE STEVIE FEATHERSTONE NATALIE HORTON VICKY
ICHARD BUFFERY HELEN COOPER JENNY COOPER JACK DALLISON JOSHUA DAVIES LIAM JEAVONS ROSCOE TAYLOR PUJA
RNALAARON STUART STEVEN SIZER MORGAN CLEMENTS ELIZABETH MOONEY JOSH KEMP LUKE LANG JEREMY KNEEBO
ENNETTENDY ATHANASAKAIS MARTIN BALL CHRISTINE CHAPMAN ROBIN DUNN KATHERINE GEORGE LEV STOCKER SA
RICHARD GILLING CHLOE TUCKER TOBY GRAHAM OMAR AL-HARTHY HANNAH JONES VASHTI JACKSON GEORGE PYE IM
P CARD SARAH FLAHERTY SADIE GRANT-DARK JAMIE HANCOCK LOGAN MATHER KEIRAN CHADWICK-LEWIS KAI NEVIN
ON FIONA PRITCHARD TOM MARSHALL BEN TREMAIN AMY BARRETT STEPHANIE BALL ROXY DURRAN LIAM WATKIN ELLA
NSLOW NADINE SPENCER IONA HOPPER JESS SUMMERLING MAIA SPARROW DALIA ABDUL RAZAH NILGUN AELECI CH
MED KHALEGI IVAN BOYE DEKA IBRAHIM HOLLY ARUP PADDI BENSON ANNA GINSBURG ESTHER ADETOBE JAIME KEEBLE
ELLA YANDOLI SOPHIE BANDA LEIGHANNE MURRAY CARLA FITI JEMI PATEL KIA PREMPEH SASKIA JONES KOTAR CHETH ABI
ALI BASTAS RACHAEL MANLEY MAX BIRD KENIESHA KENLOCK KANE DEMETRIOU MILLIE ROWSWELL TAMOY ROBINSON
M ERICKA UBASA SARAH GULMOHAMED LAUREN KENNETT COURTNIG BRADY NEOMA CHIGBUNDY EFRAIM ARCAYA
OURTNEYMESSENGERGAMUCHIRAL MAWOYD CHRIS LEMMERMAN REECE AKINRINMADE SANIL WAGHELA CARMEN
LIOT MILLS JJO SCADDING AISHA BEGUM JADE HEWSON JADE SUMMERS JEMMA KERSHAW LEE COOPER DEAN SHAW SA
OMAS MARTIN HILL SIMON ATKINSON MICHAEL ATKINSON SUSAN EVANS JAMES ABERDEEN CHRISTOPHER CONNELL TO
UMLEY DANIELLEE CHRISTOPHER KANE CARLY BOWES SALLY GREENWELL SARAH CHARLTON KATIE WOOD MARK AR
JONES STEPHANIE THOMPSON PHILIP BOYCE JOSEPH KNOX DANIEL REEVE DONALD FUTERS FINTAN DAWSON CONLLO
UFF MILLIE HAMNETT LUQMAN DAWO RHYS POWELL HUW LIVINGSTONE DALIA SABZEVARI MIRIAM GRIFFITHS JIM RAN
ON JED COOPER GEMMA DEVLIN JENNIFER STEVENS ZOE THOMPSON LUCY COPELAND ROBERT EVANS BILLY HEARN SO
HAL JASMINA HOTHI KIMDEEP BANSI ANJALI SHINGADIA NATASHA THORN DANIEL STONEHOUSE ANITA SINGADIA M
SUKAN DEL RIO DANIELLE GOTFRAIND GRACE OLIVER MYLIKA WATTS DANNY TYLER DAVID LINDLEY RACHEAL CARTER
SIDDARTH GUPTA JESSICA HORNE HAYLEY MARCROFT LUKE INGRAM MATTHEW STANDEN WILLIAM NIKHWAI SOPH
SEAN COLLIN BEATRIX RAYBOULD KATE SHINGLETON LAUREN LITTLEWOOD LAURIE WHITE SEAN CHENEY ADAM FOOS
OCK DANIEL JONES MATTHEW WRAITH SHAMISO MAKARI NIKKI PADHIAR RAJESH RAMACHANDRA AIRNA LIZA